THE BEST OF Norman Rockwell

THE BEST OF
Norman Rockwell

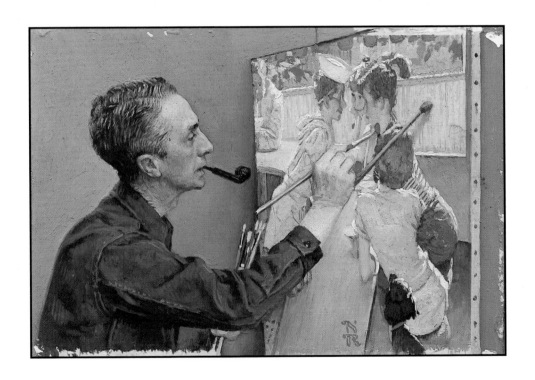

COURAGE
B O O K S

AN IMPRINT OF RUNNING PRESS
PHILADELPHIA • LONDON

17 16 15 14 13 12 11 10 9
Digit on the right indicates the number of this printing.

Library of Congress Cataloging-in-Publication Number
88–70806

ISBN 0-7624-0879-0

Front endpaper: *Norman Rockwell Bookplate*
Norman Rockwell's bookplate, circa 1925. Pen and ink on paper.
First edition copy in private collection.
Back endpaper: *Faithful Friend*
Autograph sketch, pre-1950. Ink on paper. Private Collection.

Cover design by Toby Schmidt.
Cover and title page illustration: *Portrait of Norman Rockwell Painting the
Soda Jerk* by Norman Rockwell. 1953. Private Collection.

Photographs for Endpapers, Studies, and Illustrations No. 1–31, 33–66,
68–77, 79, 82–85, 87–100 courtesy of
The Norman Rockwell Museum at Stockbridge,
Stockbridge, Massachusetts.

Illustrations No. 12 and 32 courtesy of GE Lighting, Nela Park,
Cleveland, Ohio.

Illustration No. 67 copyright © 1946 Brown and Bigelow. All rights
reserved. Produced from copyright art from the Archives of
Brown & Bigelow and with permission of the Boy Scouts of America.

Illustrations No. 78–81 Collection of Hallmark Cards, Inc.,
reproduced with permission.

Illustration No. 84 from the collections of Henry Ford Museum
and Greenfield Village, reproduced with permission.

Illustration No. 86 copyright © 1953 Brown and Bigelow. All rights
reserved. Produced from copyright art from the Archives of
Brown & Bigelow.

Typography by Fidelity Graphics.
Printed in Hong Kong.

Published by Courage Books, an imprint of
Running Press Book Publishers
125 South Twenty-second Street
Philadelphia, Pennsylvania 19103–4399

Contents

Preface

My father lived to be 84, and during nearly all those years he was drawing and painting. As a child, he made battleships out of cardboard for his older brother to cut up in mock naval battles with his friends and drew pictures of the characters from Dickens's novels while his father read to the family in the evenings; teachers asked him to draw holiday scenes on the blackboards at school. As an old man in failing health, unable to leave his room, he occasionally still tried to draw, though the results were only somewhat orderly scribbles (I don't think he realized that, however, even though sometimes he indicated what he had intended; for instance, once, a dog). In between, of course, he did more than 4,000 drawings and paintings—including over 520 magazine covers—and from his first published illustration in 1912 until his last commission in 1976, he was enormously successful.

He painted his first cover for *The Saturday Evening Post,* then the leading mass-circulation magazine, in 1916 when he was twenty-two, and by 1923 he had become one of the two most popular cover artists in America. During the Second World War his paintings of the "Four Freedoms" helped to sell more than $132,000,000 in war bonds. In 1960 the *Post* serialized his autobiography, *My Adventures as an Illustrator.* He was awarded the Presidential Medal of Freedom by President Ford in 1977.

Such a remarkable career resulted, of course, from an unusual combination of factors. My father began to work just after new printing techniques, by making the mass-circulation magazine possible, had opened up the market for illustration, but before photography began to dominate that market. He wanted his work to be accepted by a wide audience, not just the few, and he wanted and needed to paint what that audience liked to see in a way which that audience could enjoy and understand. He once noted that he painted "life as I would like it to be." As the eminent psychoanalyst, Erik H. Erikson, commented: "Perhaps that is why Norman Rockwell aims constantly to put so much happiness into his paintings, to be enjoyed by himself as well as others. Perhaps he has created his own happiness."

But his outlook and technique were not so narrow or limited that when the times changed, people no longer responded in the same ways to his work. That, for instance, is what has happened to the work of the other most popular *Post* cover artist of 1923, J.C. Leyendecker; he created the quintessential ideal man of the 1920s, the "Arrow Collar Man," but his work was limited in technique and outlook. My father always worried that he'd become "old hat," that the younger illustrators would make his work

obsolete, and he was constantly trying to improve his work, learning new techniques, trying new approaches, paying attention to changing styles and mores. He painted so many magazine covers—an average of sixteen a year during the 1920s—in addition to illustrations and advertisements, that he had difficulty thinking up new ideas and so painted what he called "topical covers": World War I, the first radio in 1920, Lindbergh's flight in 1927, the stock market crash of 1929, World War II, the advent of commercial television in 1949, and the civil rights movement and space program in the 1960s. His pictures show the distinctive ways people looked and acted and dressed in 1916 and fifty and sixty years later in the 1960s and '70s. He was interested in people, and he always used models so that he was continually working with people. If he couldn't think of the right child for a picture, he would call up the local school and go and look, for instance, at all the third grades.

He worked hard; his life was centered around his work. In 1959 he wrote:

> I put everything into my work. A lot of artists do that: their work is the only thing they've got that gives them an identity. I feel that I don't have anything else, that I must keep working or I'll go back to being pigeon-toed, narrow-shouldered—a lump. When I was younger I used to work night and day, possessed by a sort of panic that I'd lose everything if I didn't drive myself. I've given up the night work lately, but the drive is still in me. People ask me why I don't take vacations or retire altogether. I can't stop work, that's the long and the short of it.

But he also liked to work: "I'm trying not to *paint* the head. I want to *feel* it. I don't paint it, I caress it."

He had no hobbies, though he liked to get some exercise in the late afternoons—badminton, walking, tennis, riding a bicycle. During the 1920s he worked ten to twelve hours a day; on Sundays he would drive his wife to the Bonnie Briar country club and then go back to his studio. When I was young, we opened our presents early on Christmas morning, after which he would go out to the studio for a full day's work. I can remember only one family vacation—to Cape Cod; when we arrived in Provincetown, my mother looked for a house to rent, and my father went to look for a studio to work in.

His health was always good, though he struggled through the usual minor ailments—back trouble, for one. I can remember him hobbling out to the

studio with a hand on his back, complaining—or "bellyaching," as he used to say—but I don't think he ever missed a day. He was able to work through personal crises and difficulties. For instance, in the Fall of 1929 his first marriage, which had been unsatisfactory and childless though it had lasted for fourteen years, ended in divorce. In the Spring of 1930 he married my mother, who was fourteen years younger. At about the same time his older brother went bankrupt, and in 1931 his father died; so that he had to support his mother, with whom he had had a difficult, though distant, relationship. In the same year his first child, my older brother, was born, and he began to have such difficulty with his work that, as he later wrote, "My life was going down the drain. All I knew was painting and now that was failing me." But finally, characteristically, he "worked" himself out of it: "I stopped trying to understand why I was confused and dissatisfied. I don't know what's wrong, I thought... I'll just paint, because it's all I've ever been able to do."

He was, all in all, a lucky man: he liked to do what he was driven to do and he was able to earn a good living at it.

—TOM ROCKWELL

Studies

PATSY

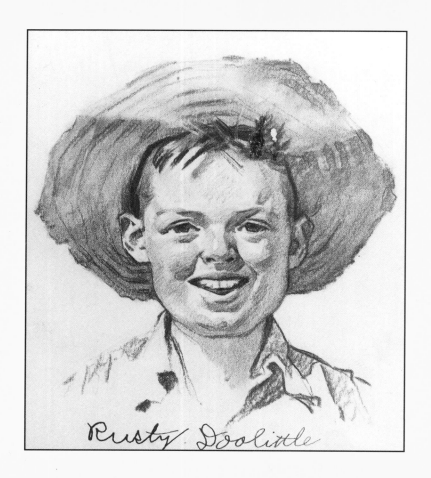

Rusty Doolittle

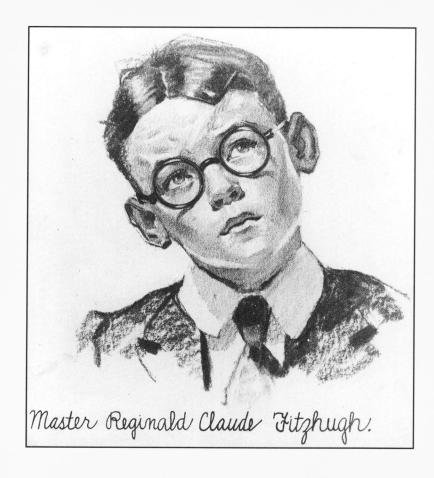

Master Reginald Claude Fitzhugh.

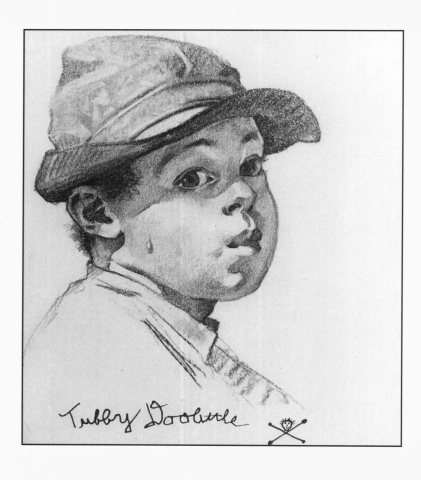

Tubby Doolittle

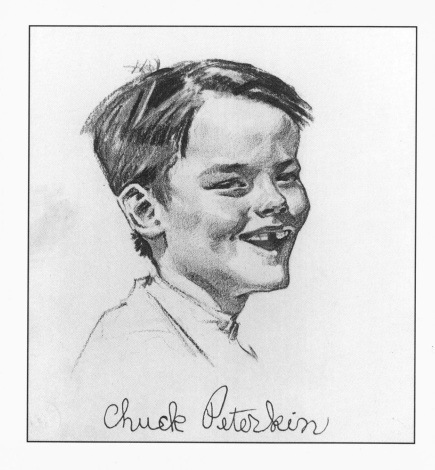

Chuck Peterkin

Preceding page and above: Character studies, *Country Gentleman,*
August 25, 1917. Charcoal.

Studies

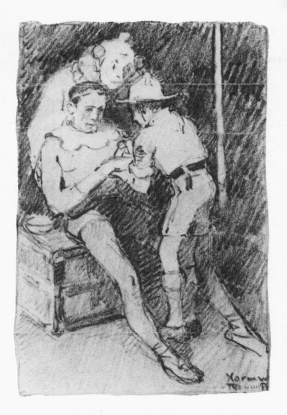

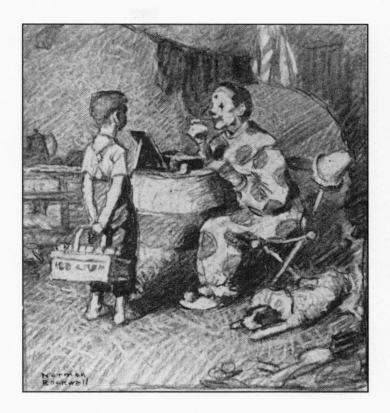

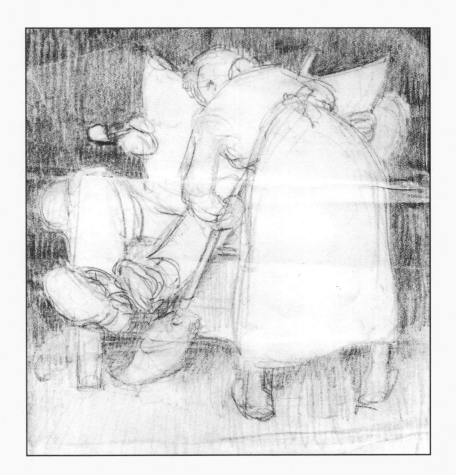

Top left: Unused idea sketch for Boy Scouts, c. 1925. Pencil.

Top right: Idea sketch, c. 1925. Wolff pencil.

Bottom: Idea sketch, c. 1925. Pencil.

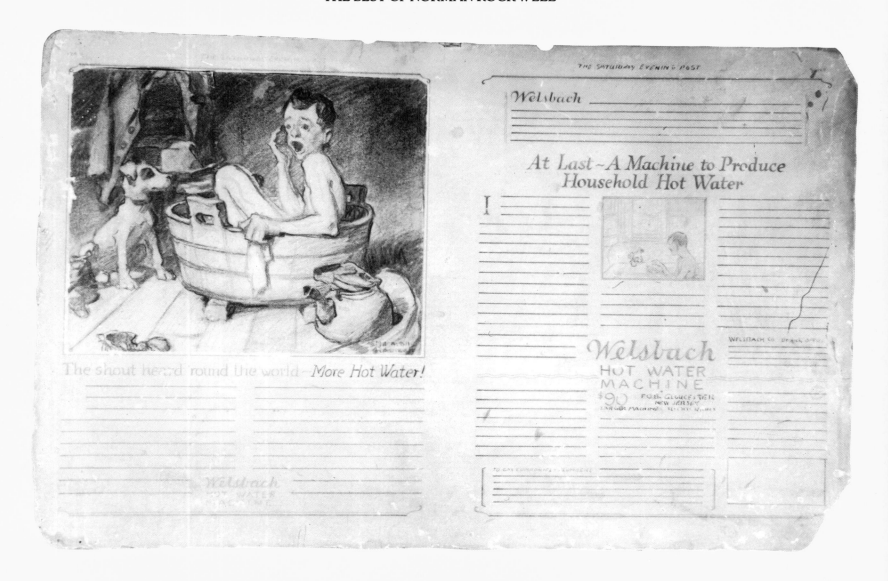

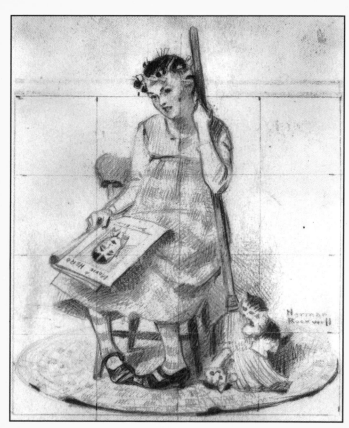

Top: Preliminary idea sketch for Welbach hot water machines advertisement, c. 1929. Pencil and watercolor.

Bottom: Idea sketch for cover illustration, *Saturday Evening Post*, November 4, 1922. Pencil.

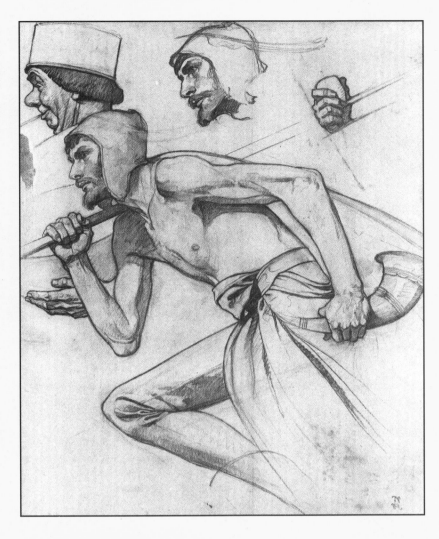

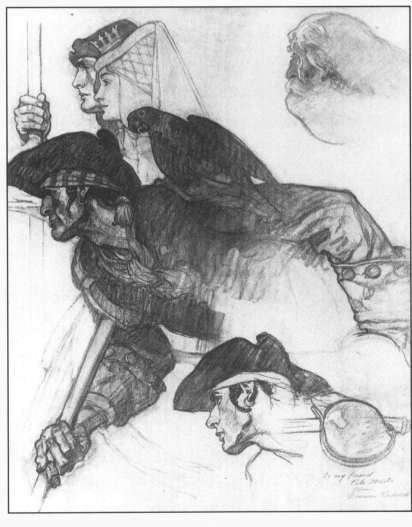

Studies for "The Land of Enchantment," *Saturday Evening Post,*
December 22, 1934. Pencil.

PORTRAITS

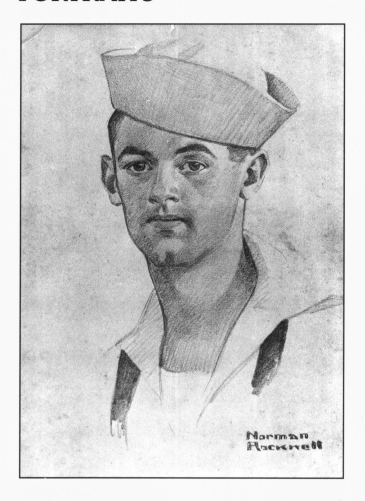

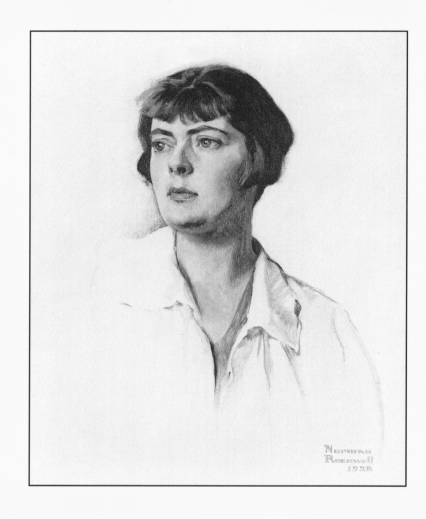

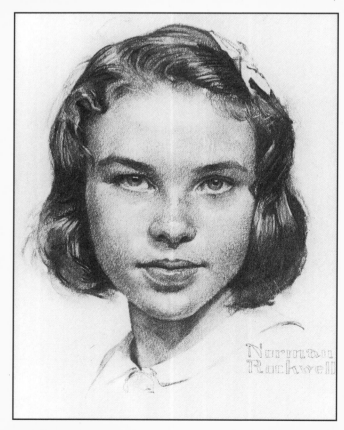

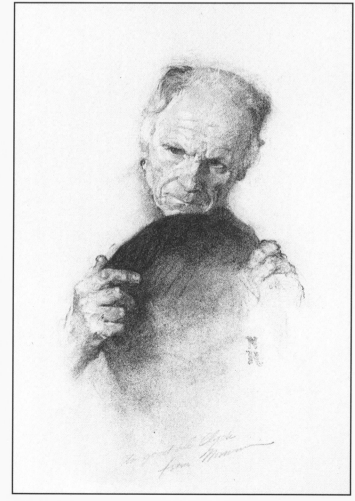

Top left: John W. Lipscomb, 1918. Charcoal.

Top right: Ruth Pine Furniss, 1928. Oil.

Bottom left: Sally Ann Hill, 1941. Charcoal.

Bottom right: Clyde Forsythe, c. 1942. Charcoal.

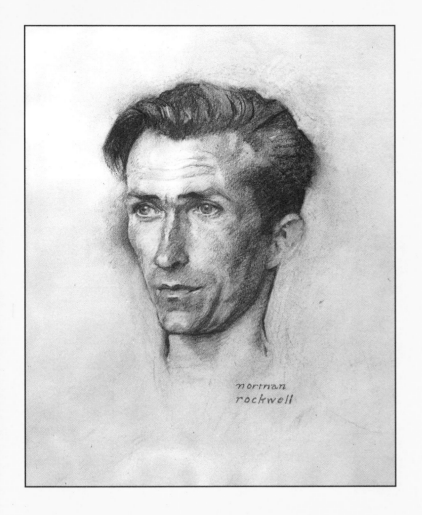

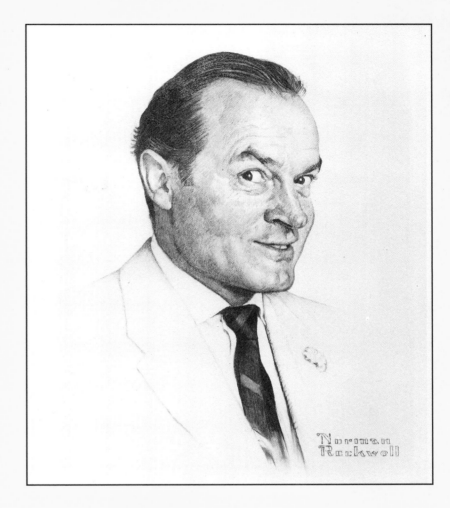

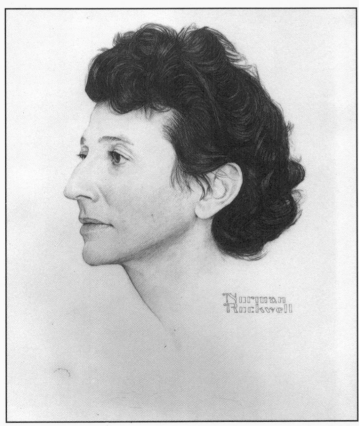

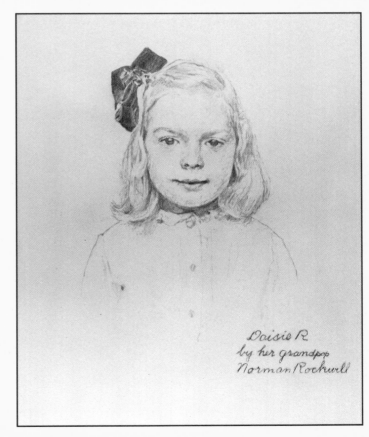

Top left: Charles Roland, c. 1950. Charcoal.

Top right: Bob Hope, study for cover illustration, *Saturday Evening Post*, February 13, 1954. Pencil.

Bottom left: Margaret Brenman-Gibson, Ph.D., 1962. Charcoal.

Bottom right: Anne Daisy Rockwell, c. 1973. Charcoal.

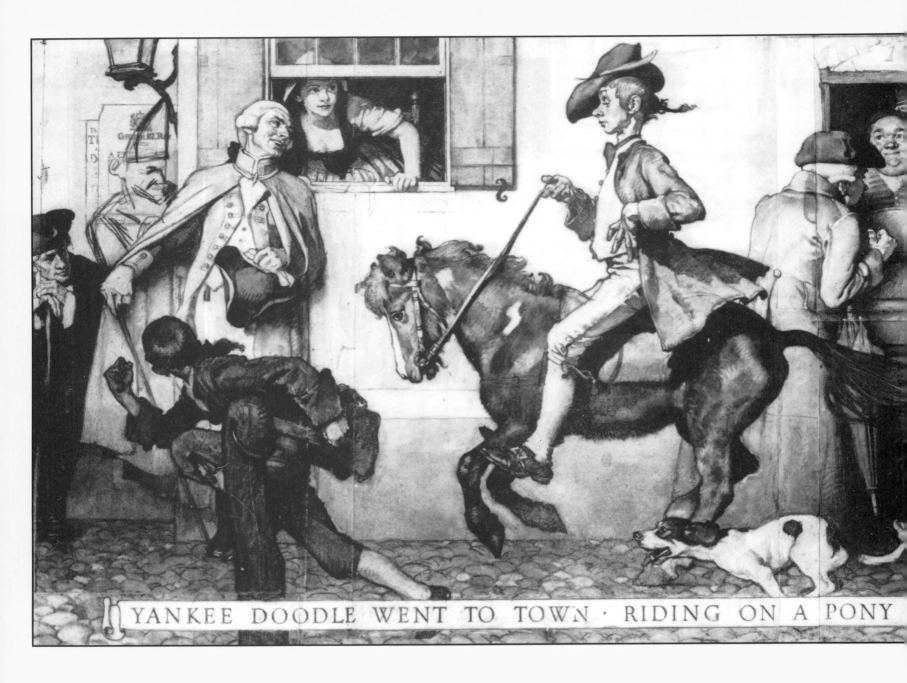

YANKEE DOODLE WENT TO TOWN · RIDING ON A PONY

Study for mural for Nassau Inn, Princeton, New Jersey, 1936.
Charcoal and pencil.

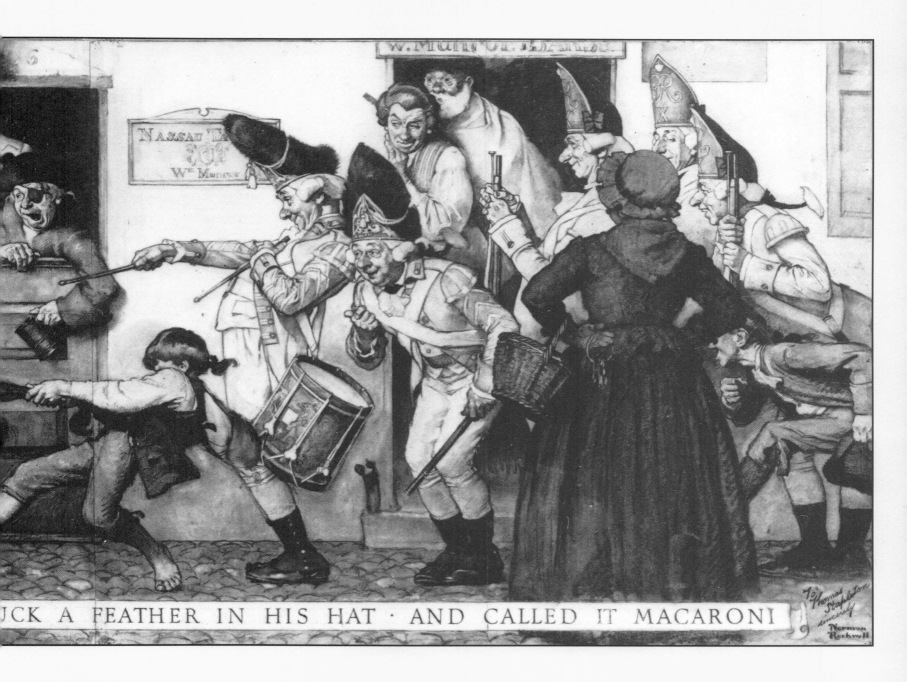

Unused idea sketch for Coca~Cola, c. 1935. Oil.

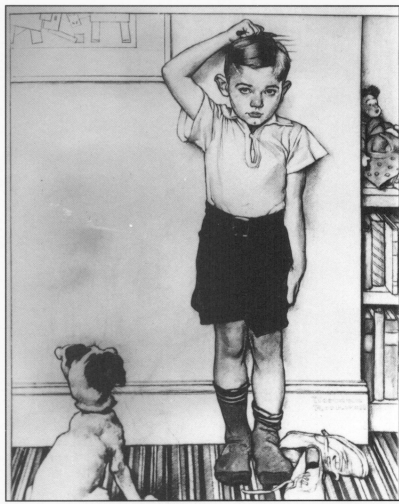

Top: Study for illustration, *Saturday Evening Post*, February 22, 1936. Charcoal.

Bottom: Study for pharmaceuticals advertisement for Upjohn, 1939. Charcoal.

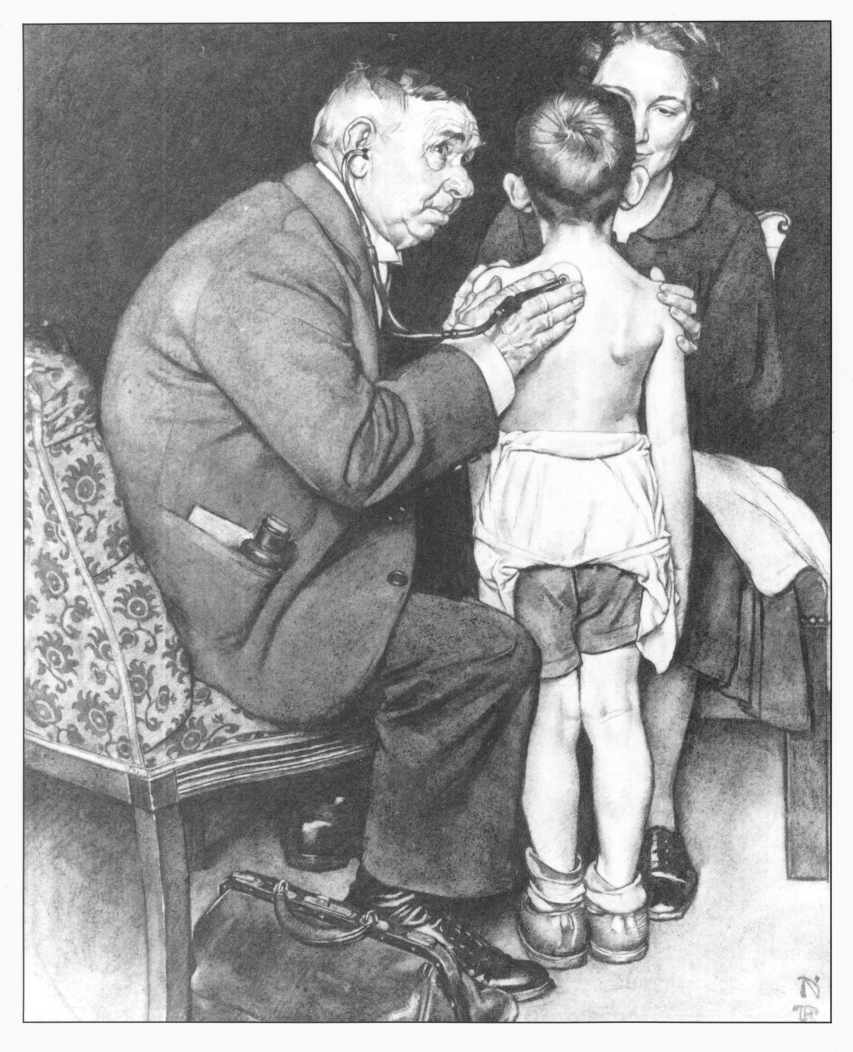

Study for illustration, *Saturday Evening Post*, December 24, 1938.
Charcoal.

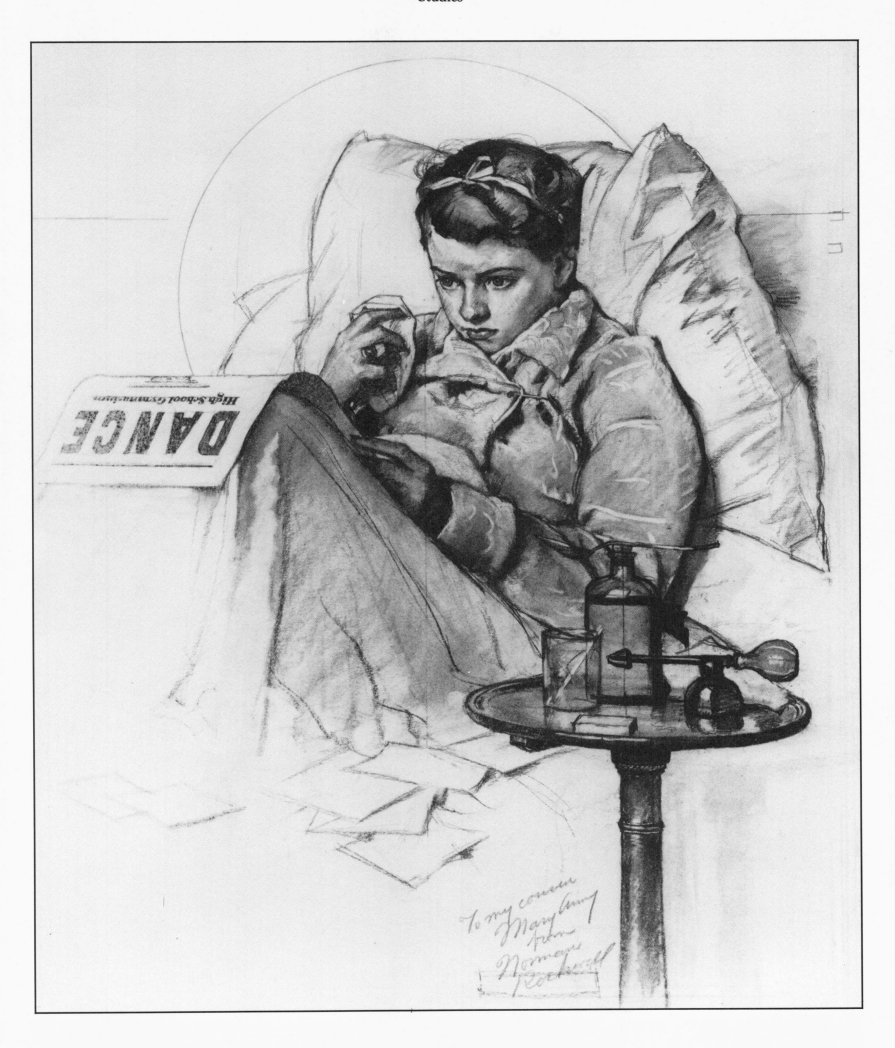

Study for cover illustration, *Saturday Evening Post*, January 23,
1937. Charcoal.

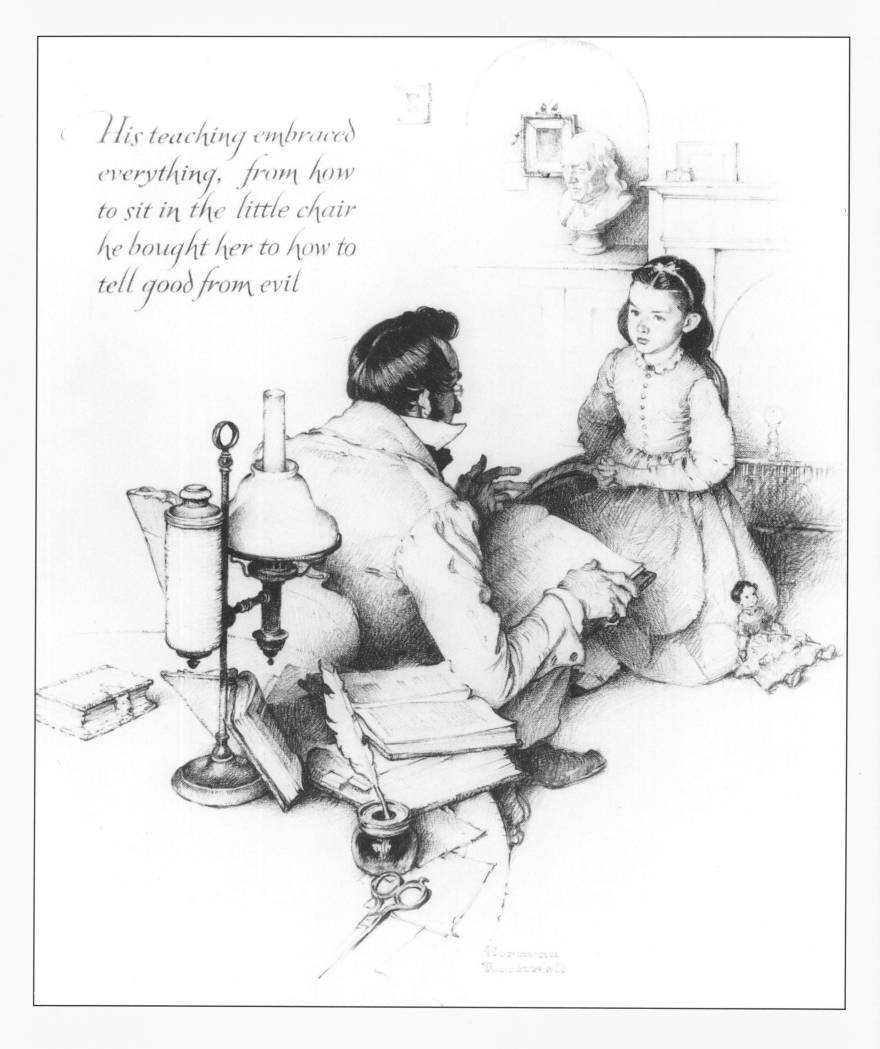

His teaching embraced everything, from how to sit in the little chair he bought her to how to tell good from evil

Illustrations for "The Most Beloved American Writer" (Louisa May Alcott) by Katherine Anthony, *Woman's Home Companion*, December, 1937. Wolff pencil.

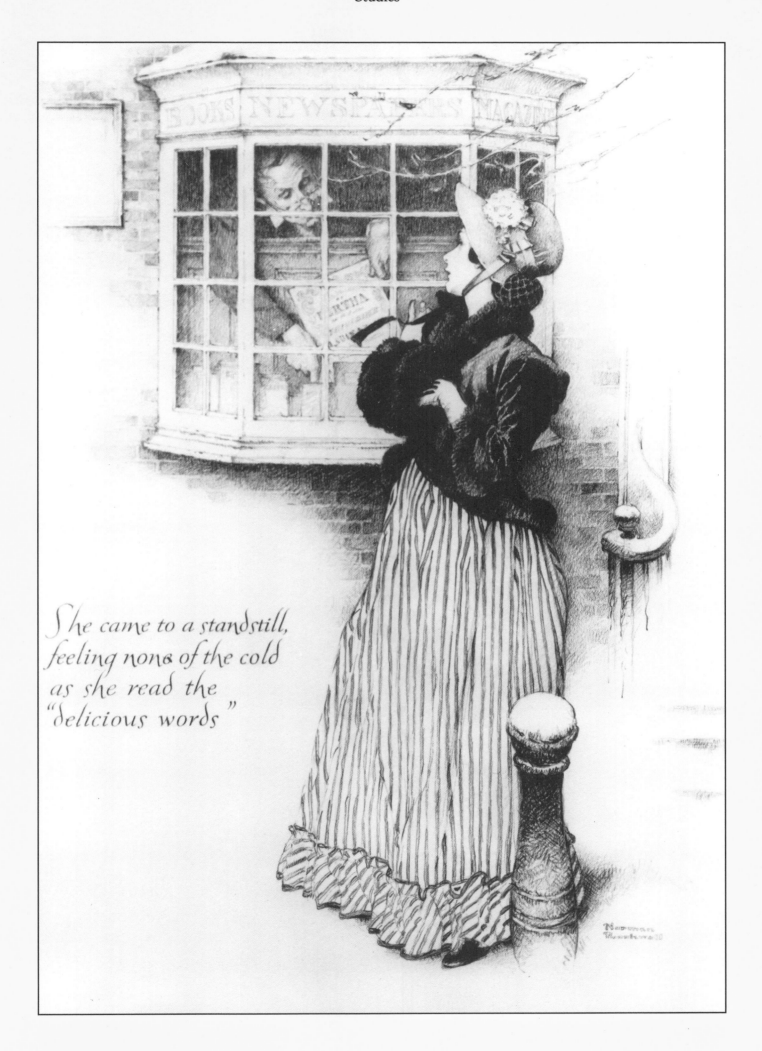

She came to a standstill, feeling none of the cold as she read the "delicious words"

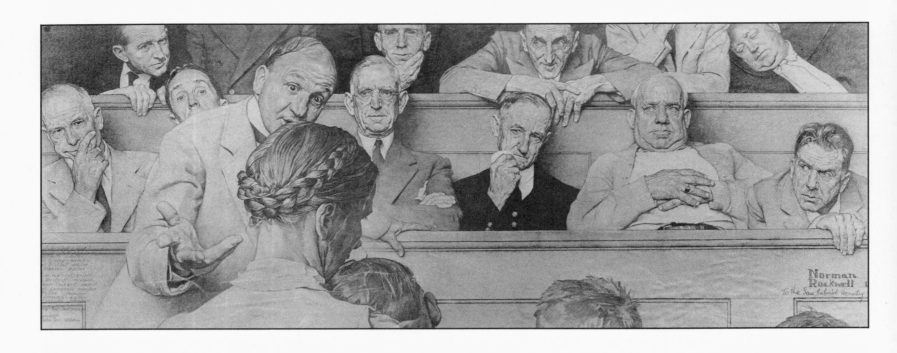

Study for illustration, *Saturday Evening Post*, June 6, 1942. Pencil.

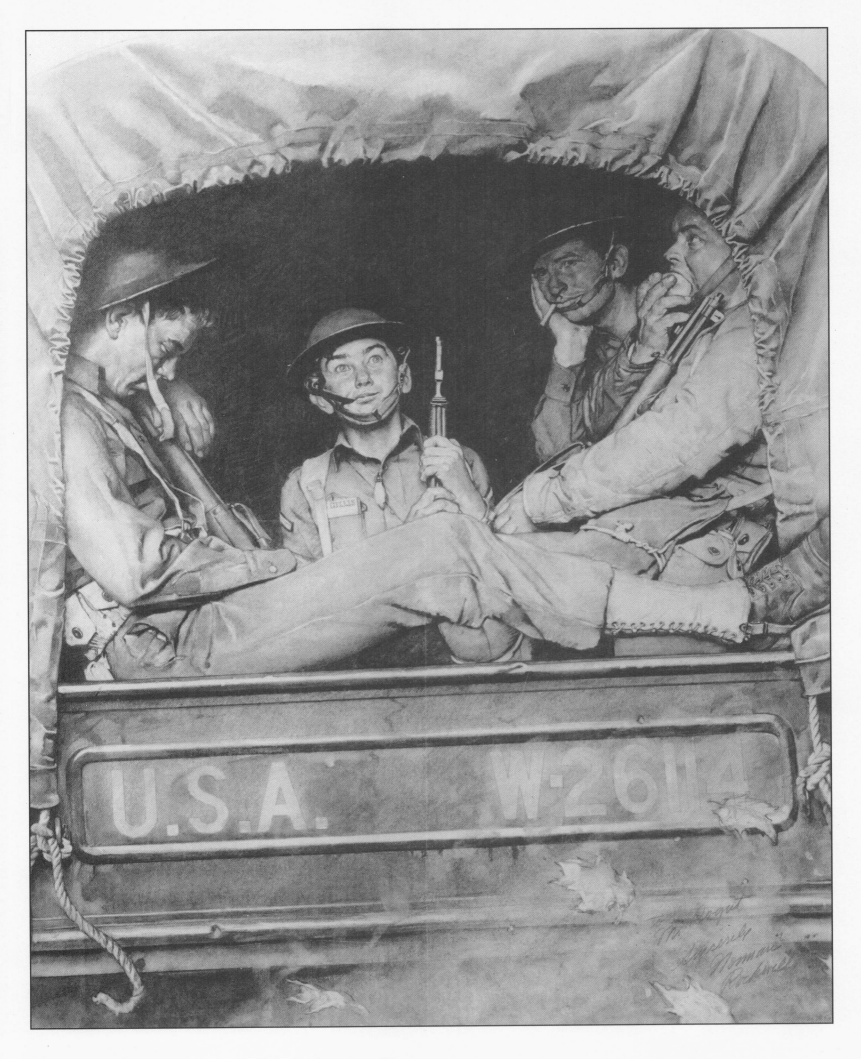

"Willie Gillis in Convoy." Unused study for cover illustration,
Saturday Evening Post, c. 1943. Charcoal.

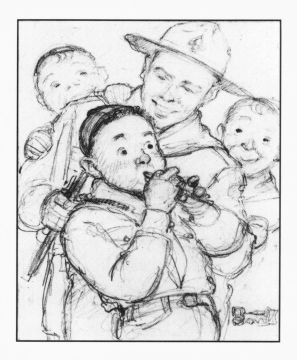

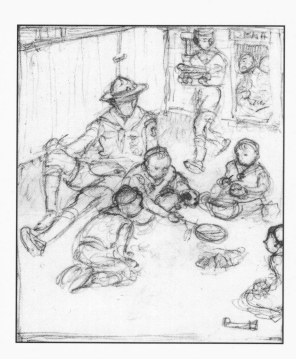

Top: Idea sketch for 1949 Boy Scouts calendar. Pencil.

Middle and Bottom: Unused idea sketches for Boy Scouts calendars, c. 1950. Pencil.

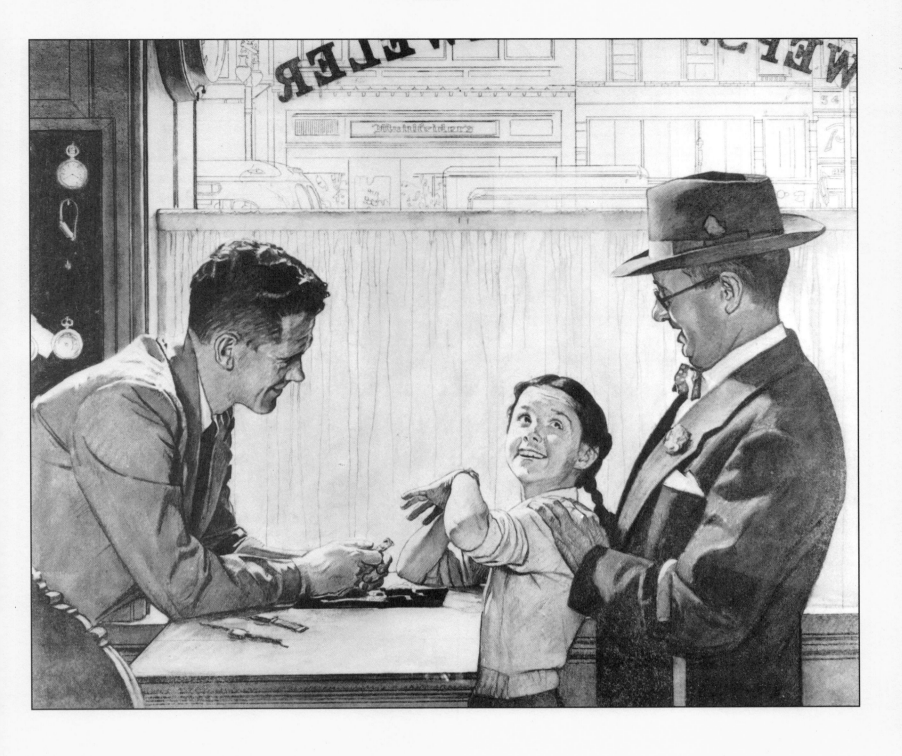

Study for Swiss Federation of Watchmakers, c. 1954. Pencil and charcoal.

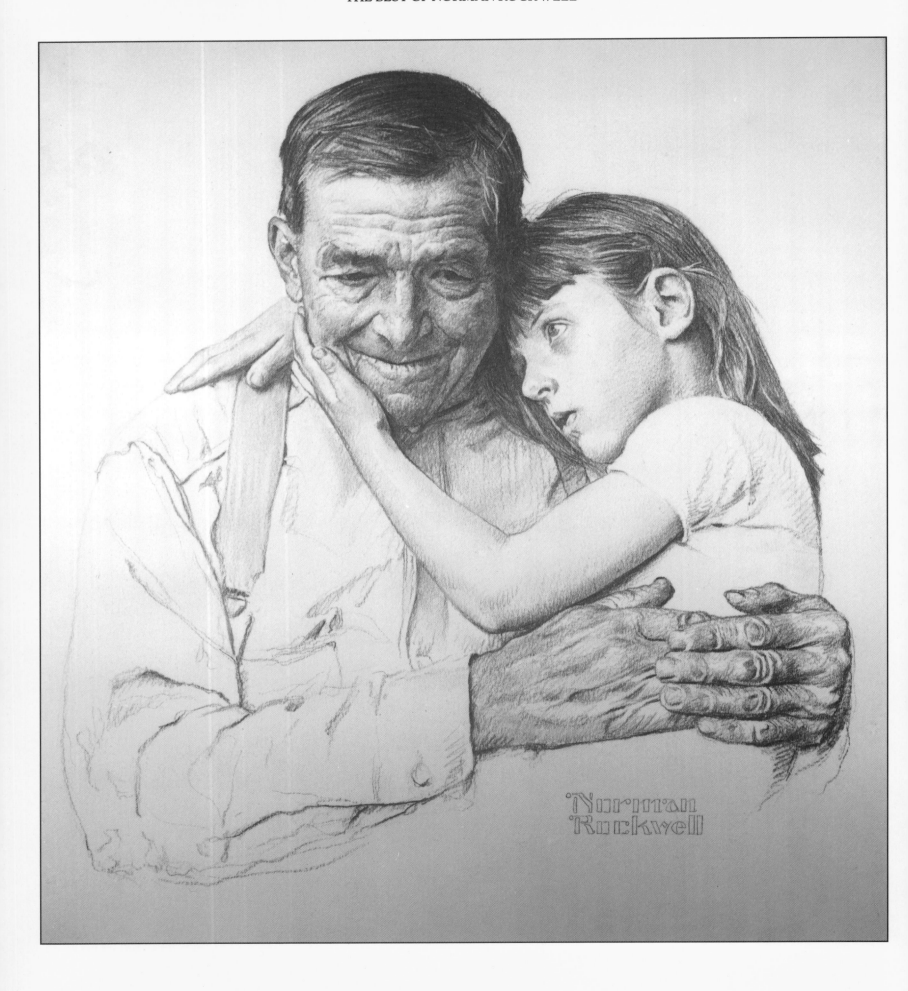

"Forsaken," *New York Times:* "One Hundred Neediest Cases, 41st
Appeal." 1952. Charcoal.

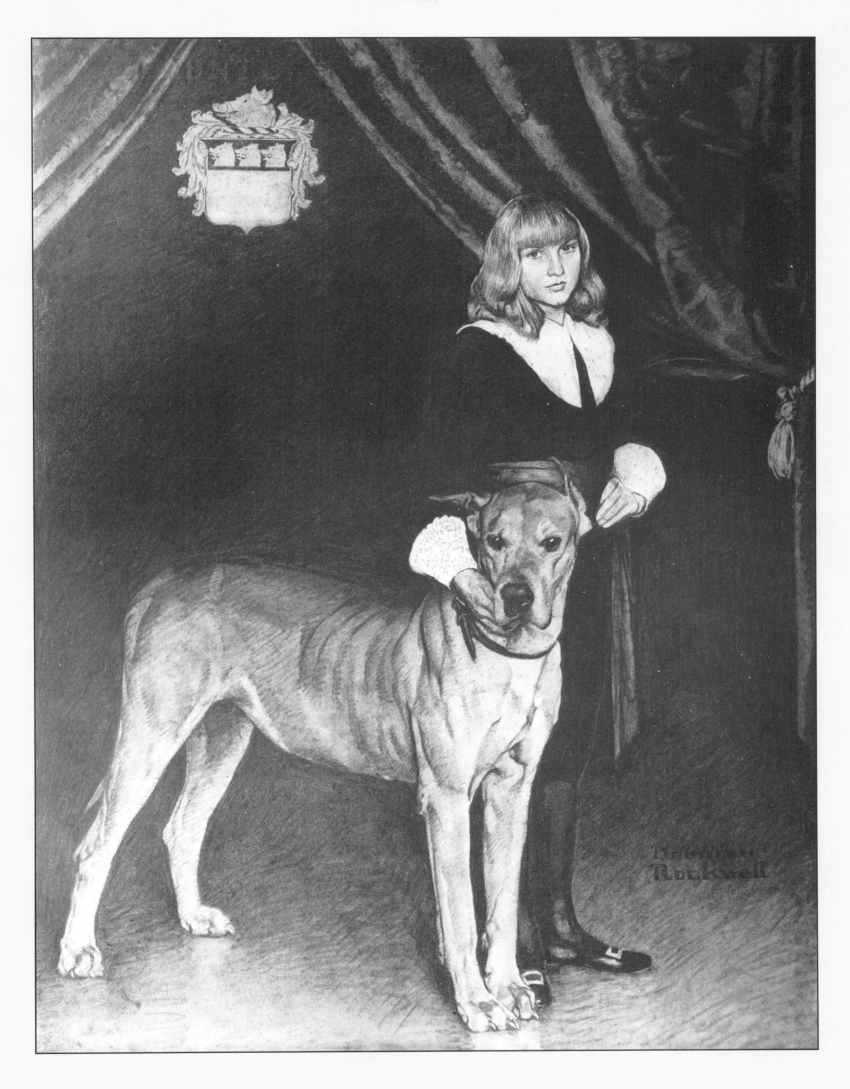

"Little Lord Fauntleroy," c. 1945. Study. Charcoal.

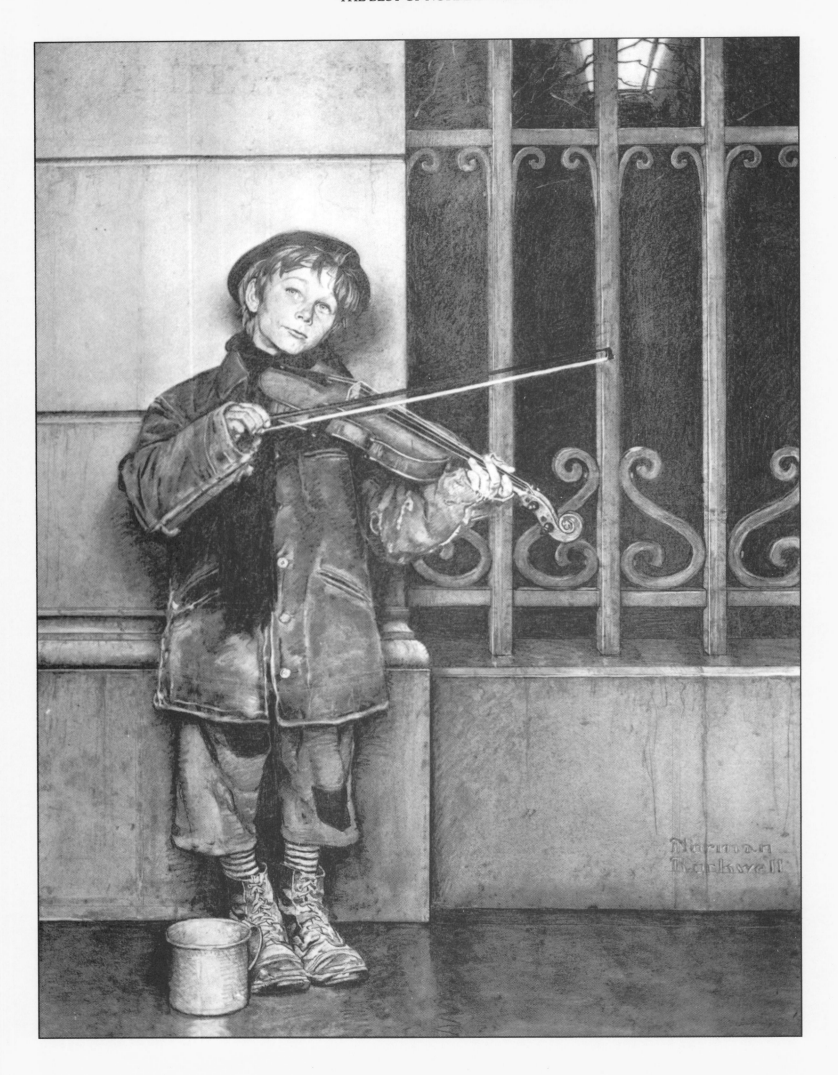

"Phil the Fiddler," c. 1950. Study. Charcoal.

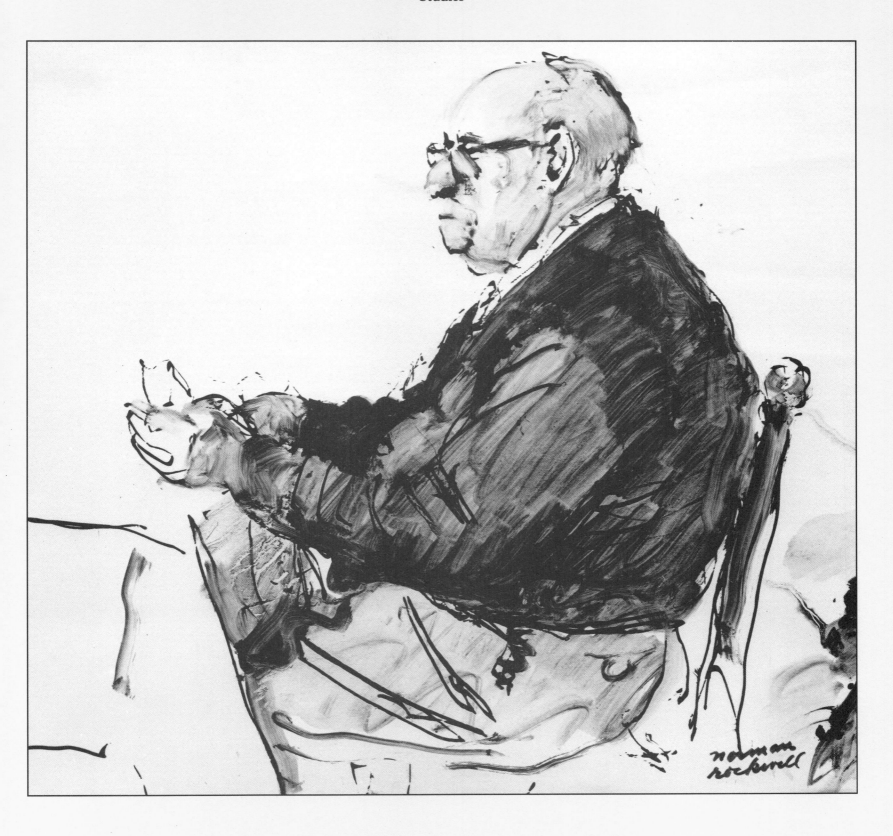

Sketch, c. 1960. Ink.

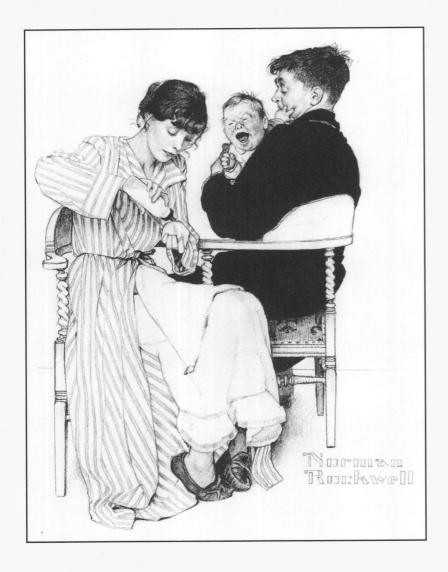

Top: Advertisement for Texas Commerce Bank, 1955. Pencil.

Bottom: Advertisement for Massachusetts Mutual Insurance
Company, 1961. Pencil.

Top: Advertisement for Massachusetts Mutual Insurance
Company, 1955. Pencil.

Bottom: Advertisement for Massachusetts Mutual Insurance
Company, 1960. Pencil.

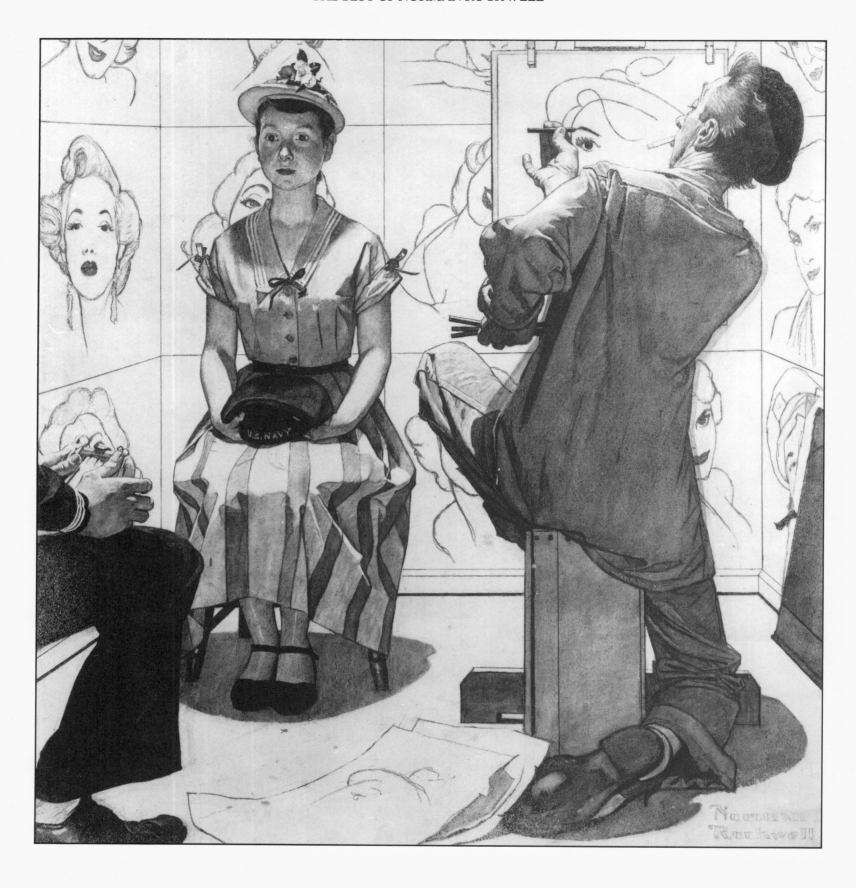

Unused study for cover illustration, *Saturday Evening Post*, 1956. Charcoal.

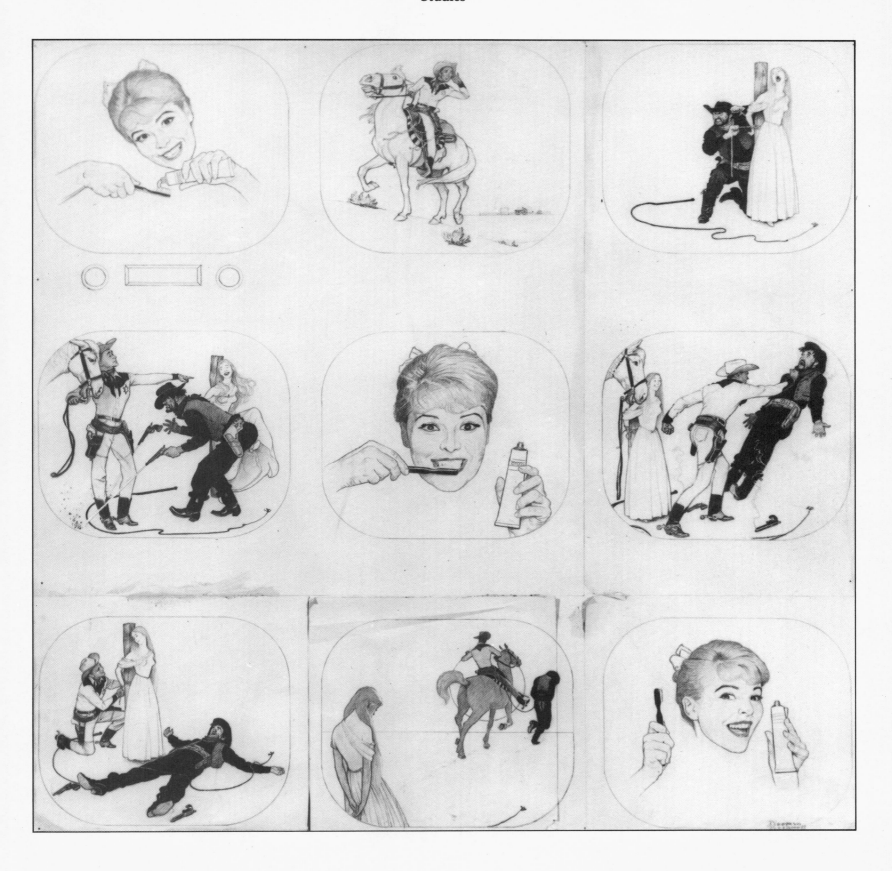

Unused study for cover illustration, *Saturday Evening Post*, c. 1955. Pencil.

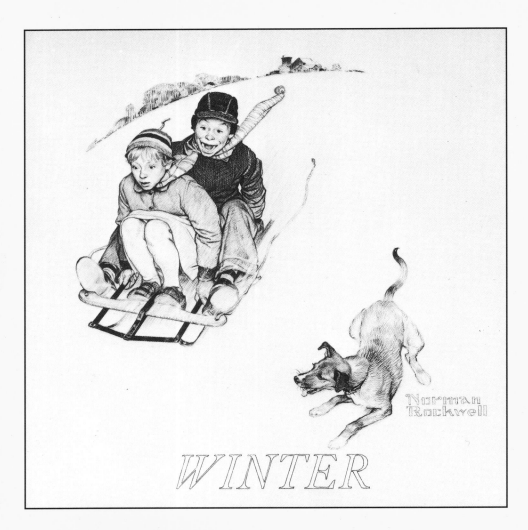

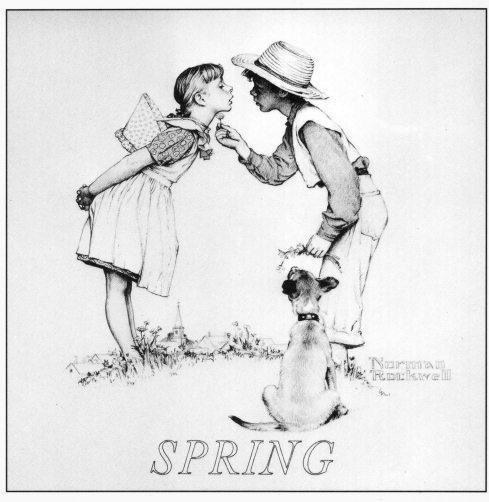

Studies for 1949 Four Seasons calendar. Charcoal.

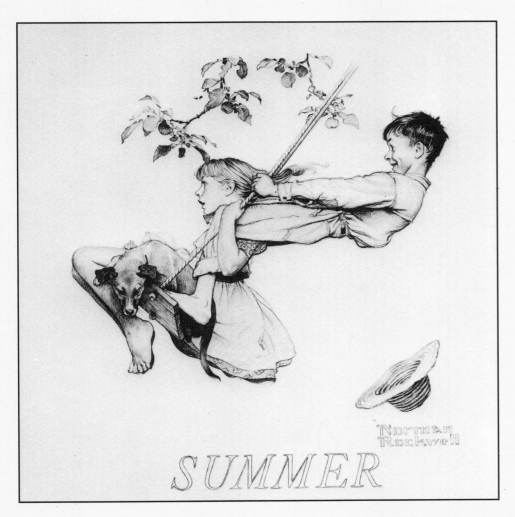

SUMMER

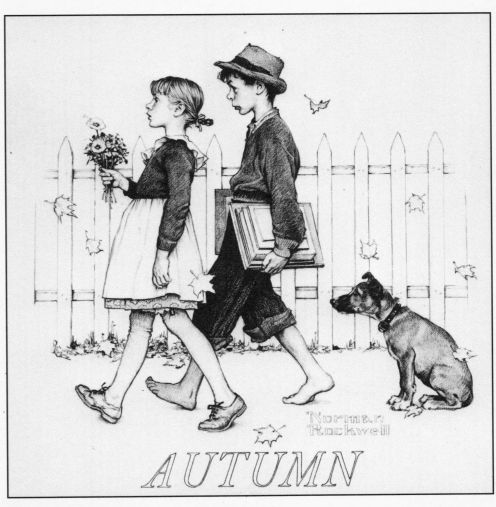

AUTUMN

*What's proper is becoming;
See the Blacksmith with
his white Silk Apron!*

*If your head is wax,
Don't walk in the Sun*

*Those who in quarrels
interpose,
must often wipe a bloody
nose.*

*Craft must be at charge for clothes,
but Truth can go naked*

Unused illustrations for The Heritage Press edition of *Poor Richard's Almanacks* by Benjamin Franklin, 1964. Pen and ink.

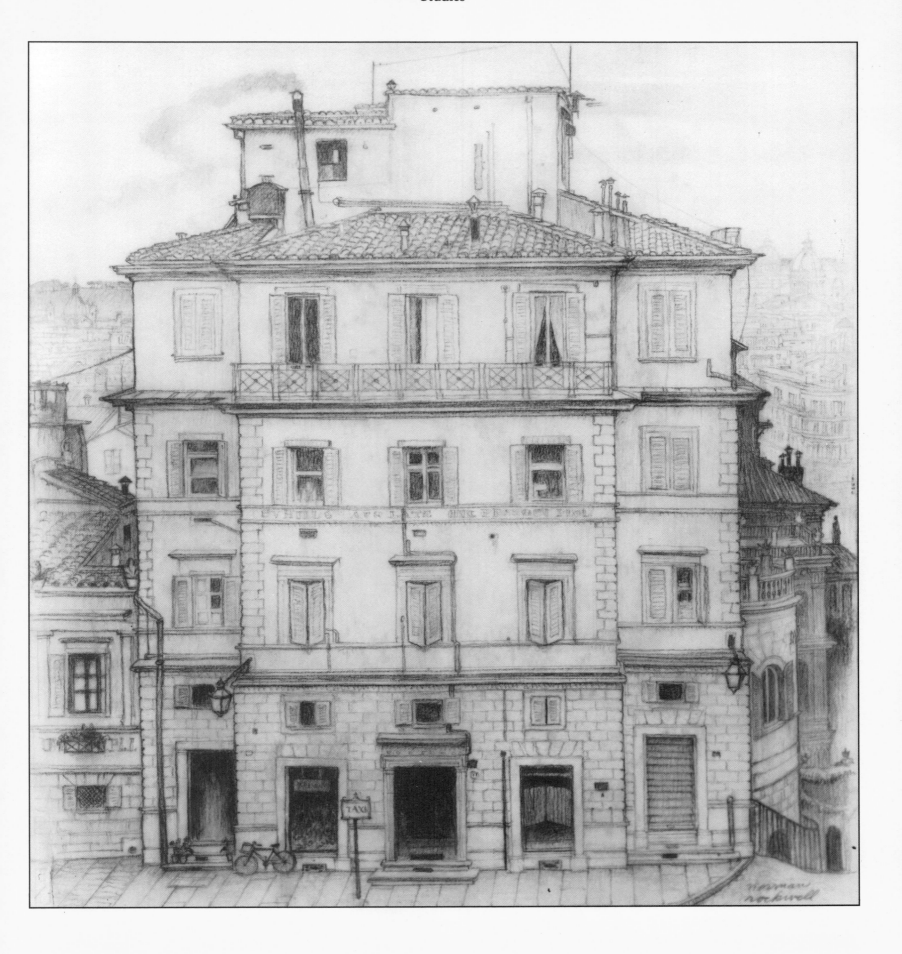

"View of Rome from My Hotel Window," 1962. Pencil.

The Baths, Virgin Gorda, Feb '74.
Norman Rockwell

One of Norman Rockwell's last drawings, 1974. Pencil.

Part One
1910 to 1920

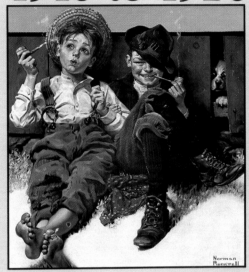

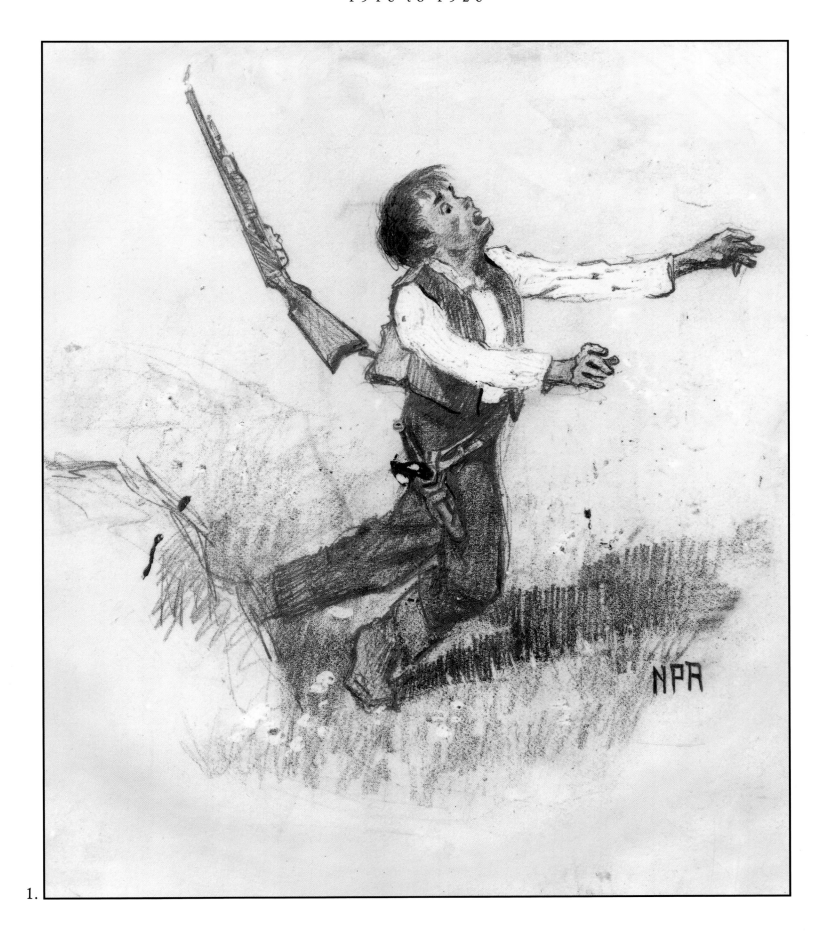

1. ***The Hazing of Kid Burnham***
 Boy's Life, March, 1914, page 4. Illustration for "The Hazing of
 Kid Burnham" by Eugene J. Young.

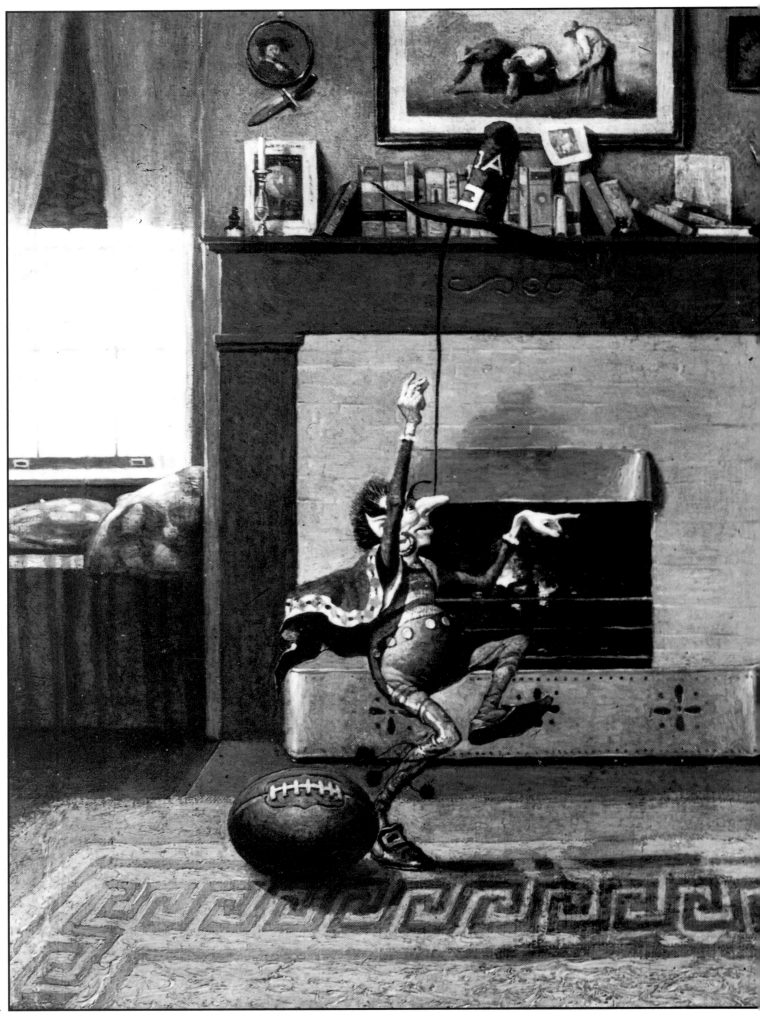

2.

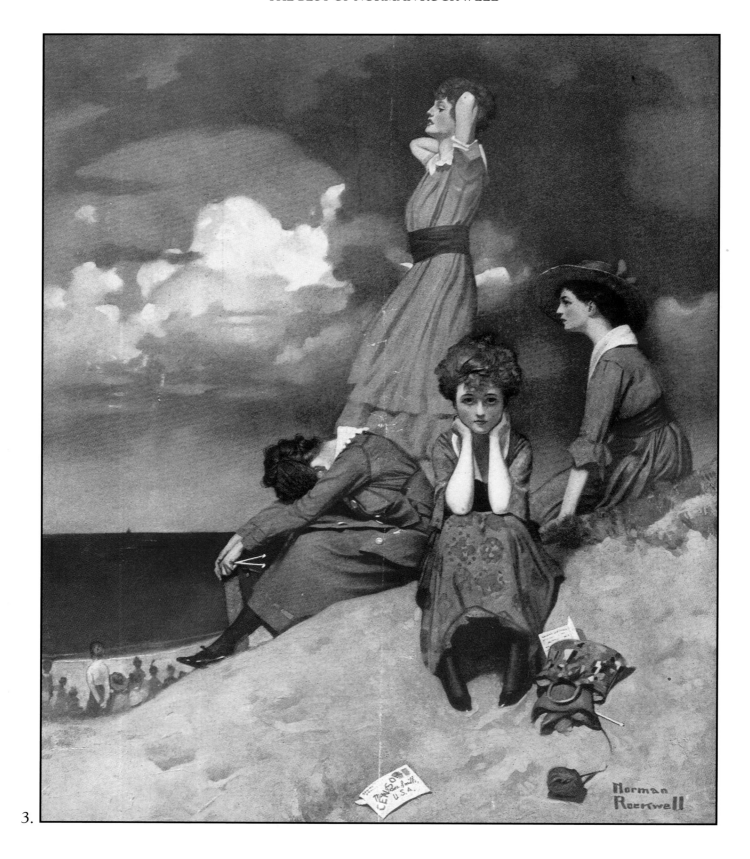

3.

2. *The Magic Football*
 St. Nicholas, December, 1914, page 131. Illustration for "The
 Magic Football" by Ralph Henry Barbour. Oil on canvas.
 Collection of the Norman Rockwell Museum at Stockbridge.

3. *Till the Boys Come Home*
 Life, August 15, 1918, cover. Oil on canvas. Private collection.

4. *The Little Mother*
 Life, November 7, 1918, cover. Oil on canvas. Private collection.

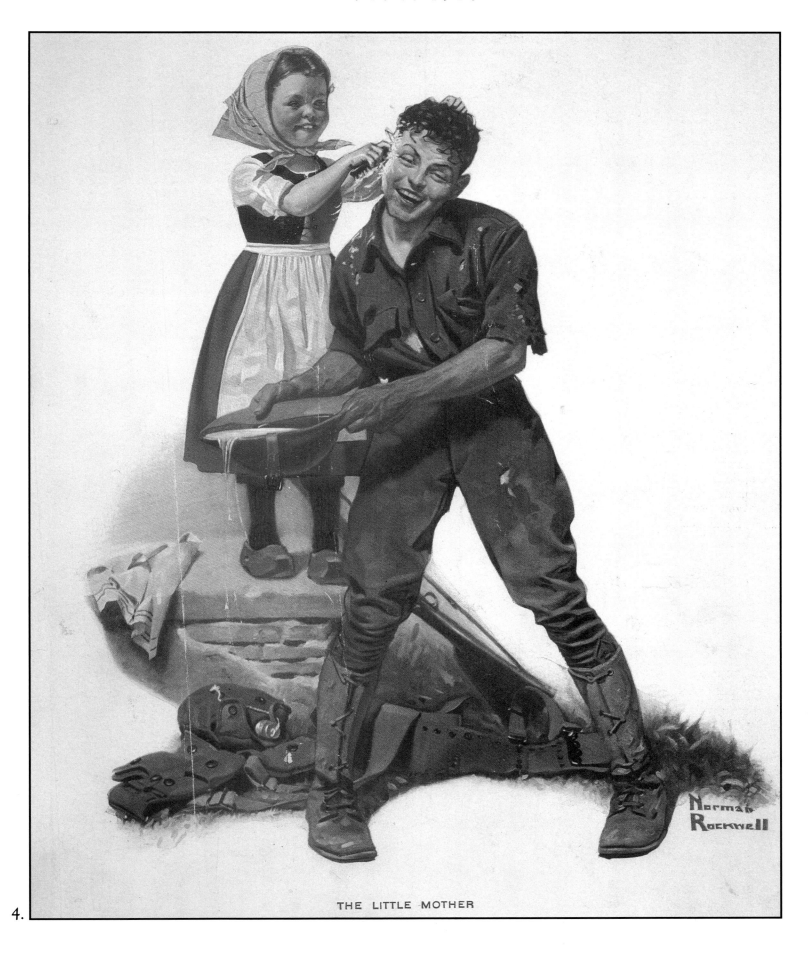

THE LITTLE MOTHER

4.

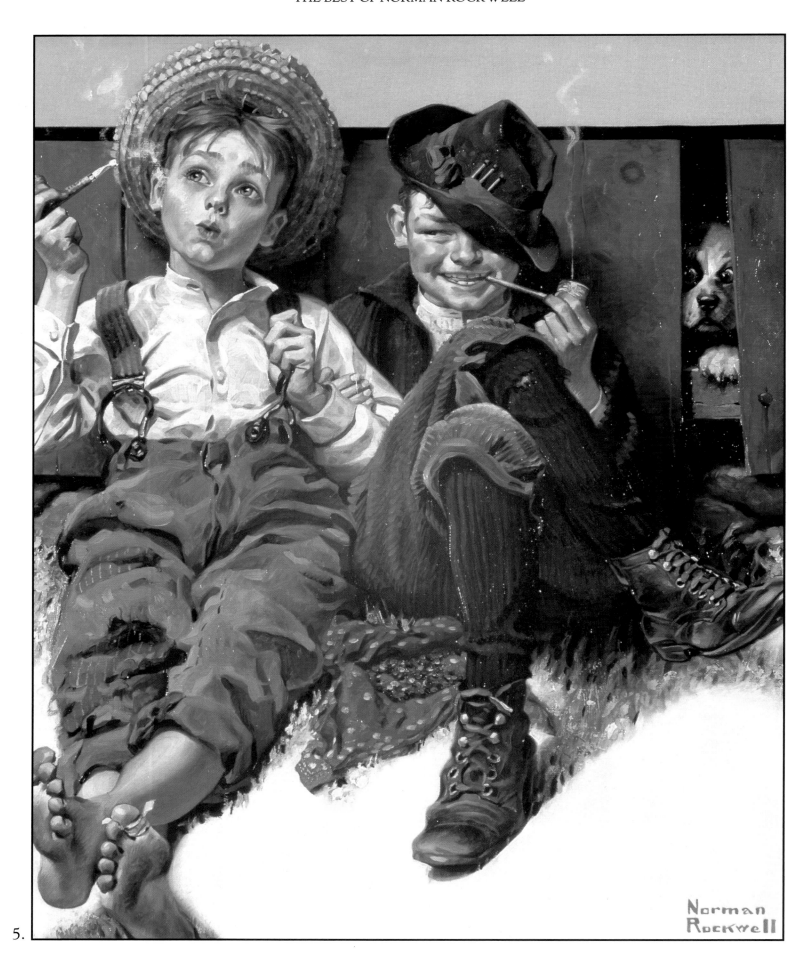

5.

5. ...*But Wait til Next Week!*
 Country Gentleman, May 8, 1920, cover.

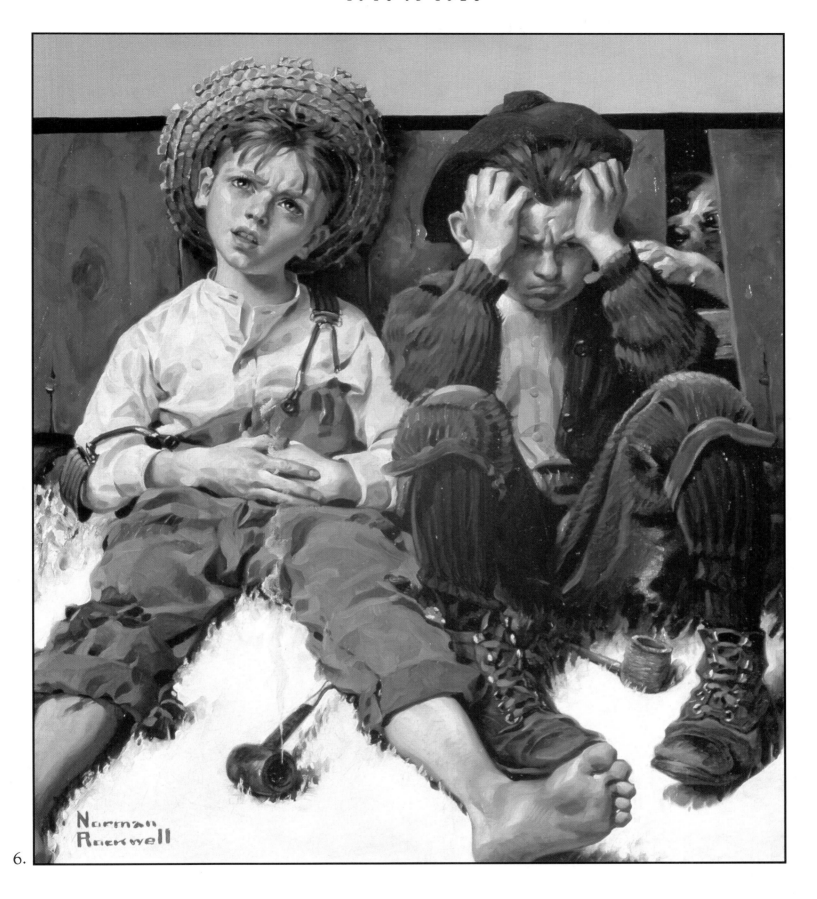

6.

6. *Retribution!*
 Country Gentleman, May 15, 1920, cover.

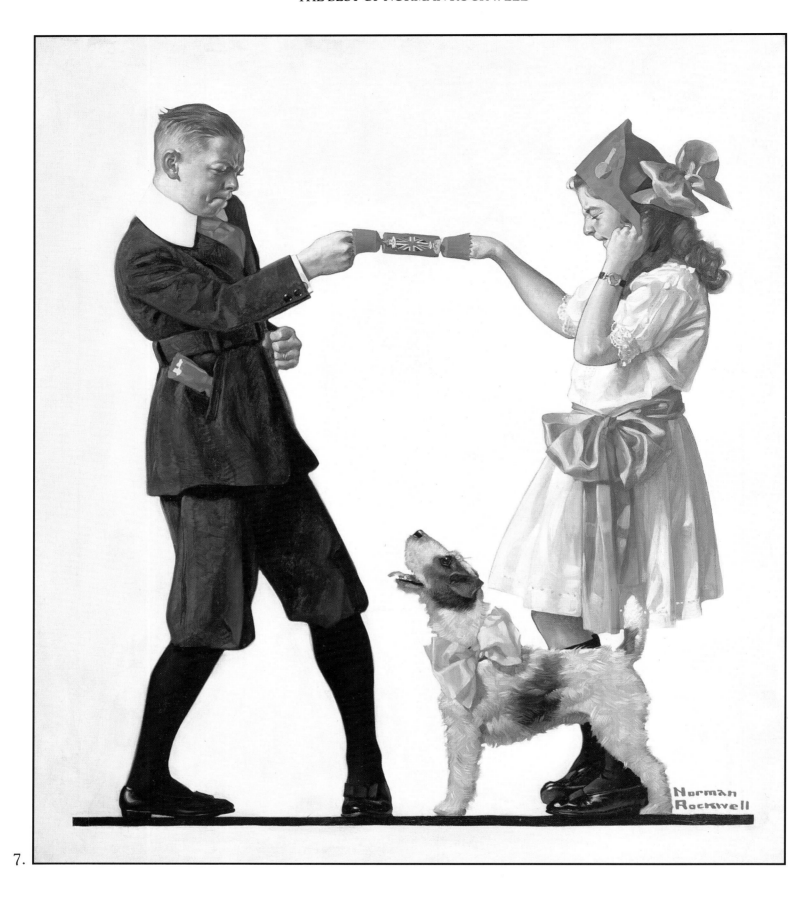

7.

7. *The Party Favor*
 Saturday Evening Post, April 26, 1919, cover. Oil on canvas.
 Private collection.

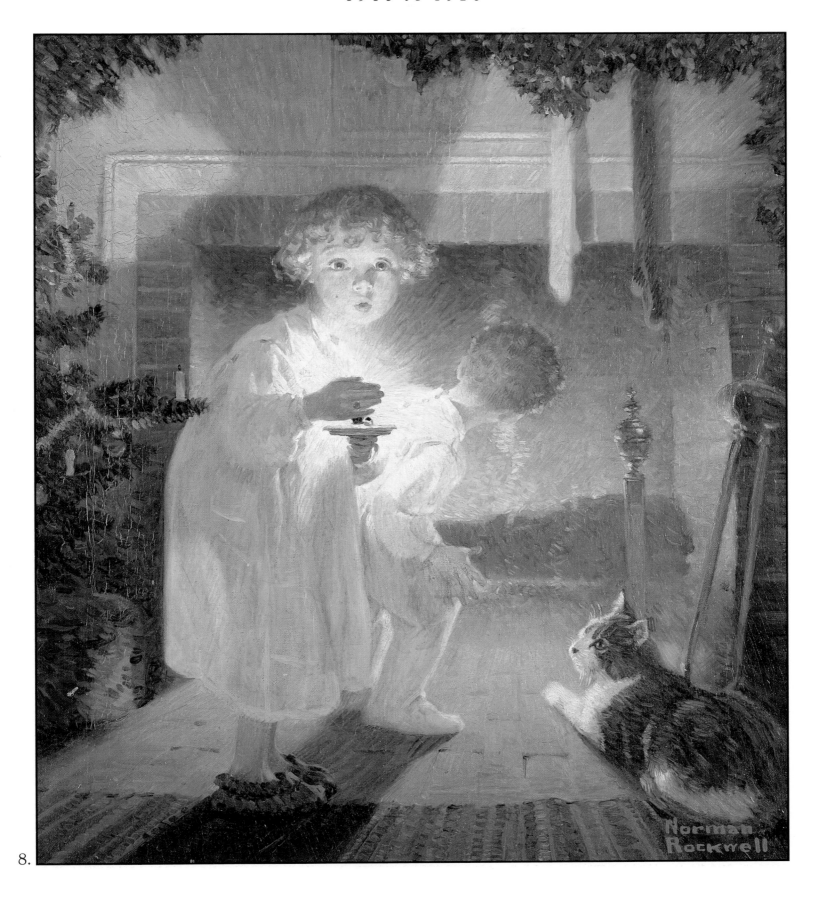

8.

8. · *Is He Coming?*
 Life, December 16, 1920, cover. Oil on canvas. Private
 collection.

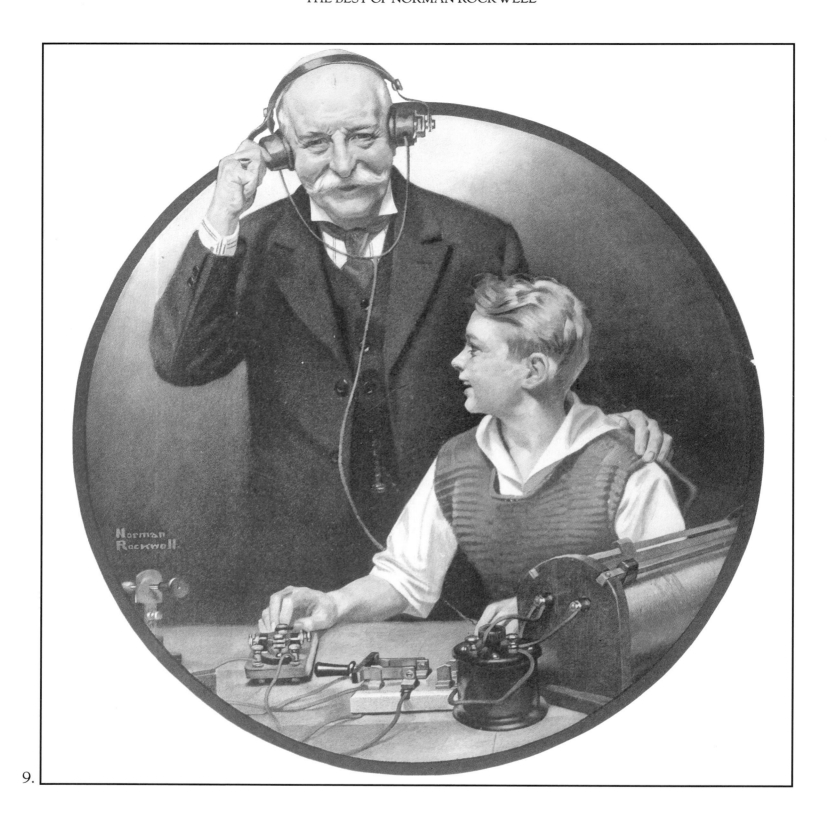

9.

9. *Grandpa Listening In on the Wireless*
 Literary Digest, February 21, 1920, cover. Oil on canvas. Private
 collection.

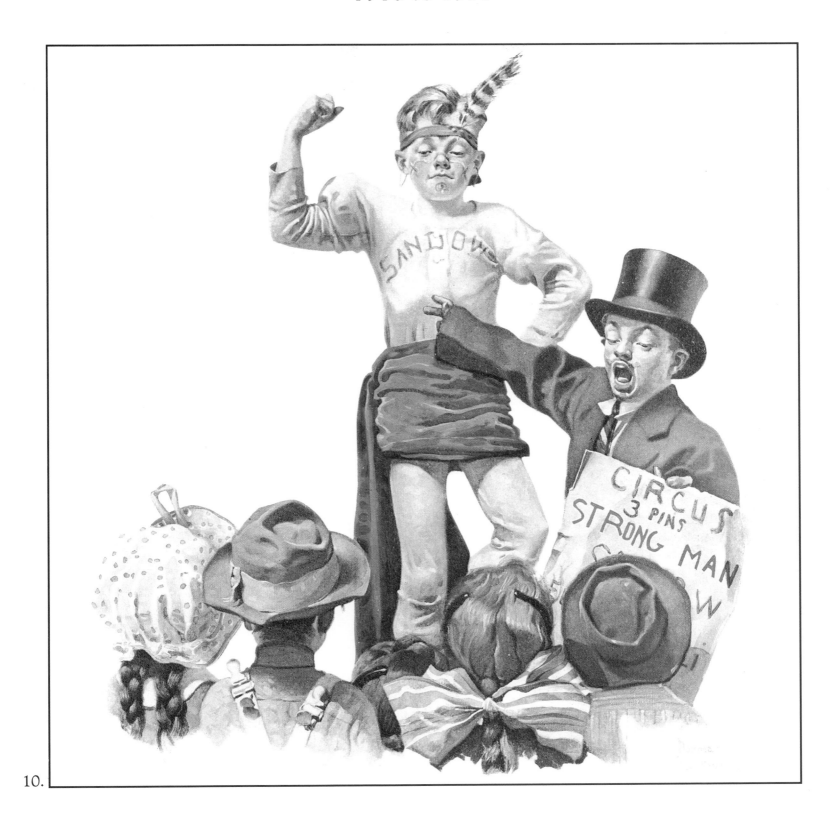

10.

10. **The Circus Barker (The Strongman)**
Saturday Evening Post, June 3, 1916, cover. Oil on canvas.
Collection of Curtis Publishing Company.

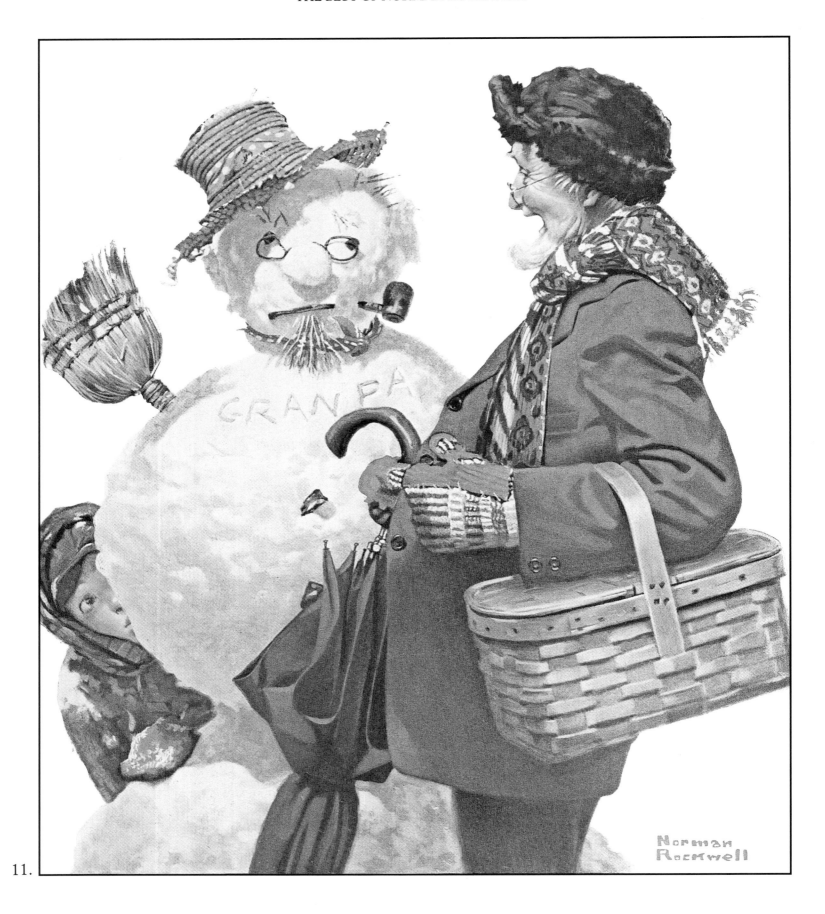

11.

11. *Grandfather and Snowman*
Saturday Evening Post, December 20, 1919, cover. Oil on canvas.
Collection of Newman Galleries.

23

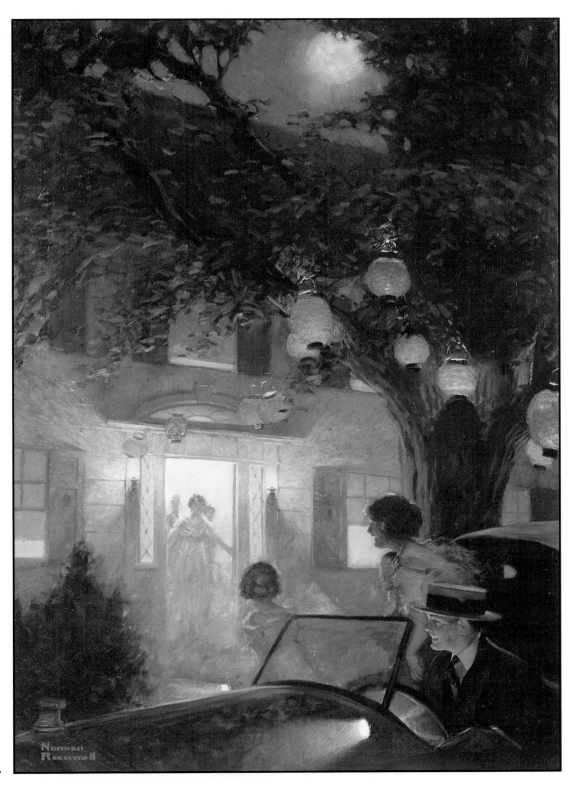

12.

12. *And the Symbol of Welcome Is Light*
Lamp advertisement for Edison Mazda, 1920. Oil on canvas.
Collection of General Electric Lighting Company, Cleveland.

Part Two
The 1920s

27

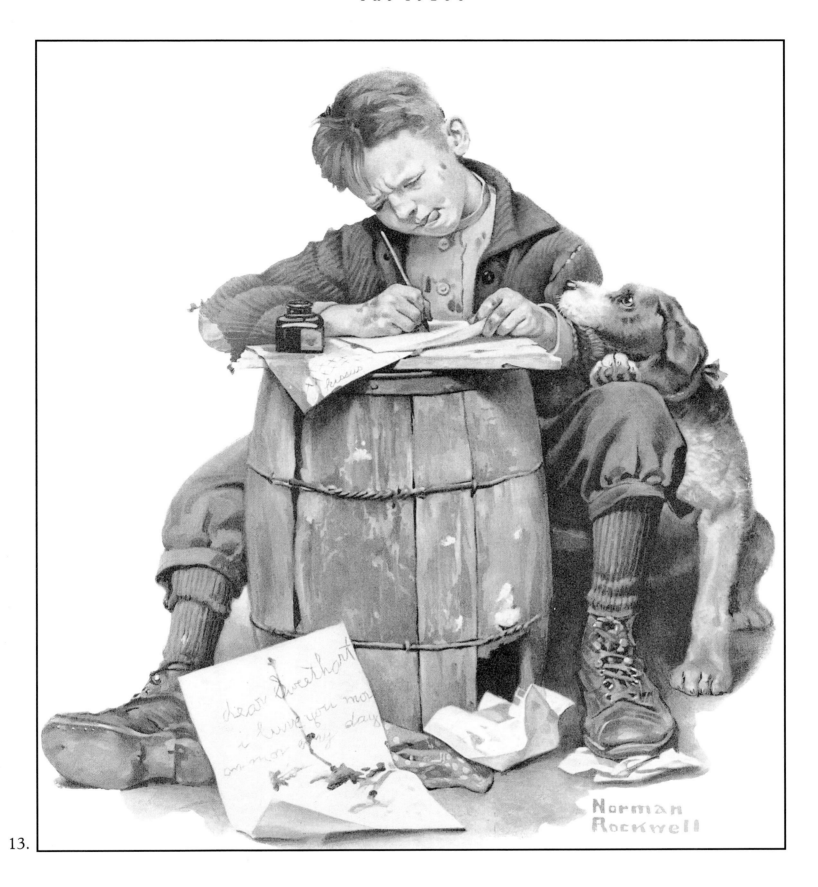

13.

13. *Little Boy Writing Letter*
 Saturday Evening Post, January 17, 1920, cover. Oil on canvas.
 Private collection.

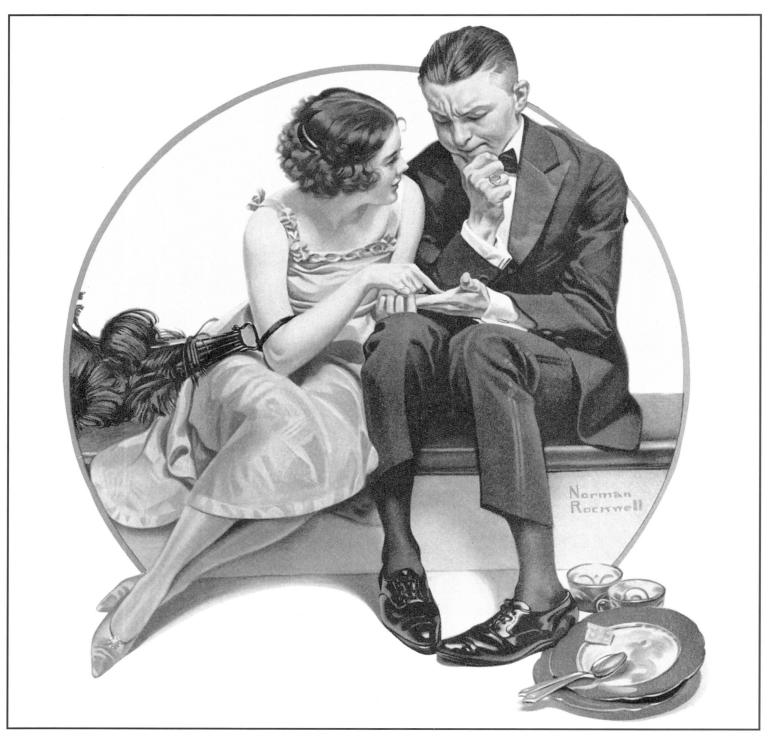

14.

14. *Girl Reading Palm*
 Saturday Evening Post, March 12, 1921, cover. Oil on canvas.
 Private collection.

15. *Home Sweet Home*
 Life, August 23, 1923, cover.

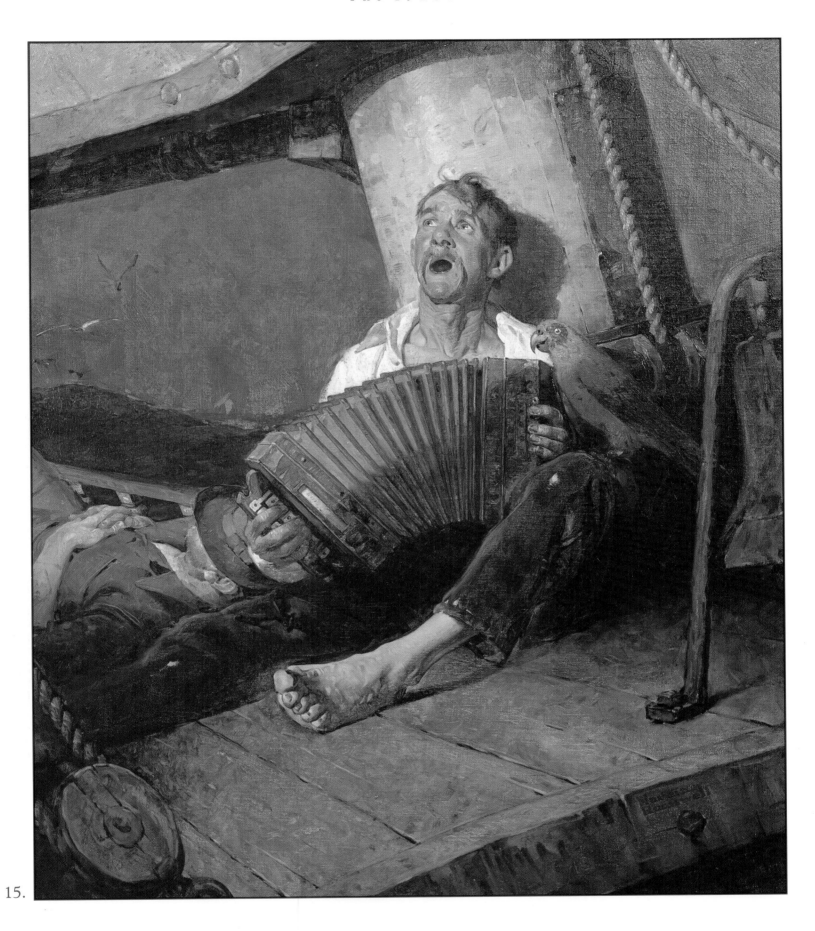

15.

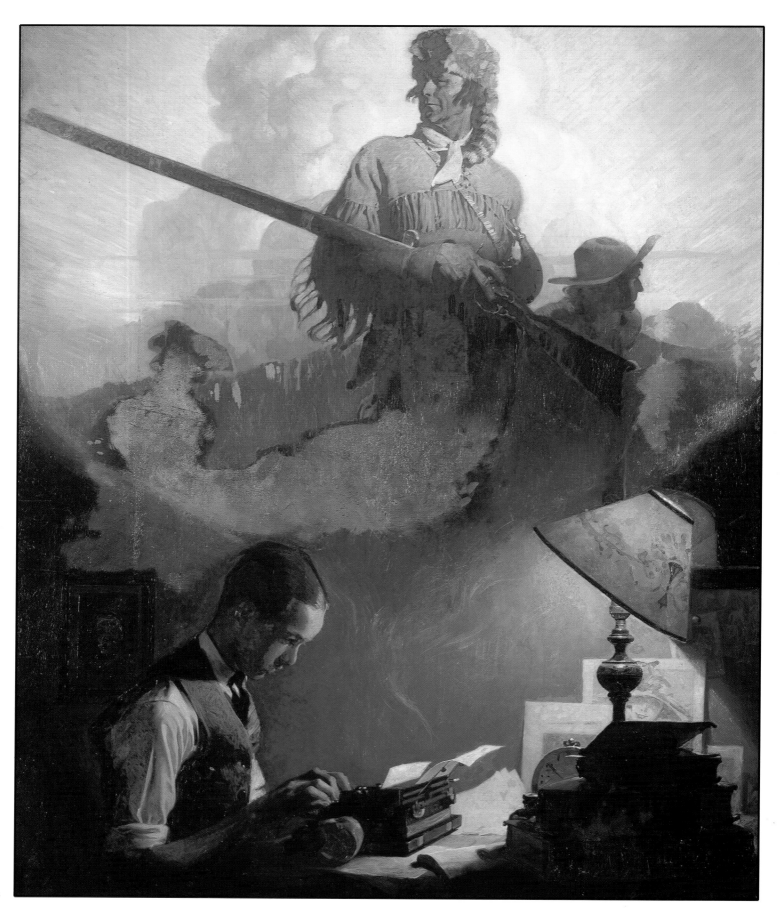

16.

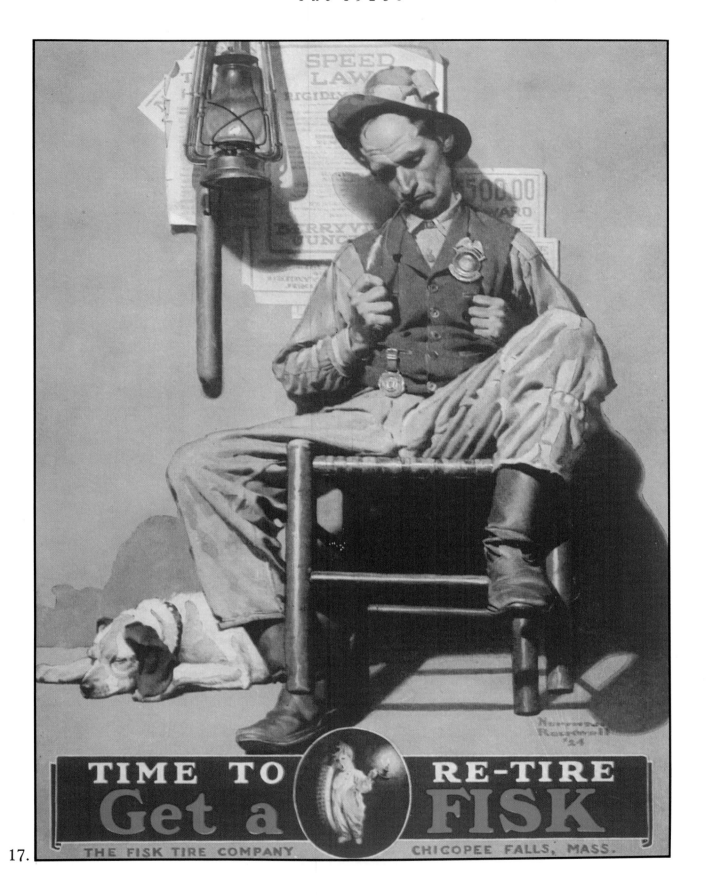

17.

16. *—And Daniel Boone Comes to Life on the Underwood Portable*
Advertisement for Underwood typewriters, 1923. Oil on
canvas. Private collection.

17. *Time to Retire: Sleeping Sheriff*
Advertisement for Fisk Automobile tires, 1924. Oil on canvas.
Use of Fisk symbol courtesy of Uniroyal Goodrich Tire Company.

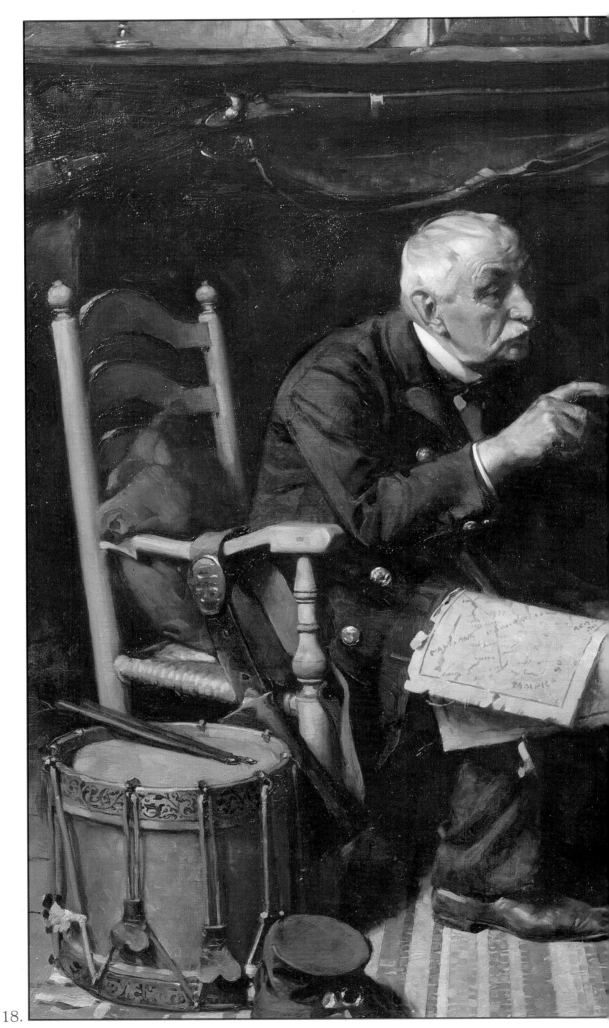

18.

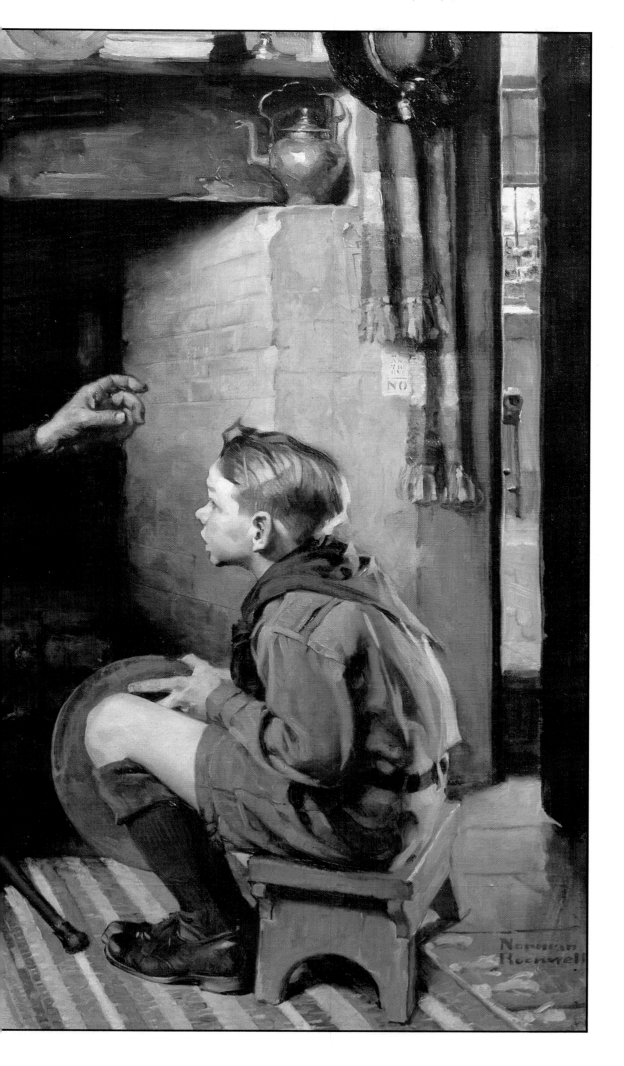

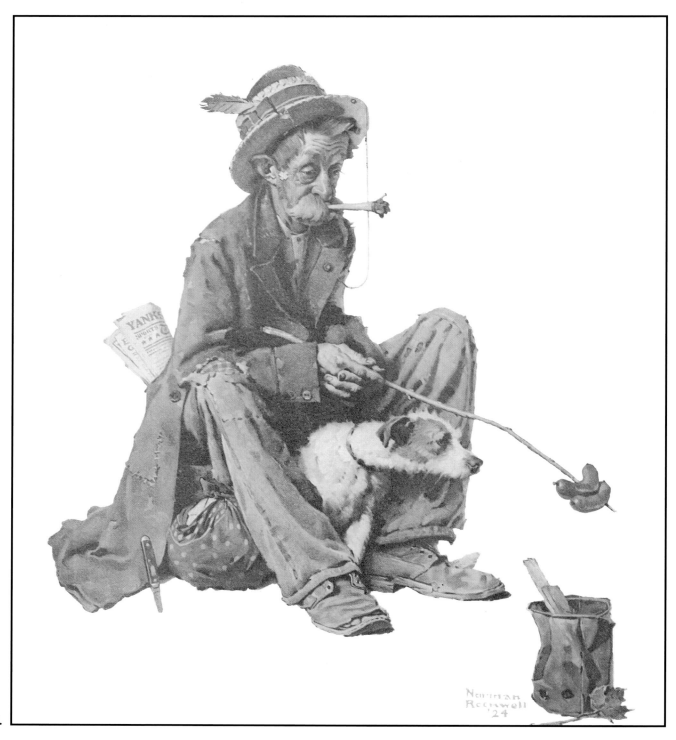

19.

18. *If Your Wisdom Teeth Could Talk They'd Say, "Use Colgate's"*
Advertisement for Colgate Dental Cream, 1924. Oil on canvas.
Collection of the Norman Rockwell Museum at Stockbridge,
bequest of Mrs. George H. Sheldon.

19. *Hobo and Dog*
Saturday Evening Post, October 18, 1924, cover. Oil on canvas.
Collection of Tee-Pak, Inc.

20. *Parade*
Saturday Evening Post, November 8, 1924, cover. Oil on canvas.

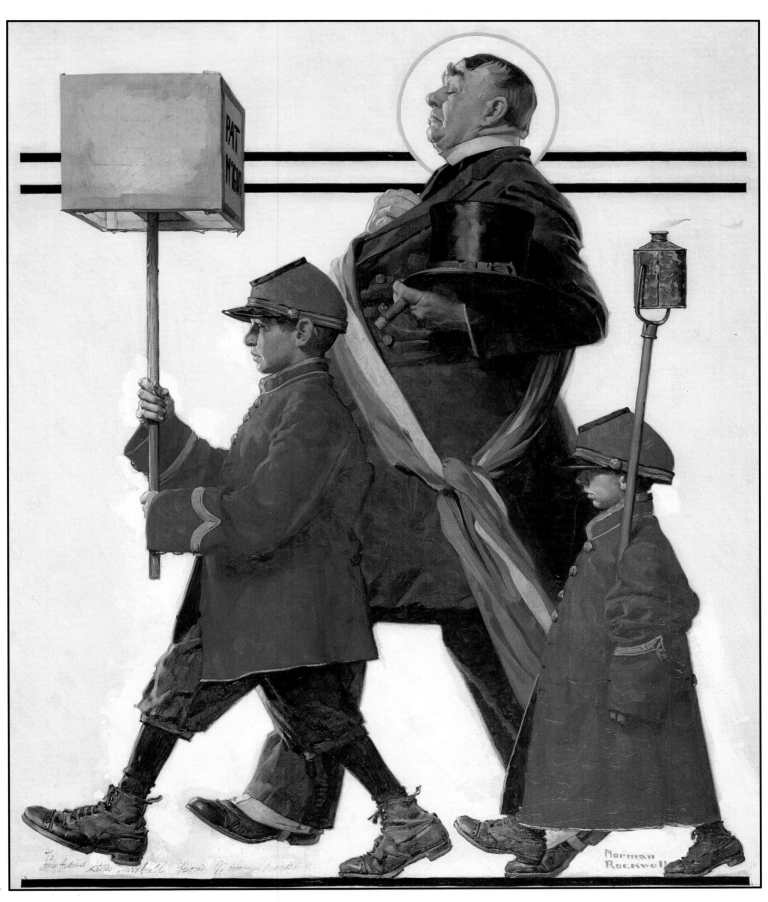

20.

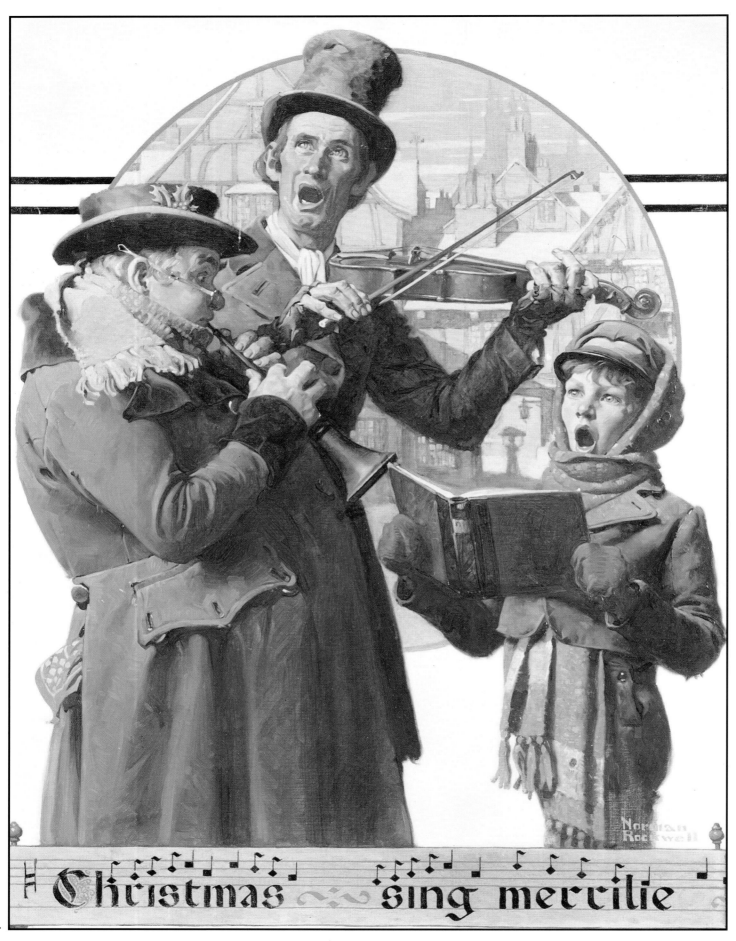

21.

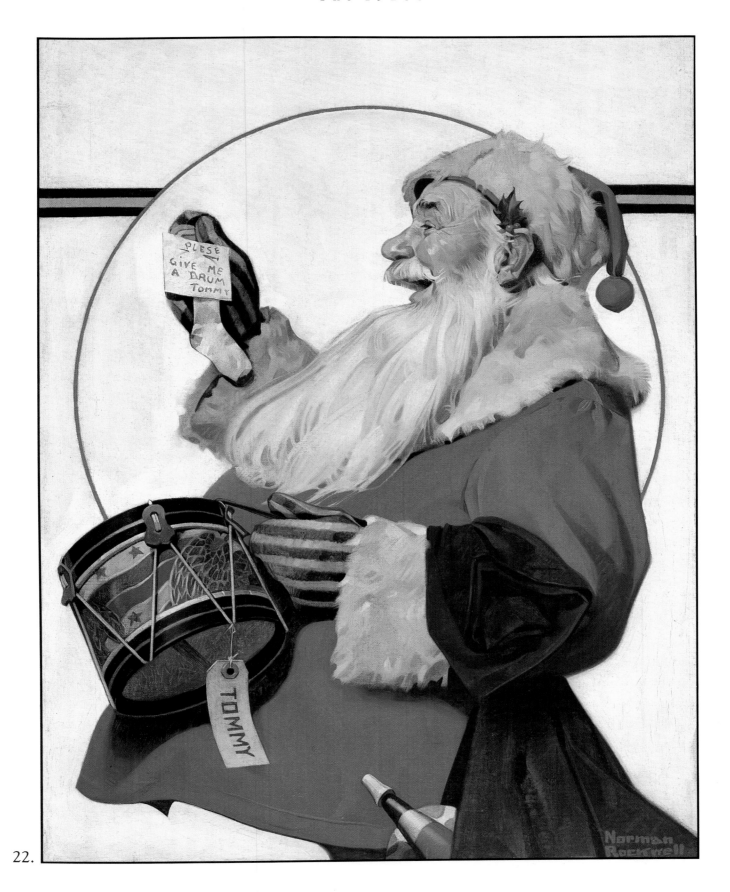

22.

21. *Christmas Trio*
Saturday Evening Post, December 8, 1923, cover. Oil on board.
Collection of the Norman Rockwell Museum at Stockbridge.

22. *A Drum for Tommy*
Country Gentleman, December 17, 1921, cover. Oil on canvas.
Private collection.

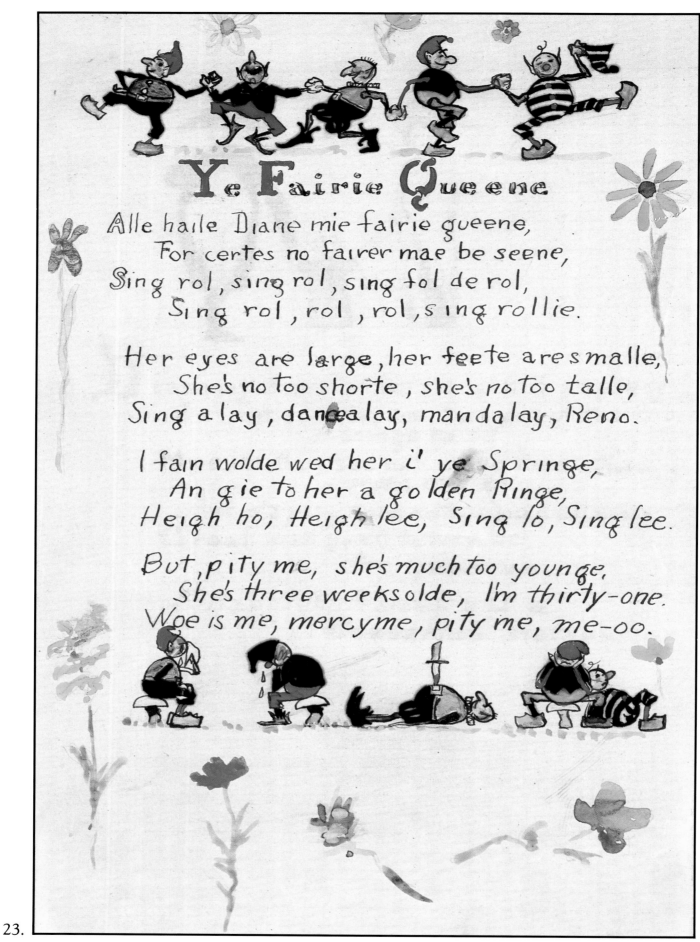

23.

23. *Ye Fairie Queene*
 Illustrated poem from "3 Pomes Rite to Diane Davenport from
 an Admirer," written on five pages, 1925. Pencil and watercolor
 on paper.

39

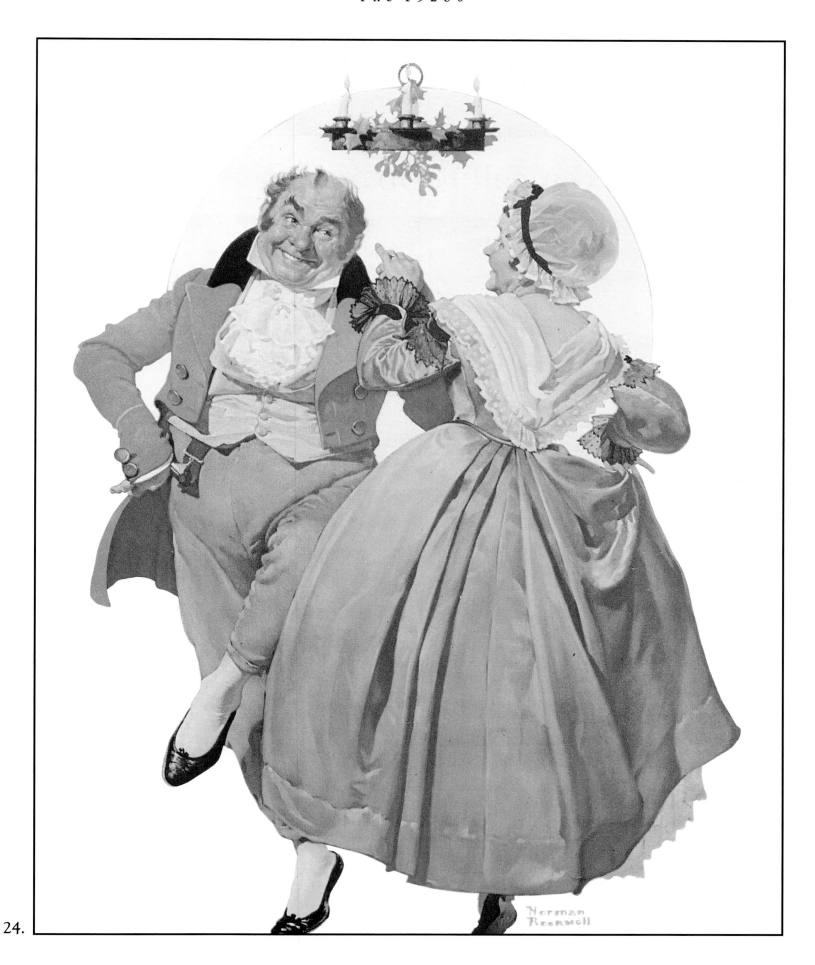

24.

24. **Merrie Christmas: Couple Dancing under Mistletoe**
Saturday Evening Post, December 8, 1928, cover. Oil on canvas.
Private collection.

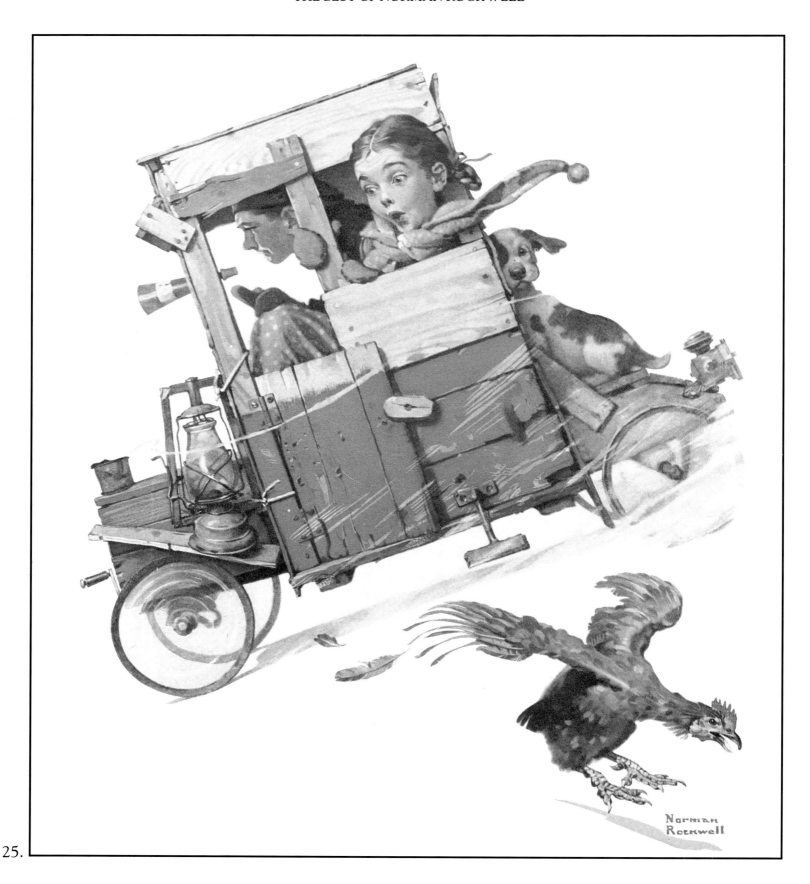

25.

25. **Downhill Racing Cart**
 Saturday Evening Post, January 9, 1926, cover. Oil on canvas.
 Private collection.

26. **Pipe and Bowl Sign Painter**
 Saturday Evening Post, February 6, 1926, cover. Oil on canvas.
 Private collection.

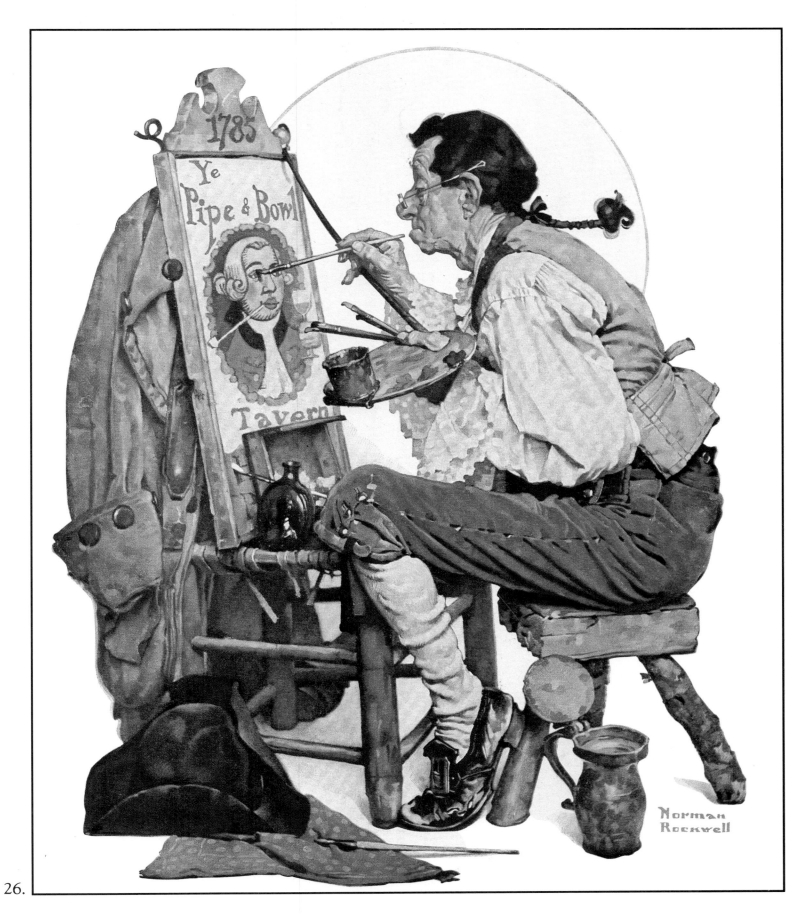

26.

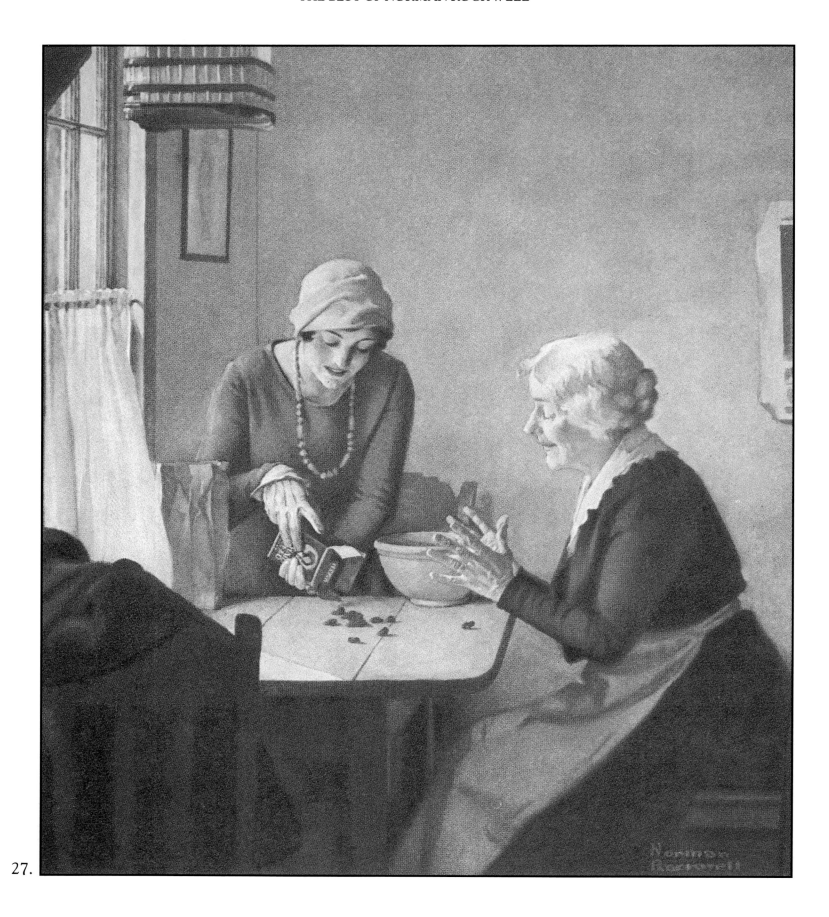

27.

27. *Fruit of the Vine*
 Advertisement for Sun Maid raisins. Oil on canvas.
 Private collection.

43

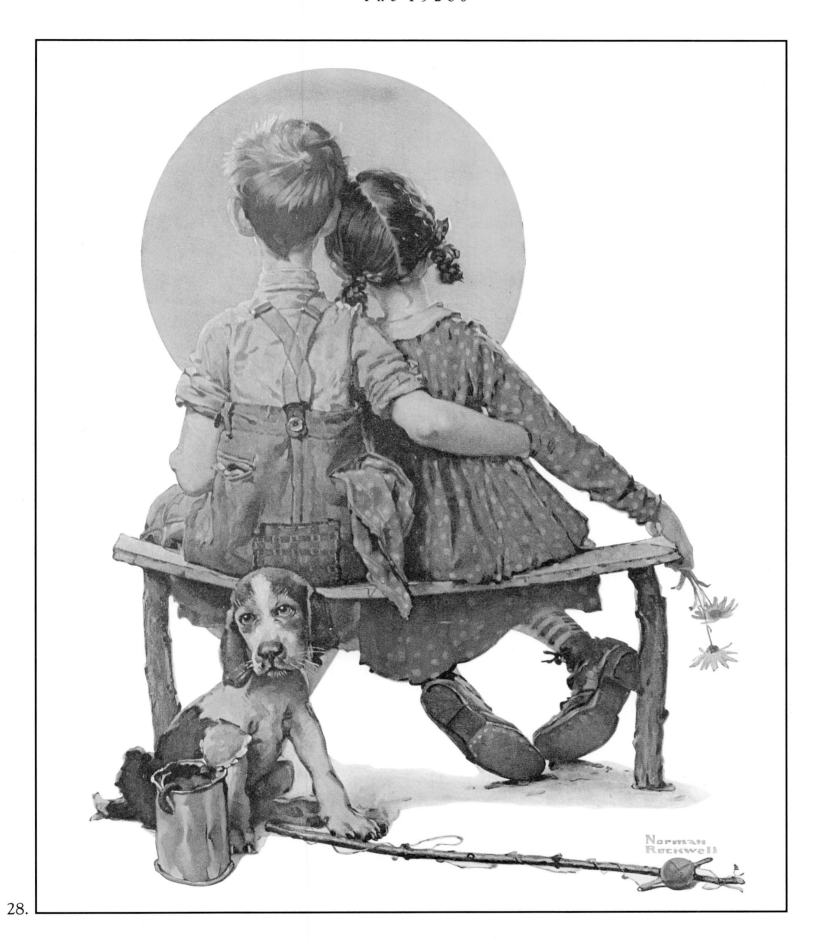

28.

28. *Boy and Girl Gazing at Moon (Puppy Love)*
Saturday Evening Post, April 24, 1926, cover. Oil on canvas.
Private collection.

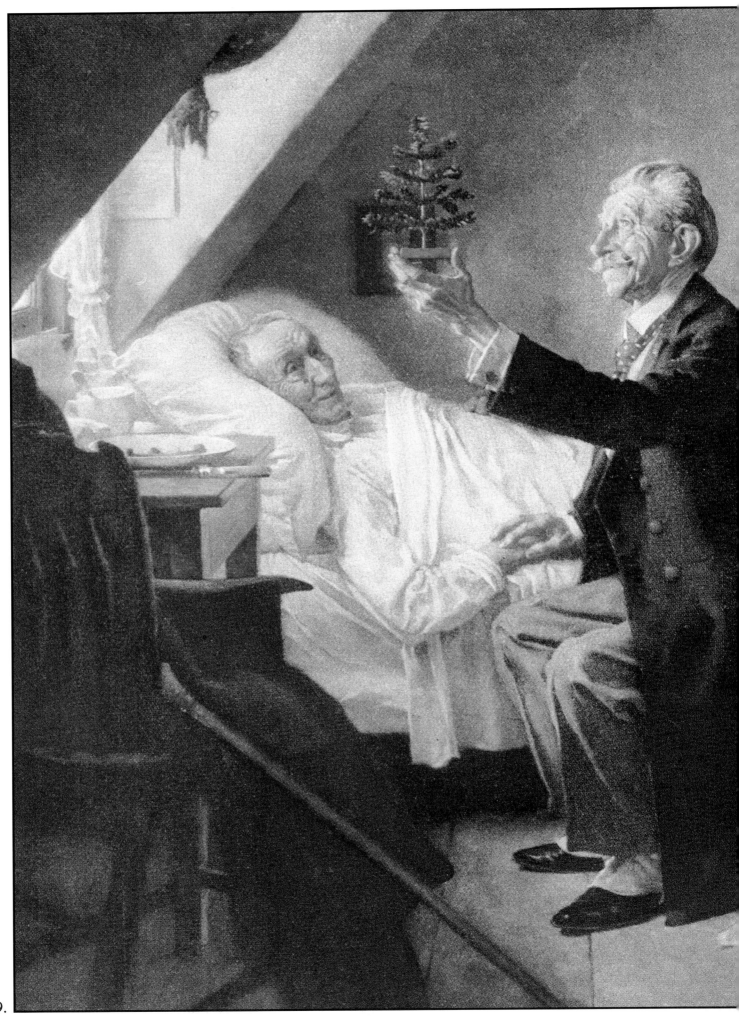

29.

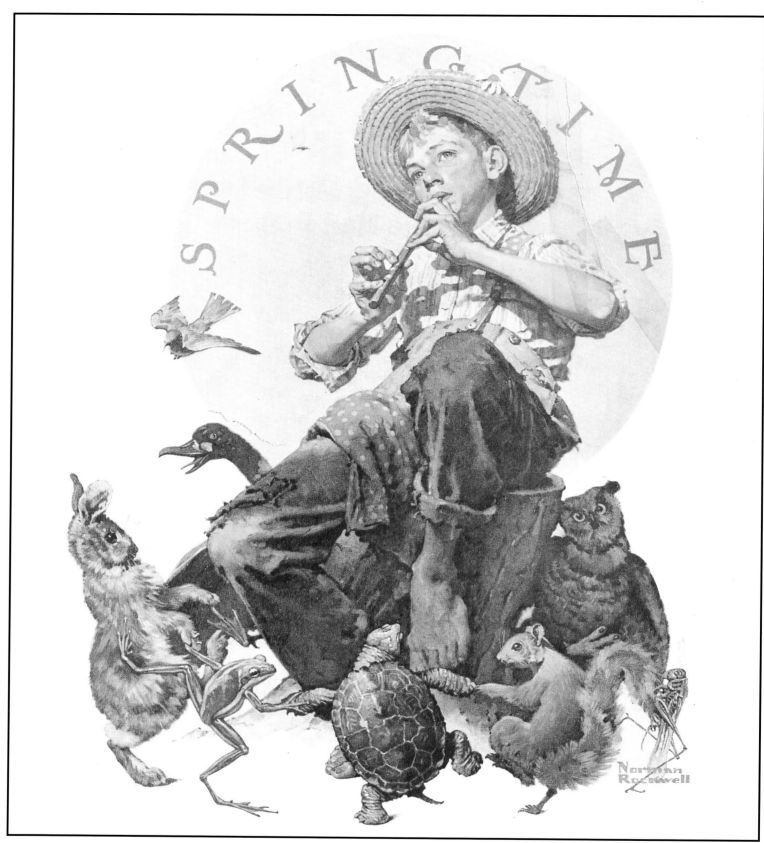

30.

47

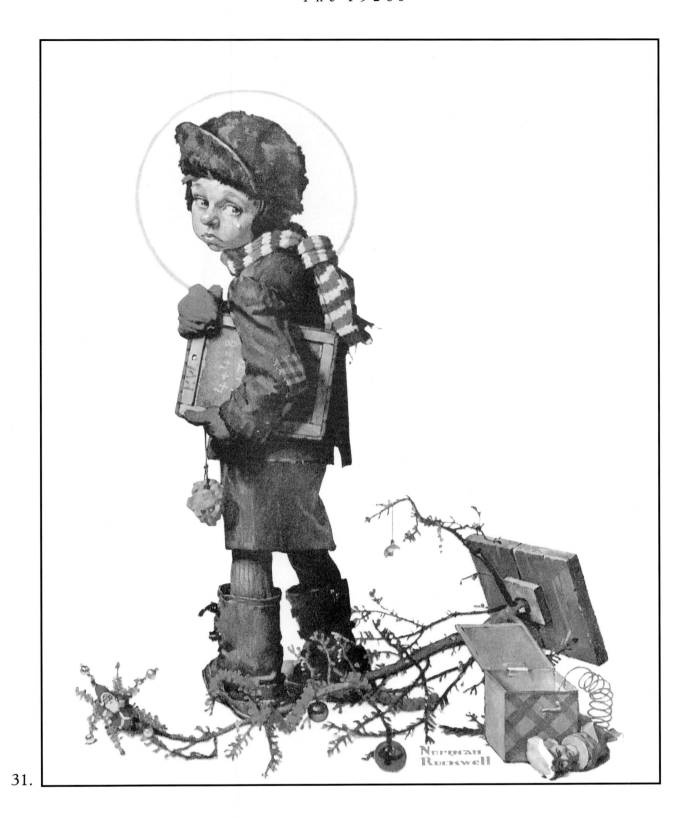

31.

29. **A Christmas Reunion**
 Ladies' Home Journal, December 1927, page 15. Oil on canvas.
 Private collection.

30. **Boy Playing Flute Surrounded by Animals**
 Saturday Evening Post, April 16, 1927, cover. Oil on canvas.
 Private collection.

31. **Little Boy Holding Chalk Board**
 Saturday Evening Post, January 8, 1927, cover. Oil on canvas.
 Private collection.

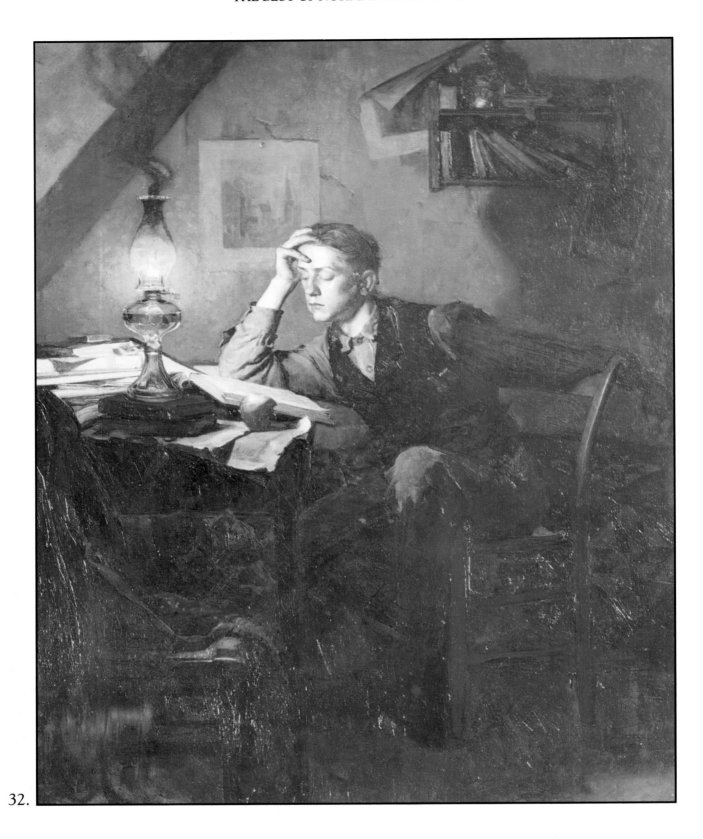

32.

32. ***Look at This Picture—Then Look at Your Light***
Lamp advertisement for Edison Mazda, 1925. Oil on canvas.
Collection of General Electric Lighting Company, Cleveland.

33. ***The Stay at Homes***
Ladies' Home Journal, October, 1927, page 24. Oil on canvas.
Collection of the Norman Rockwell Museum at Stockbridge.

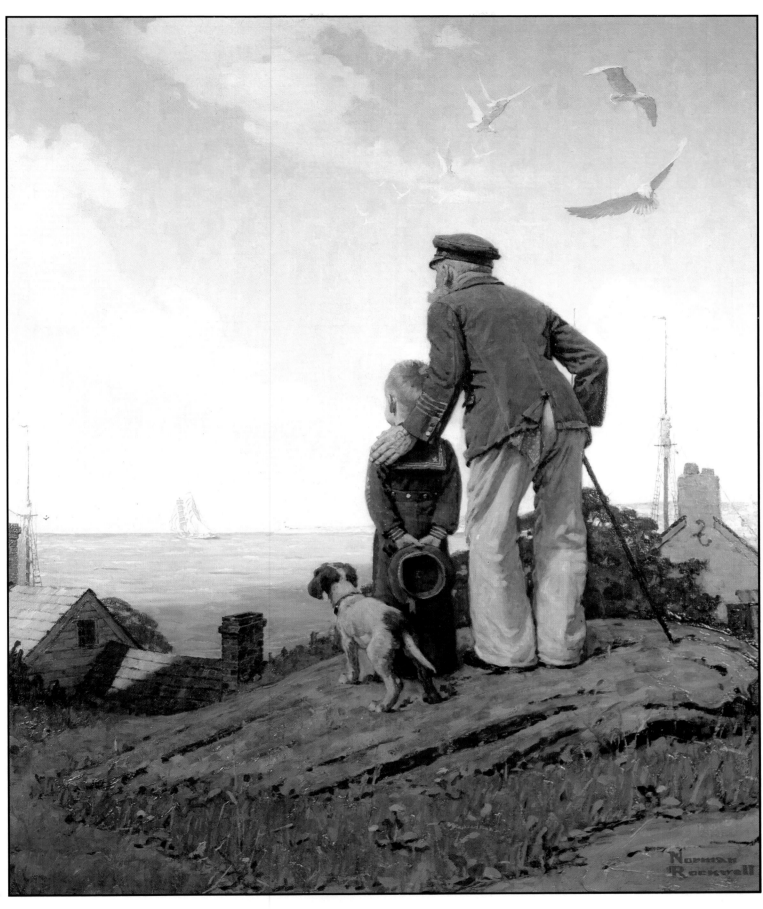

33.

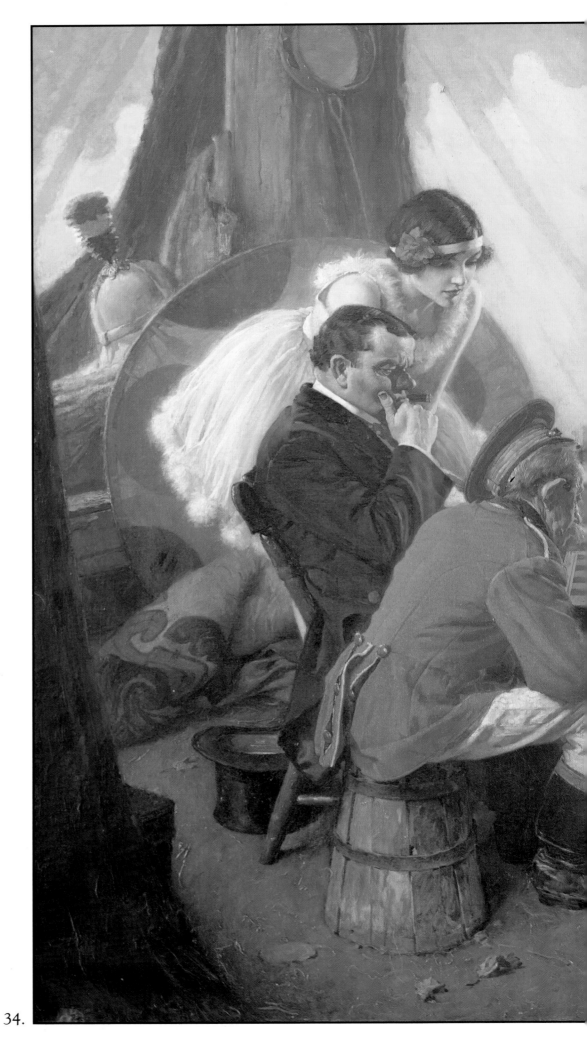

34.

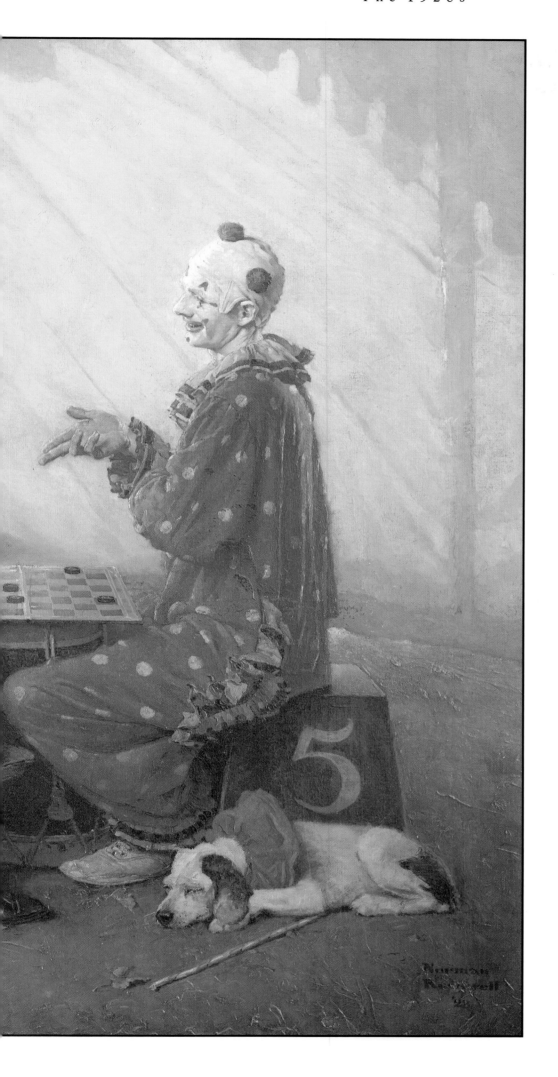

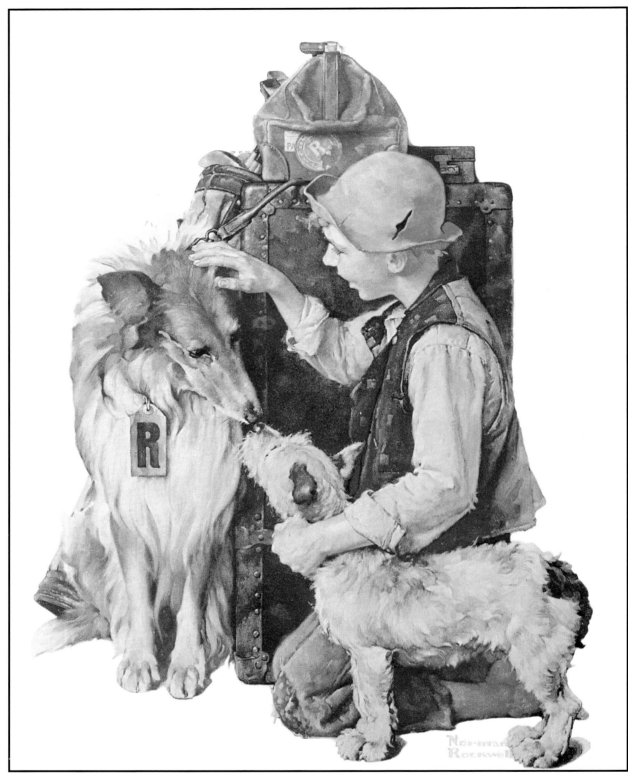

35.

34. *Checkers*
Ladies' Home Journal, July 1929. Illustration for "With an Incident of the Circus as Remembered by Courtney Ryley Cooper," page 11. Oil on canvas. Collection of the Norman Rockwell Museum at Stockbridge.

35. *Boy with Two Dogs (Raleigh Rockwell Travels)*
Saturday Evening Post, September 28, 1929, cover. Oil on canvas. Private collection.

36. *Doctor and Doll*
Saturday Evening Post, March 9, 1929, cover. Oil on canvas. Private collection.

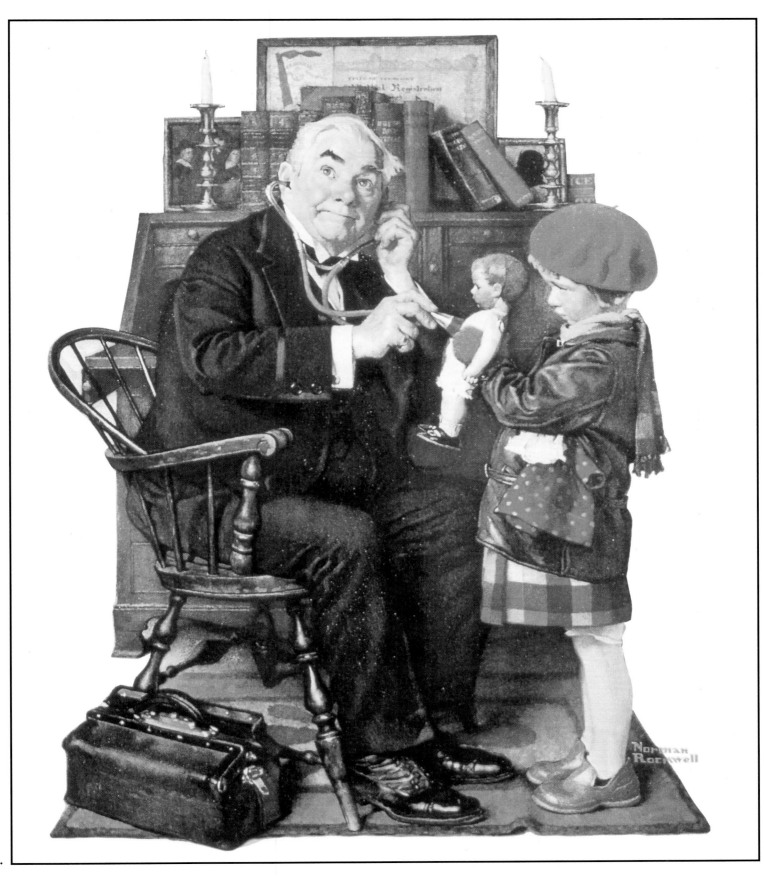

36.

Part Three
The 1930s

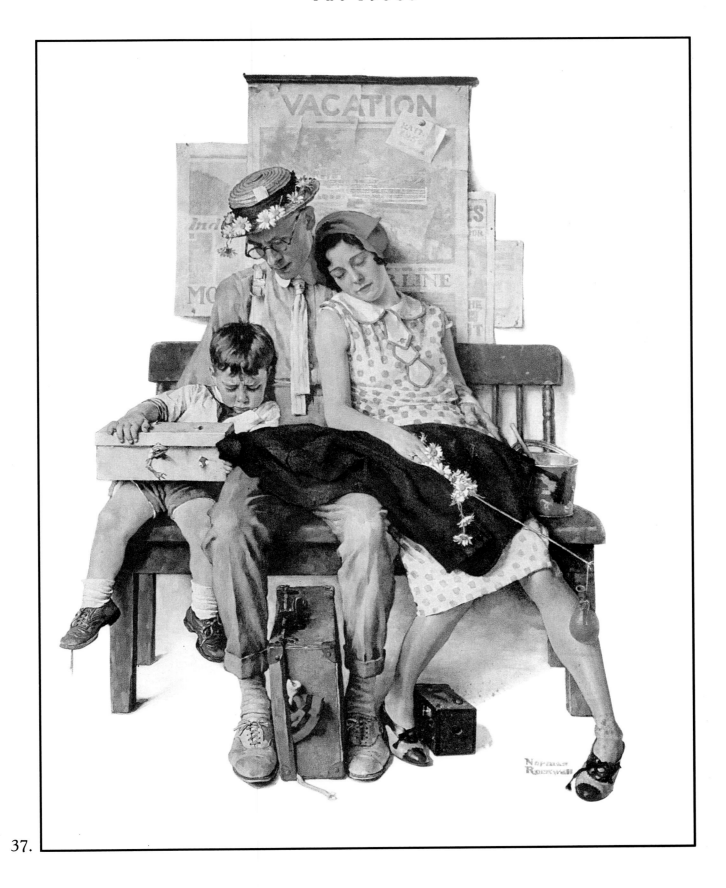

37.

37. *Family Home from Vacation*
 Saturday Evening Post, September 13, 1930, cover. Oil on canvas.
 Private collection.

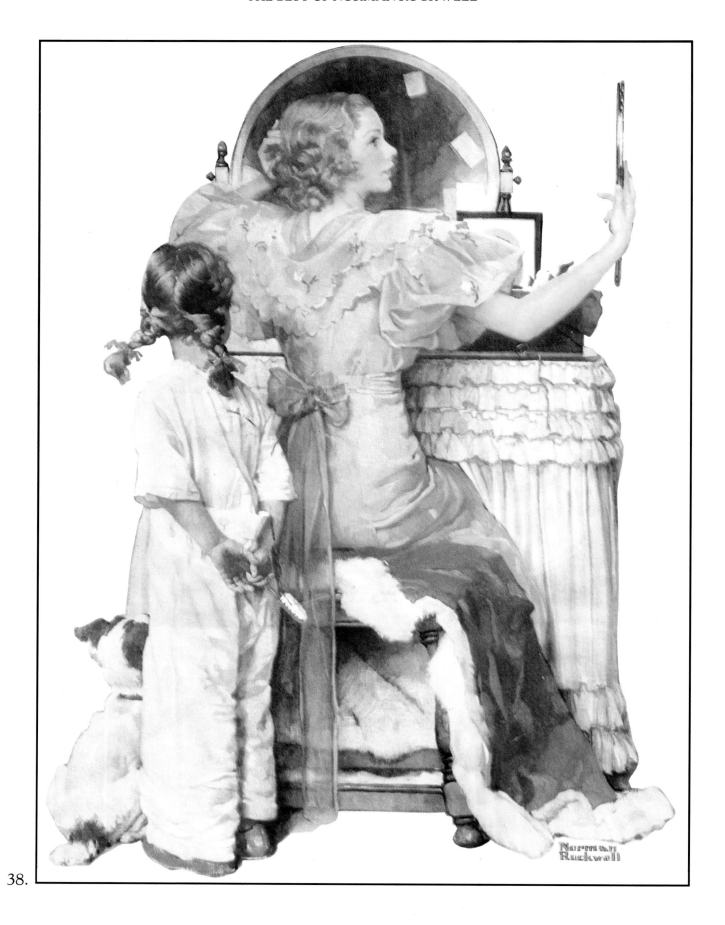

38.

38. **Woman at Vanity (Girl Getting Ready for Date)**
Saturday Evening Post, October 21, 1933, cover. Oil on canvas.

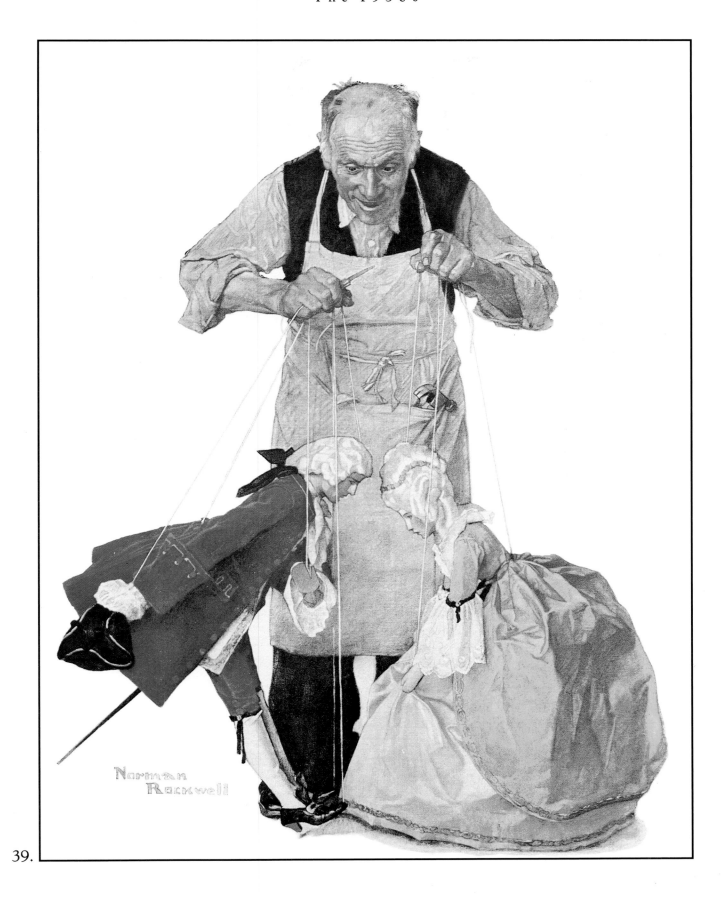

39.

39. *The Puppeteer*
Saturday Evening Post, October 22, 1932, cover. Oil on canvas.
Private collection.

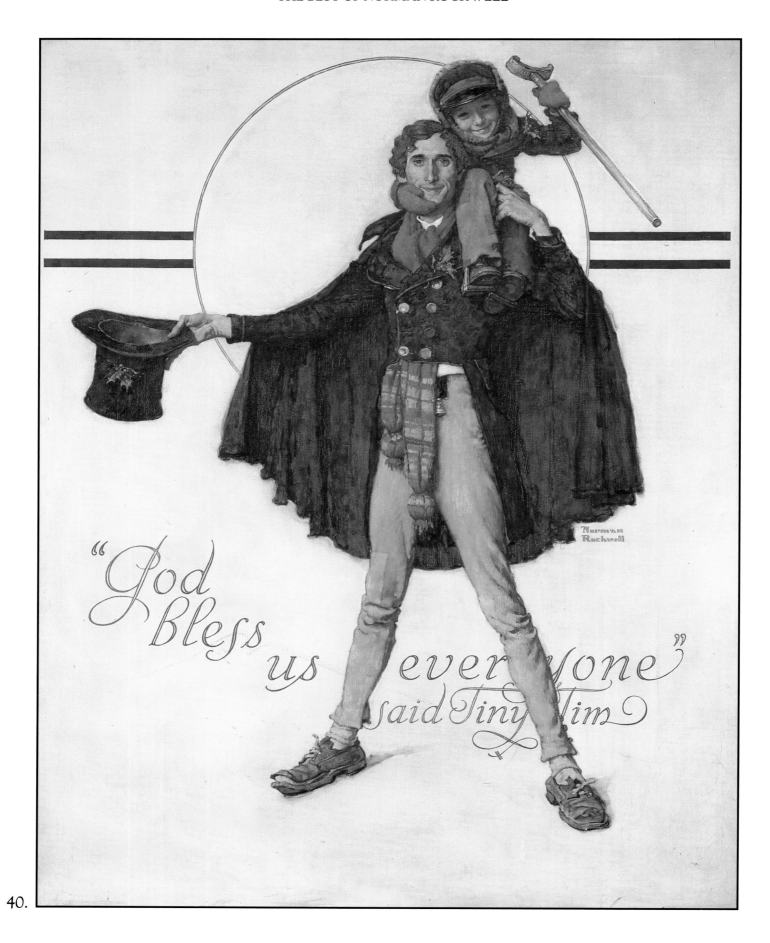

40.

40. *Tiny Tim and Bob Cratchit (God Bless Us Everyone)*
Saturday Evening Post, December 15, 1934, cover. Oil on canvas.
Private collection.

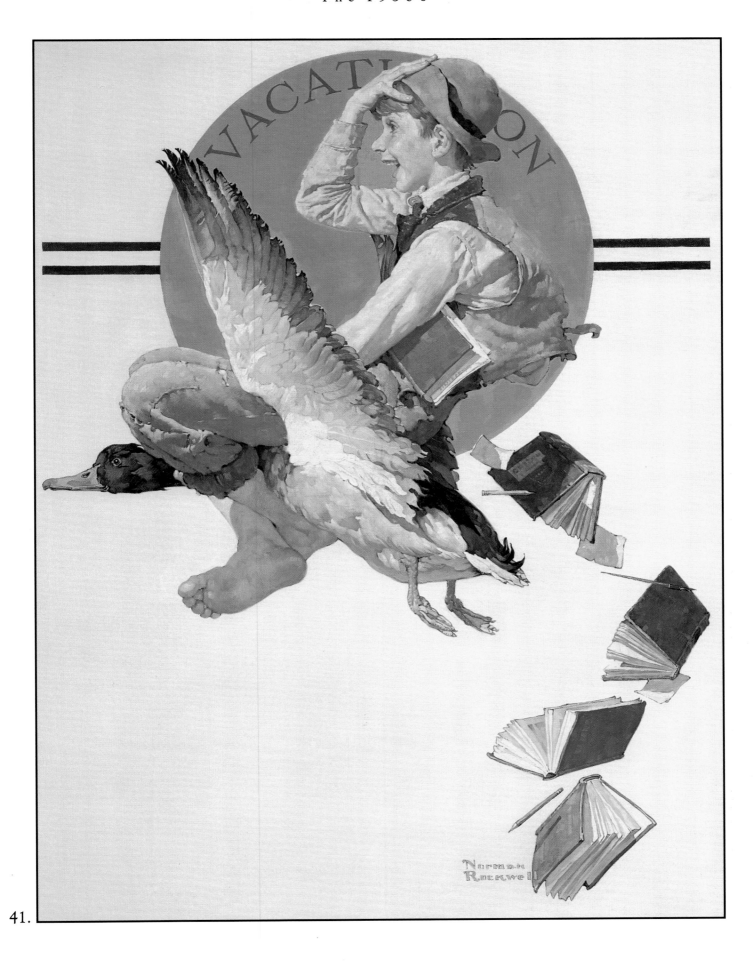

41.

41 *Vacation: Boy Riding Goose*
 Saturday Evening Post, June 30, 1934, cover. Oil on canvas.

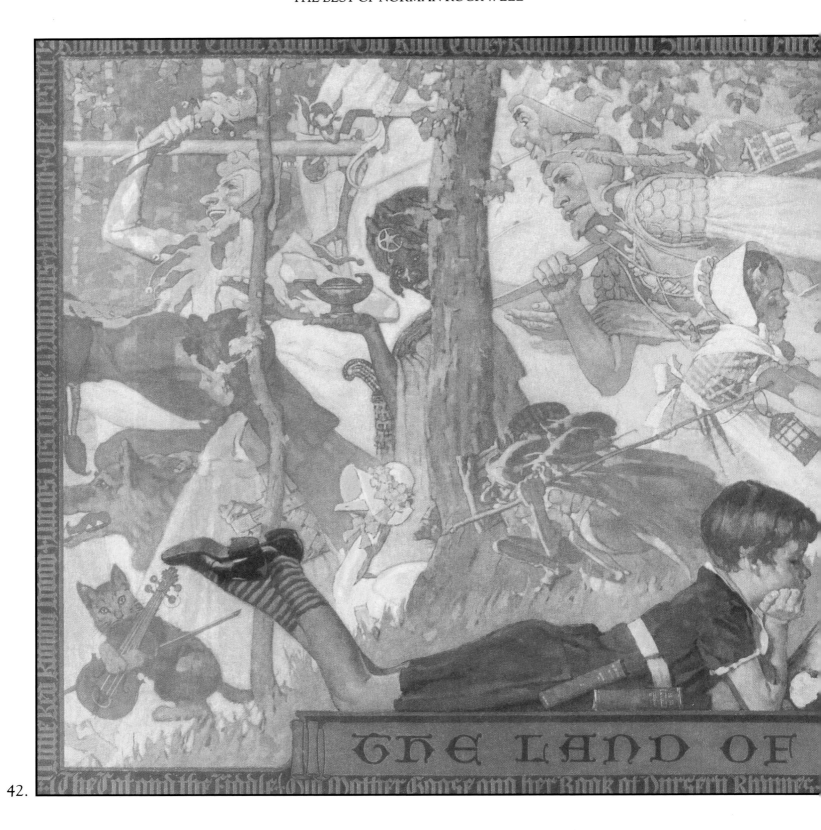

42.

42. *The Land of Enchantment*
 Saturday Evening Post, December 22, 1934, pages 18-19. Oil on
 canvas. Collection of the New Rochelle Library.

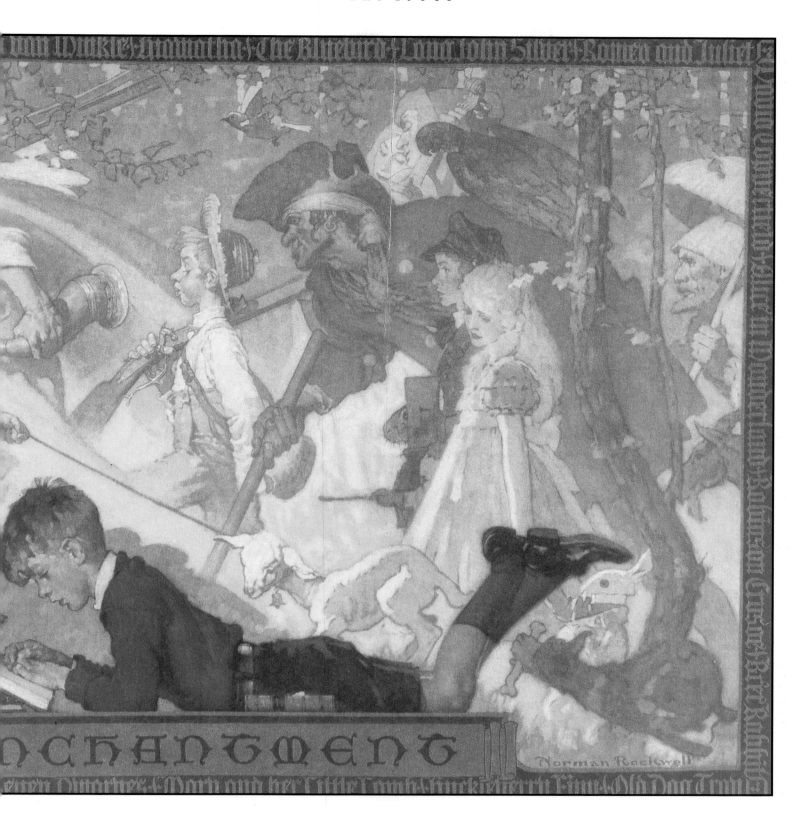

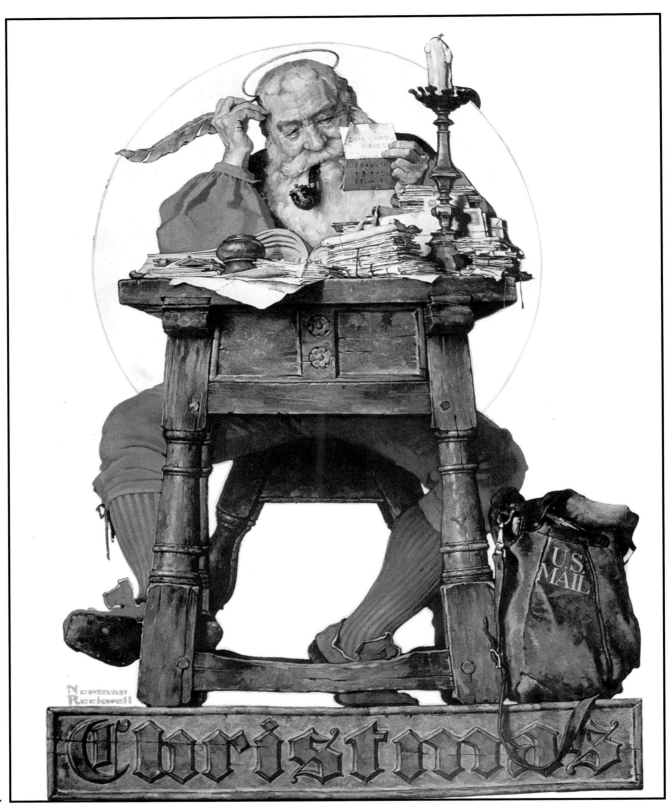

43.

43. **Christmas: Santa Reading Mail**
Saturday Evening Post, December 21, 1935, cover. Oil on canvas.
Private collection.

44. **Spring Tonic**
Saturday Evening Post, May 30, 1936, cover. Oil on canvas.
Private collection.

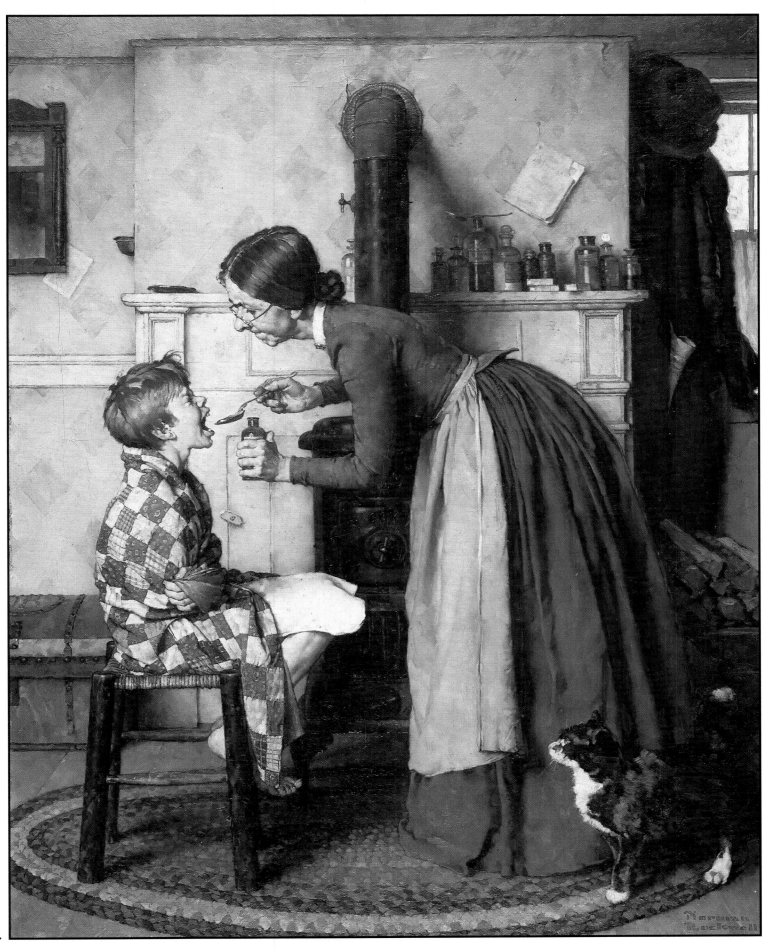

44.

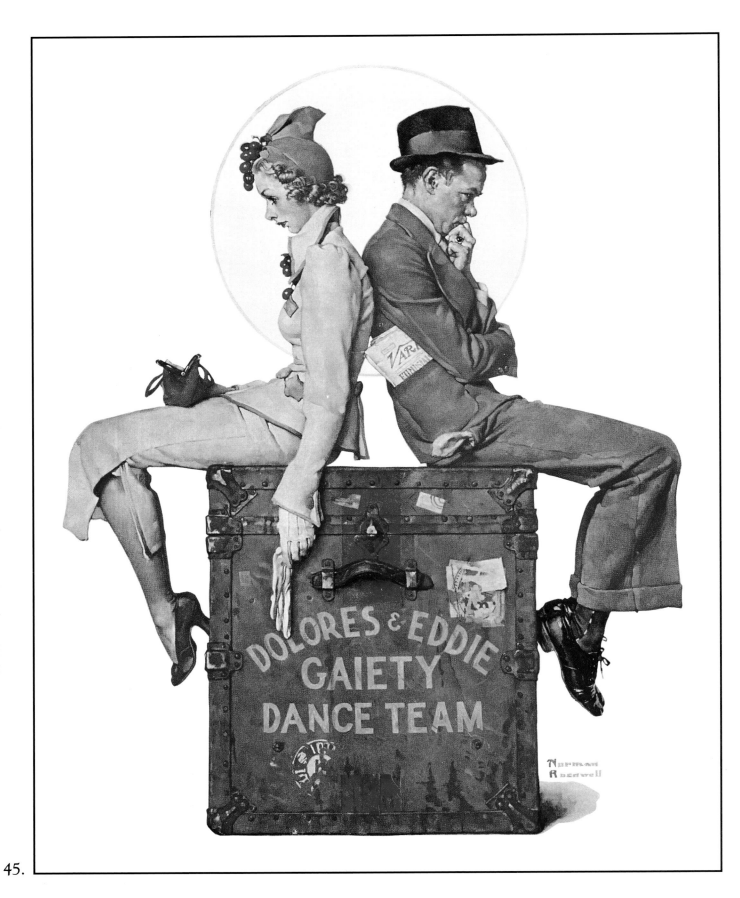

45.

45. *Gaiety Dance Team*
 Saturday Evening Post, June 12, 1937, cover. Oil on canvas.
 Collection of Variety, Inc.

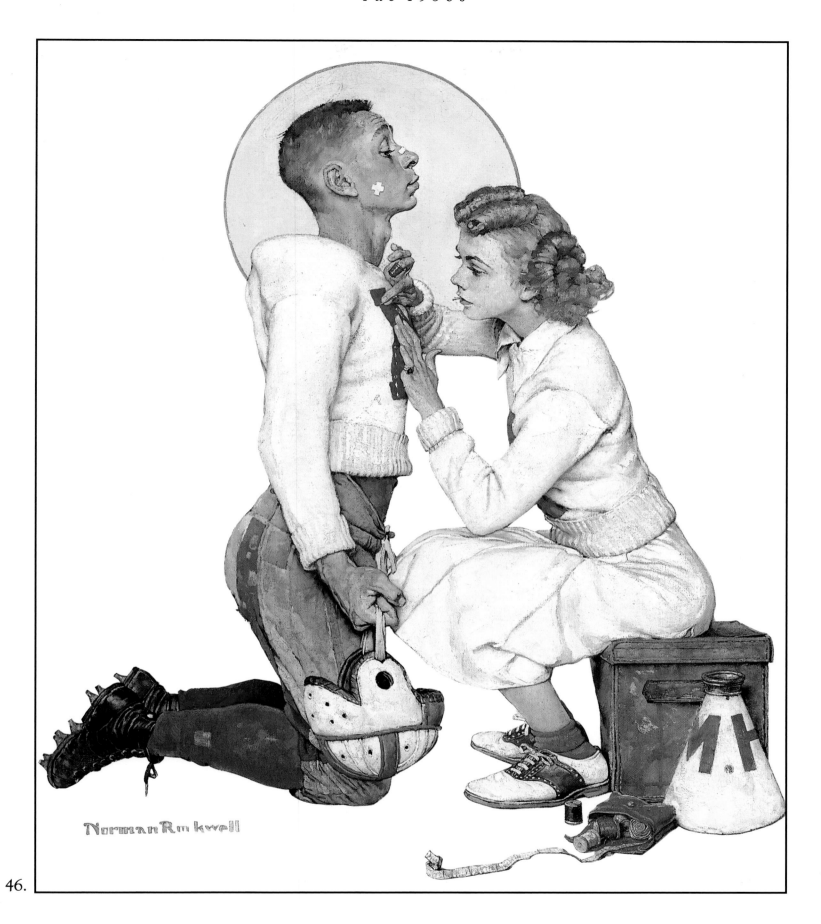

46.

46. *Football Hero (The Letterman)*
Saturday Evening Post, November 19, 1938, cover. Oil on canvas.
Collection of the Norman Rockwell Museum at Stockbridge,
gift of Connie Adams Maples.

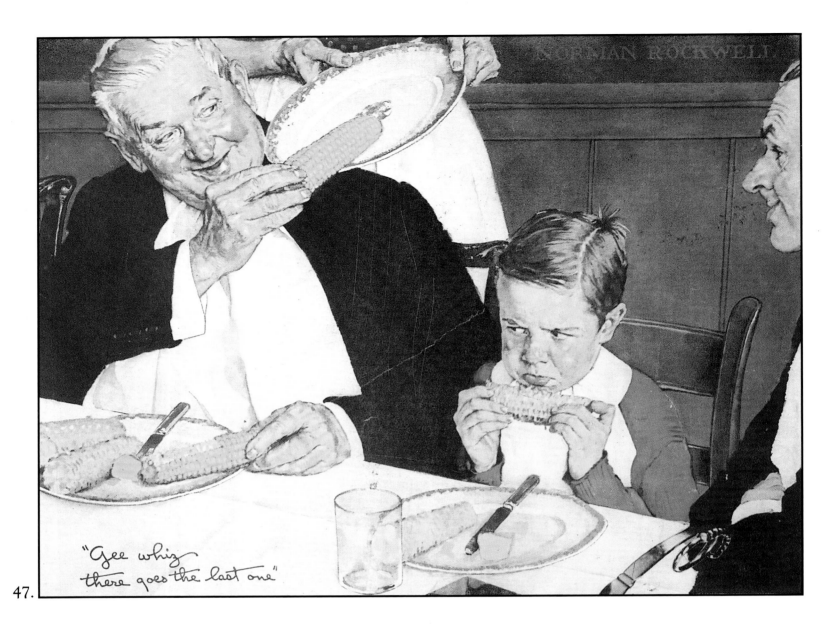

47.

47. **"Gee Whiz There Goes the Last One"**
Advertisement for Green Giant canned corn, 1938-1940. Oil on
canvas. Private collection.

48. ***Merrie Christmas: Man with Christmas Goose***
Saturday Evening Post, December 17, 1938, cover. Also known as
"Muggleton Stage Coach" or "Mr. Pickwick." Oil on canvas.
Private collection.

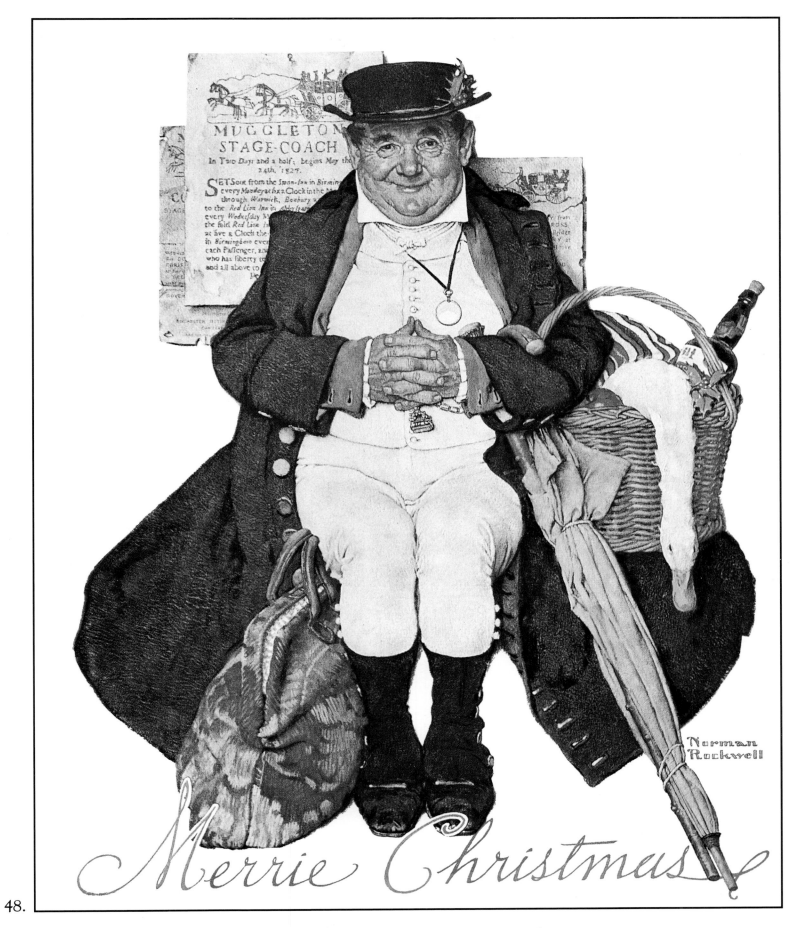

48.

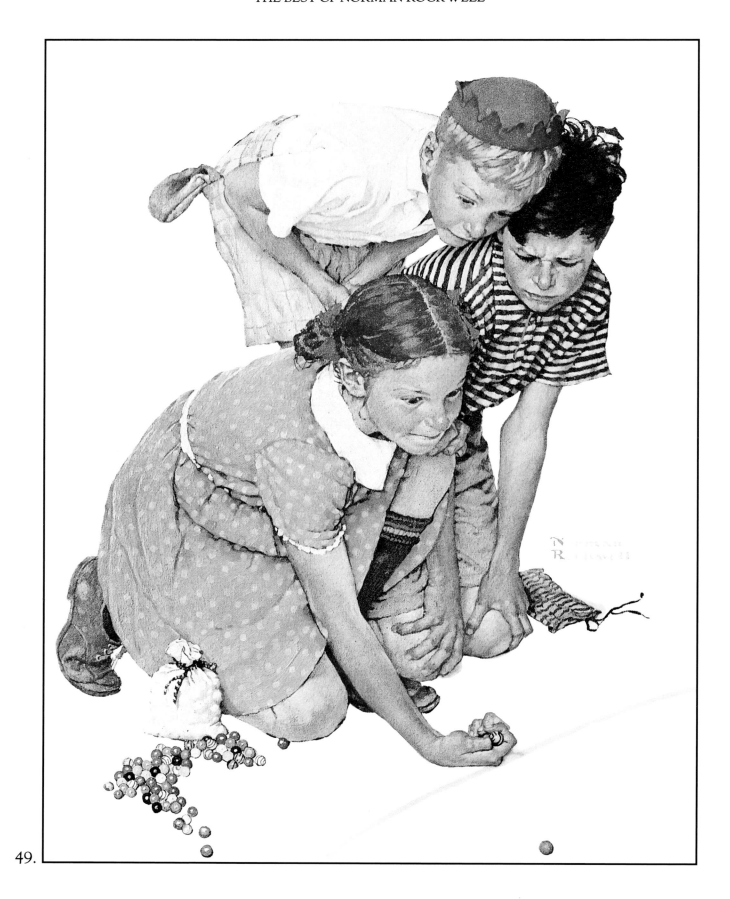

49.

49. *Marble Champion*
 Saturday Evening Post, September 2, 1939, cover. Oil on canvas.
 Private collection.

50. *Barbershop Quartet*
 Saturday Evening Post, September 26, 1936, cover. Oil on canvas.
 Private collection.

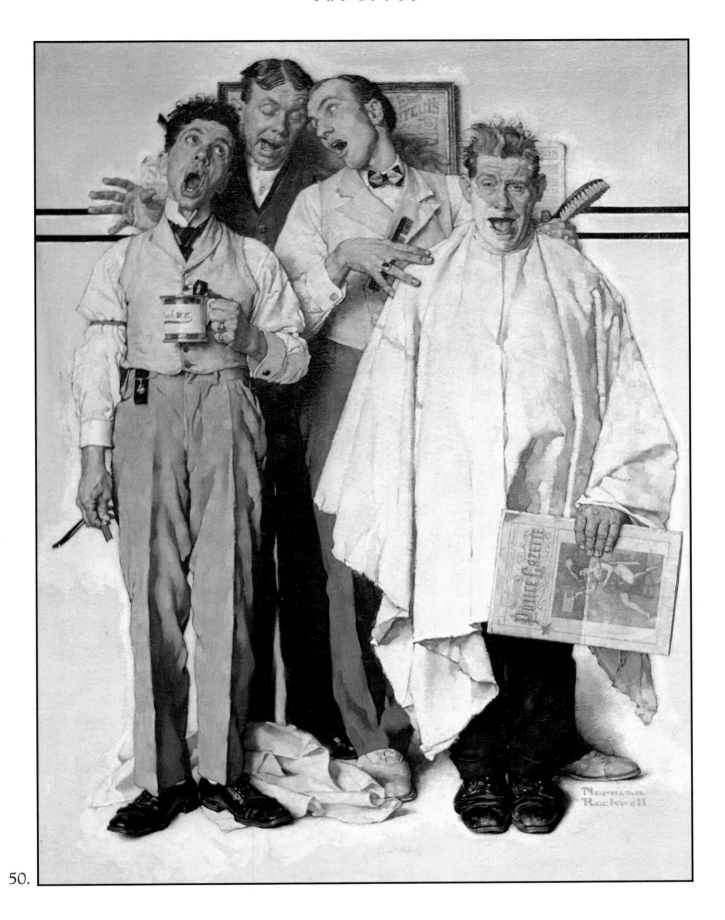

50.

Part Four
The 1940s

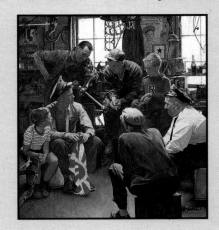

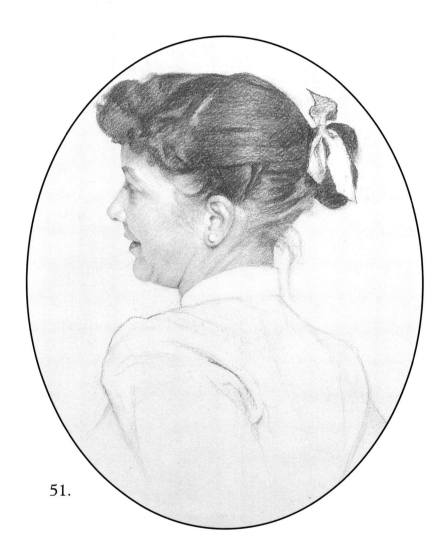

51.

51. *Portrait of Mary Barstow Rockwell*
 c. 1950. Charcoal on paper. Private collection.

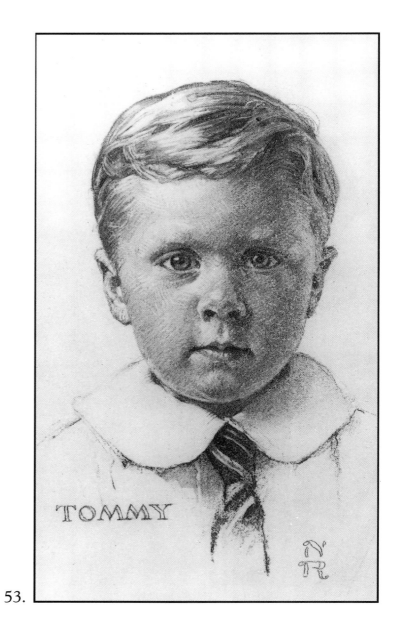

53.

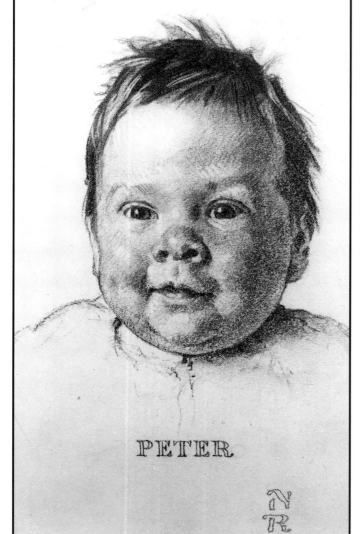

52.

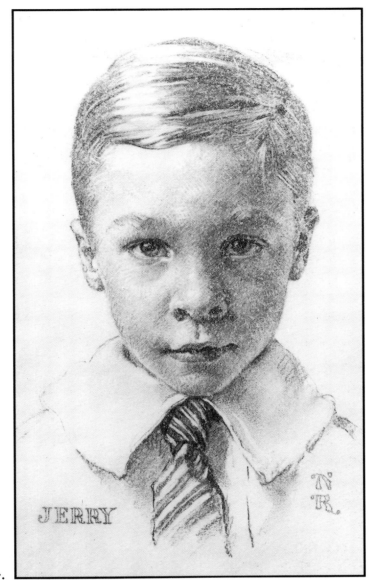

54.

52. *Portrait of Peter Rockwell*
 c. 1940. Charcoal on paper. Private collection.

53. *Portrait of Tommy Rockwell*
 c. 1940. Charcoal on paper. Private collection.

54. *Portrait of Jerry Rockwell*
 c. 1940. Charcoal on paper. Private collection.

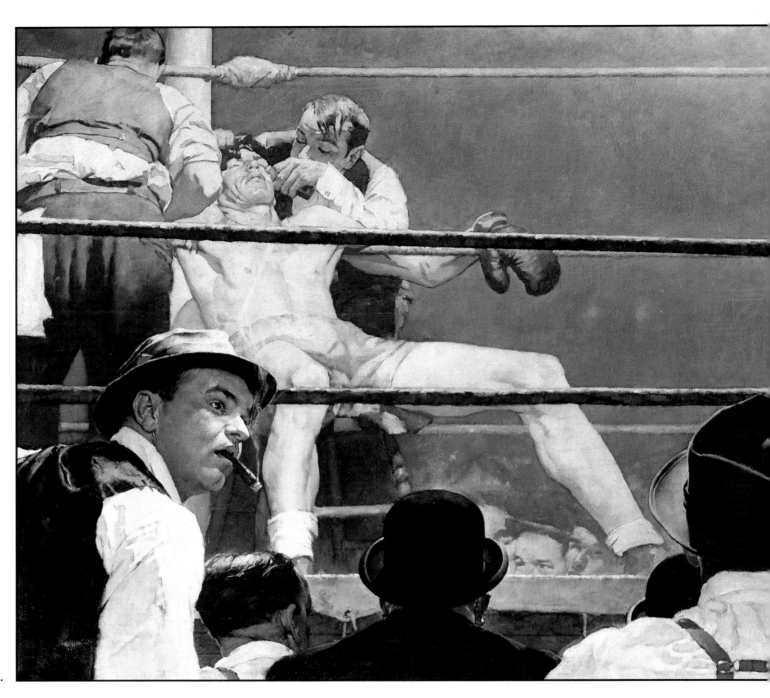

55.

55. *Strictly a Sharpshooter*
 American Magazine, June, 1941. Illustration for "Strictly a
 Sharpshooter" by D.D. Beauchamp, pages 40-41. Oil on canvas.
 Collection of the Norman Rockwell Museum at Stockbridge.

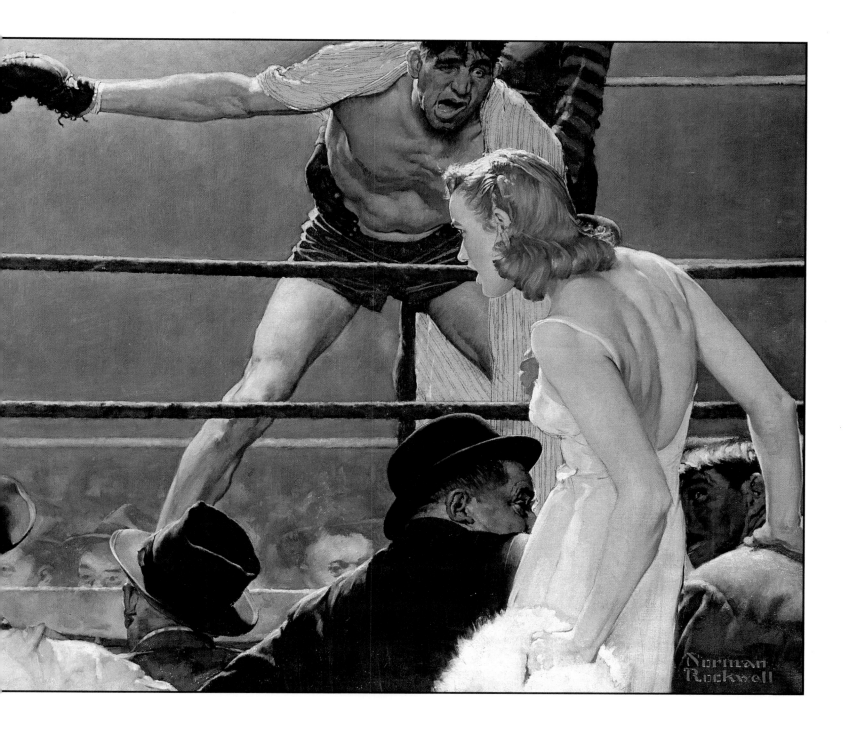

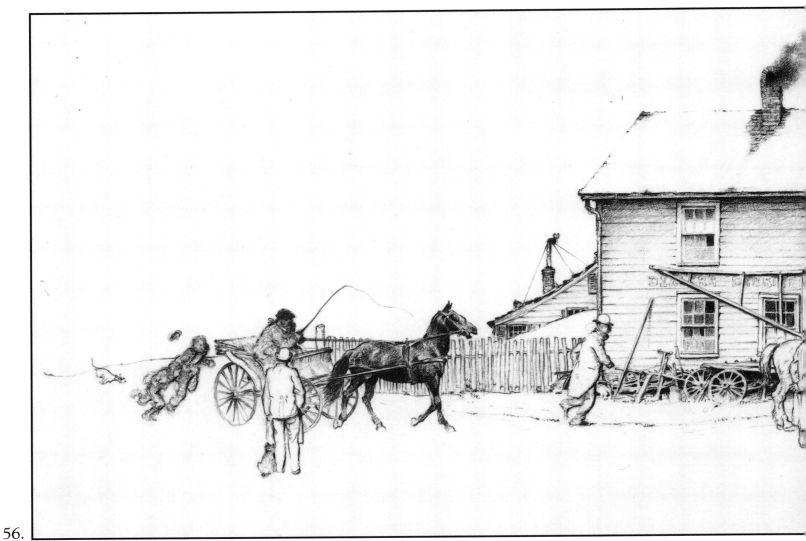

56.

56. *Blacksmith's Boy—Heel and Toe (Blacksmith's Shop)*
Saturday Evening Post, November 2, 1940. Illustration for
"Blacksmith's Boy—Heel and Toe" by Edward W. O'Brien,
page 9. Charcoal on paper. Private collection.

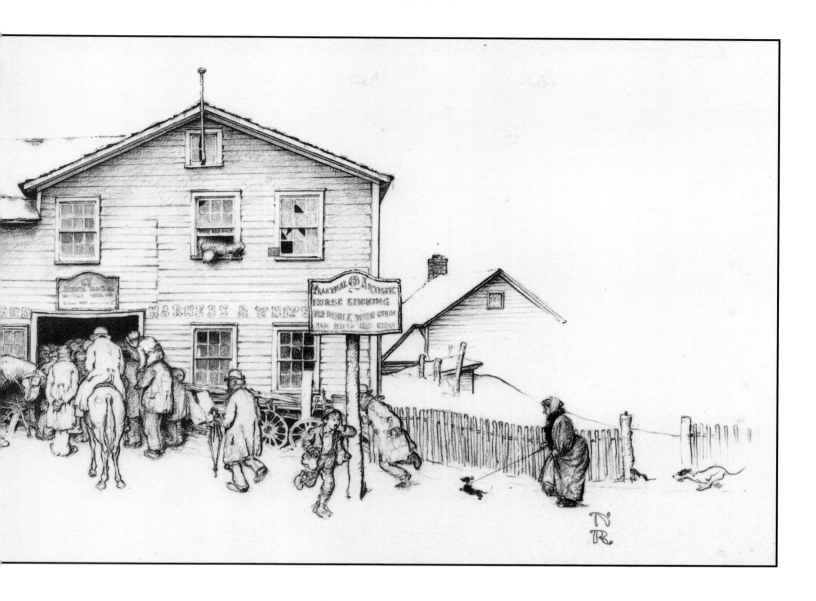

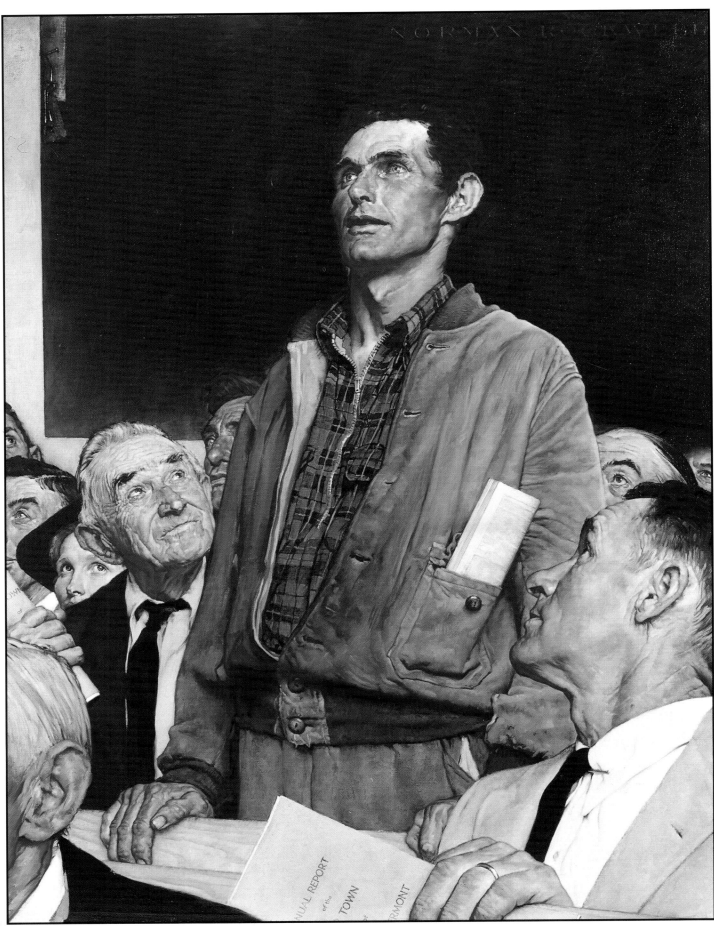

57.

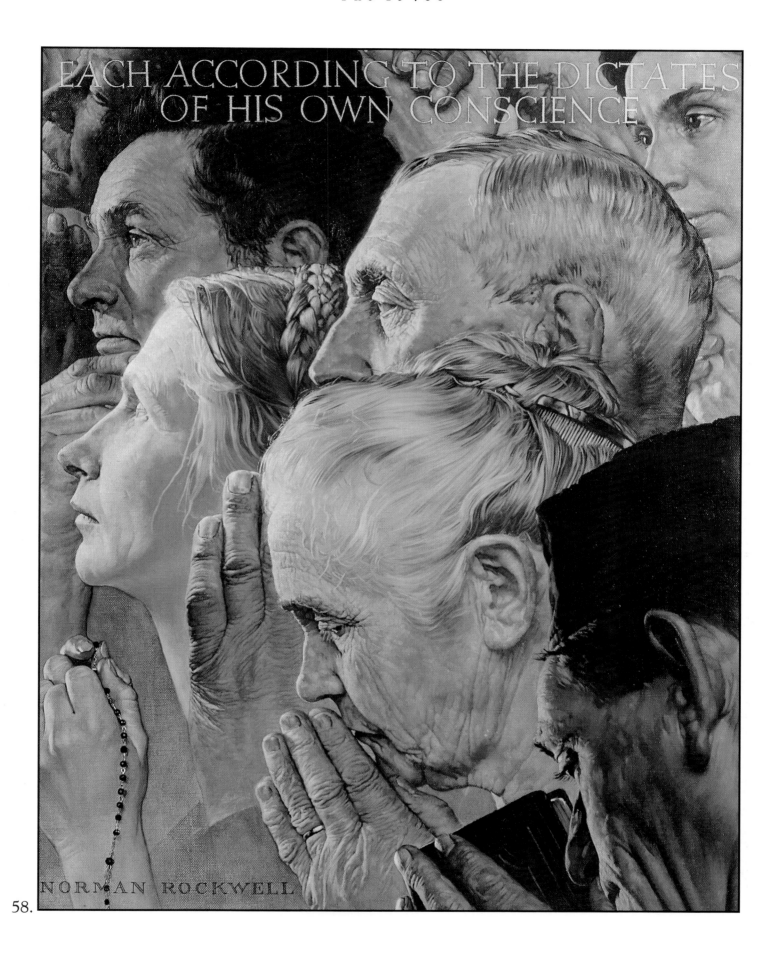

58.

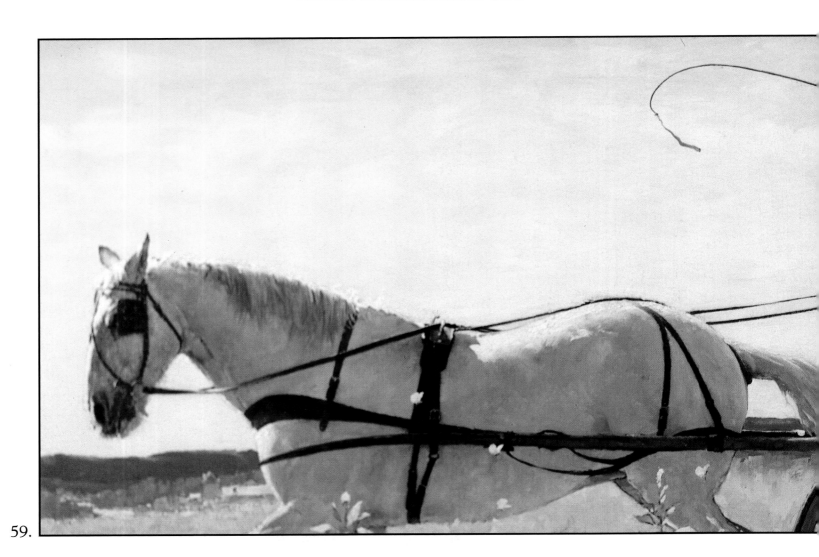

59.

57. *Freedom of Speech*
 Saturday Evening Post, February 20, 1943. Illustration for
 "Freedom of Speech" by Booth Tarkington, page 85. Oil on
 canvas. Collection of the Norman Rockwell Museum at
 Stockbridge.

58. *Freedom to Worship*
 Saturday Evening Post, February 27, 1943. Illustration for
 "Freedom of Worship" by Will Durant, page 85. Oil on canvas.
 Collection of the Norman Rockwell Museum at Stockbridge.

59. *Aunt Ella Takes a Trip*
 Ladies' Home Journal, April, 1942. Illustration for "Aunt Ella
 Takes a Trip" by Marcelene Cox, pages 20-21. Oil on canvas.
 Collection of the Norman Rockwell Museum at Stockbridge.

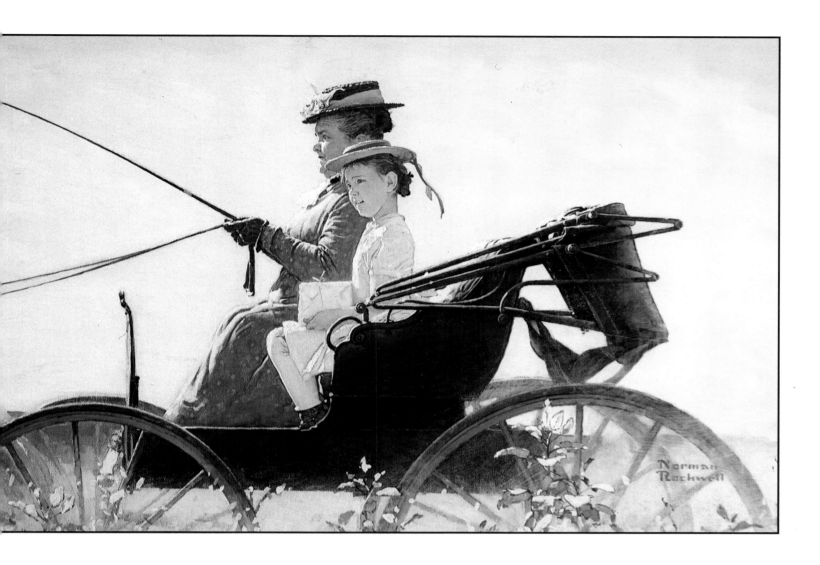

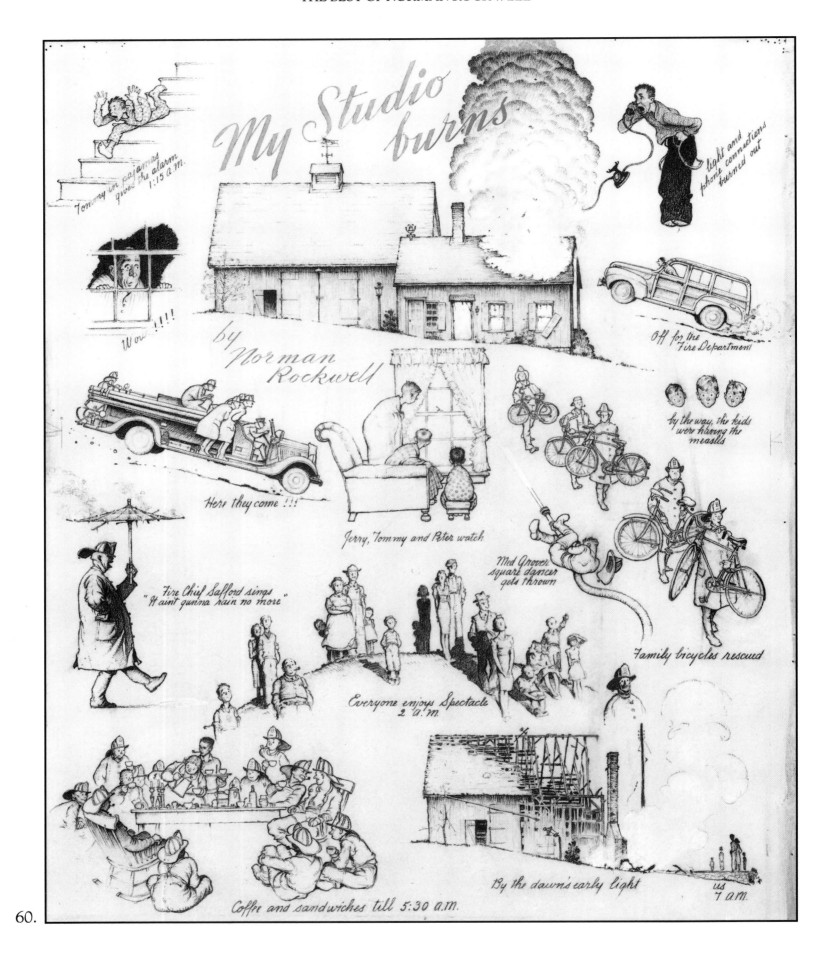

60.

60. *My Studio Burns*
 Saturday Evening Post, July 17, 1943, page 11. Charcoal on paper.
 Private collection.

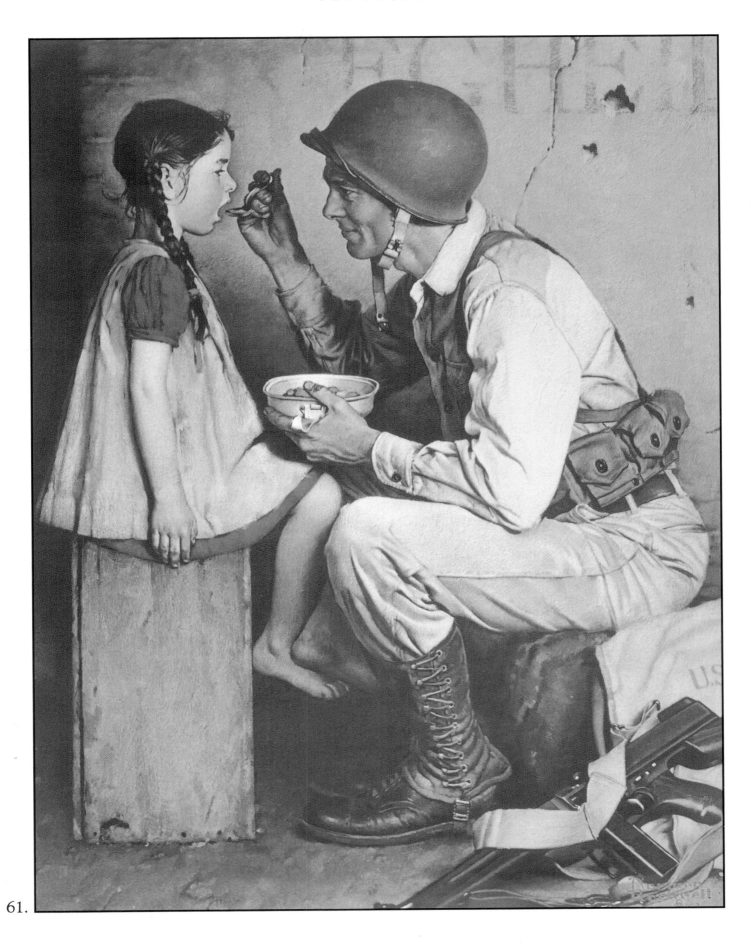

61.

61. *The American Way*
 World War II poster for Disabled American Veterans, 1944.
 Oil. Collection of Disabled American Veterans.

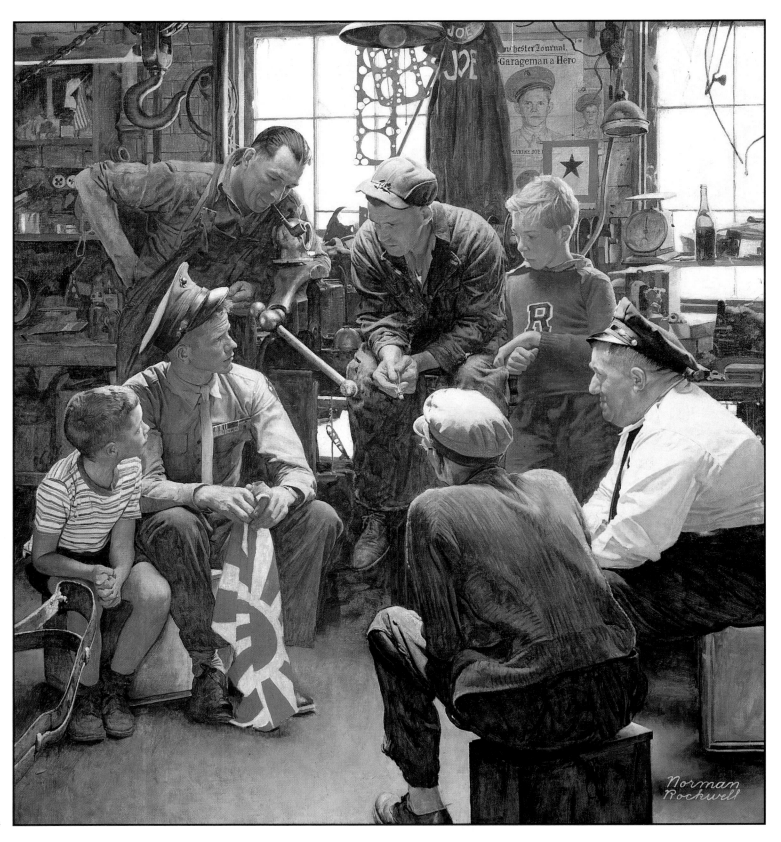

62.

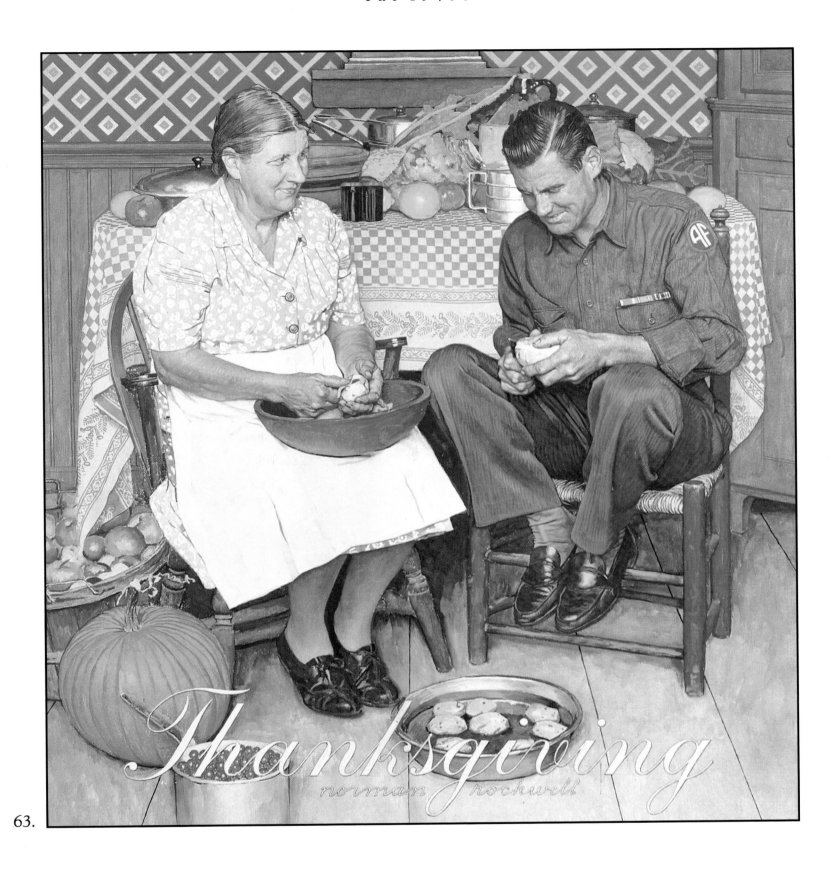

63.

62. **Homecoming Marine**
Saturday Evening Post, October 13, 1945, cover. Oil on canvas.

63. **Thanksgiving: Mother and Son Peeling Potatoes**
Saturday Evening Post, November 24, 1945, cover. Oil on canvas.
Private collection.

64.

64. *Norman Rockwell Visits a Country School*
 Saturday Evening Post, November 2, 1946. Illustration for
 "Norman Rockwell Visits a Country School," page 24. Wolff
 pencil on paper. Private collection.

91

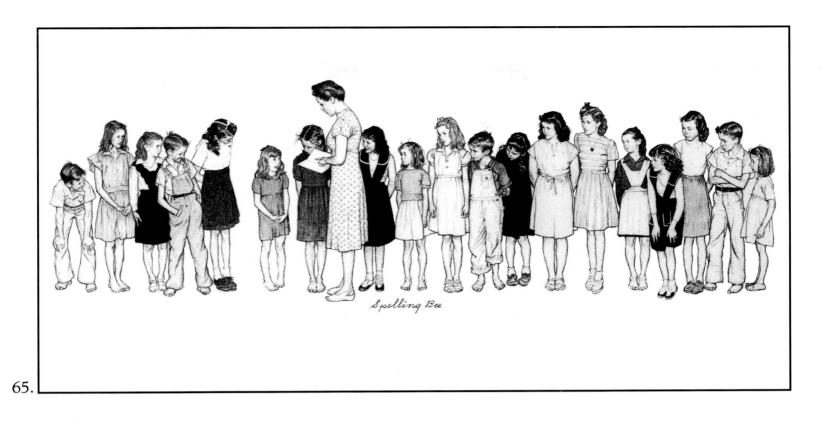

65.

65. **Norman Rockwell Visits a Country School**
Saturday Evening Post, November 2, 1946. Illustration for
"Norman Rockwell Visits a Country School: 'Spelldown. Just
remember, it's i before e, except after c—except for the
exceptions,'" pages 26-27. Wolff pencil on paper. Private
collection.

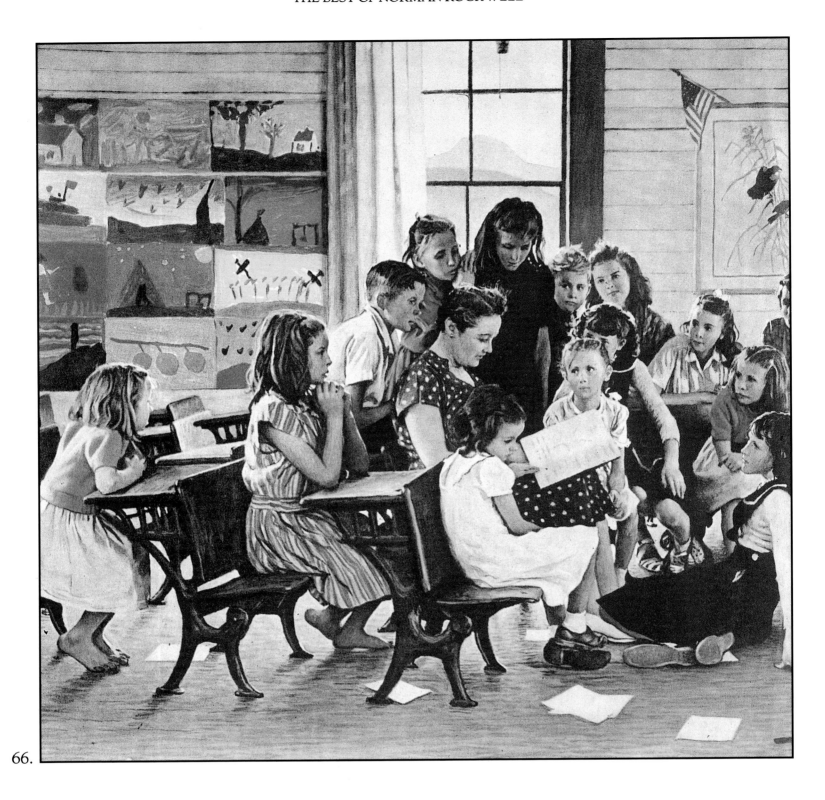

66.

66., 66a. *Norman Rockwell Visits a Country School*
Saturday Evening Post, November 2, 1946. Illustration for
"Norman Rockwell Visits a Country School," pages 24-25. Oil
on canvas. Private collection.

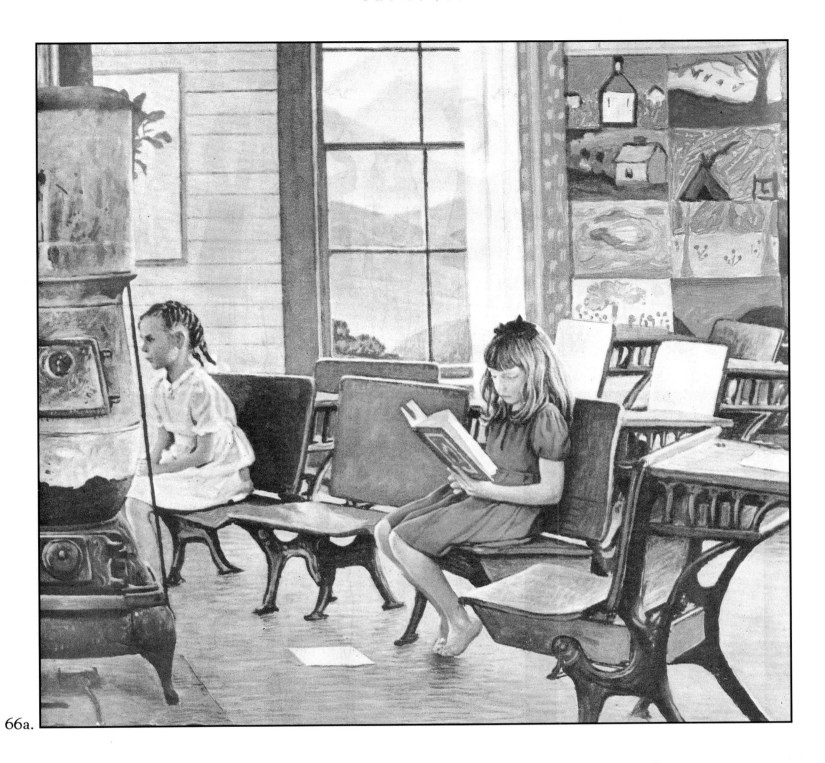

66a.

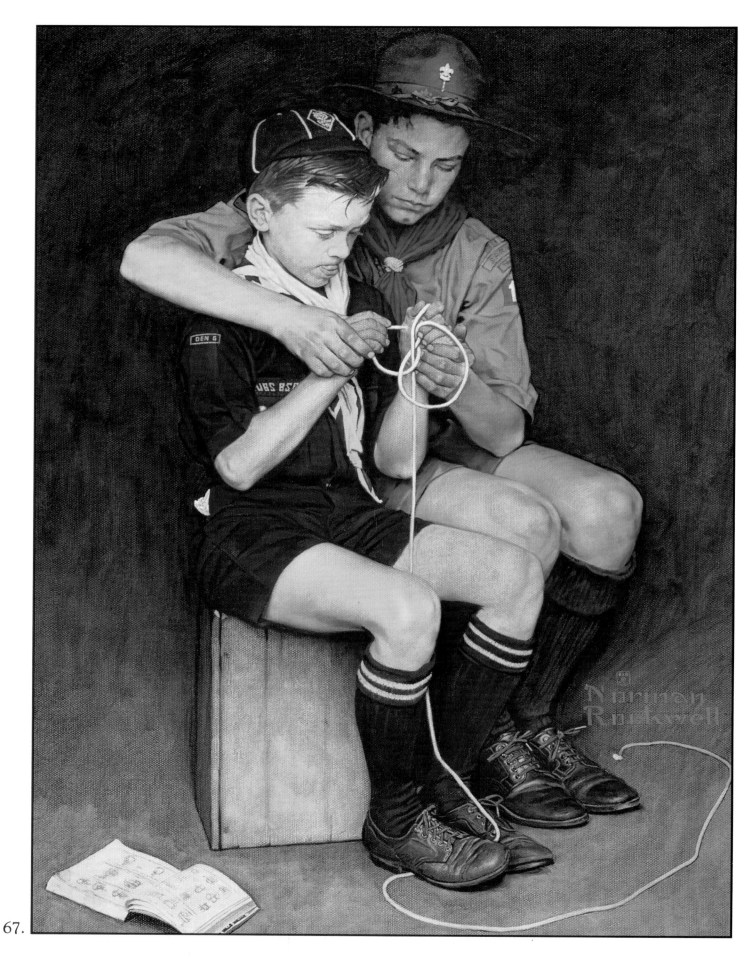

67.

67. *A Guiding Hand*
Calendar illustration for Boy Scouts of America, 1946.
Copyright © 1946 by Brown and Bigelow. All rights reserved.
Oil on canvas. Collection of National Office, Boy Scouts of America.

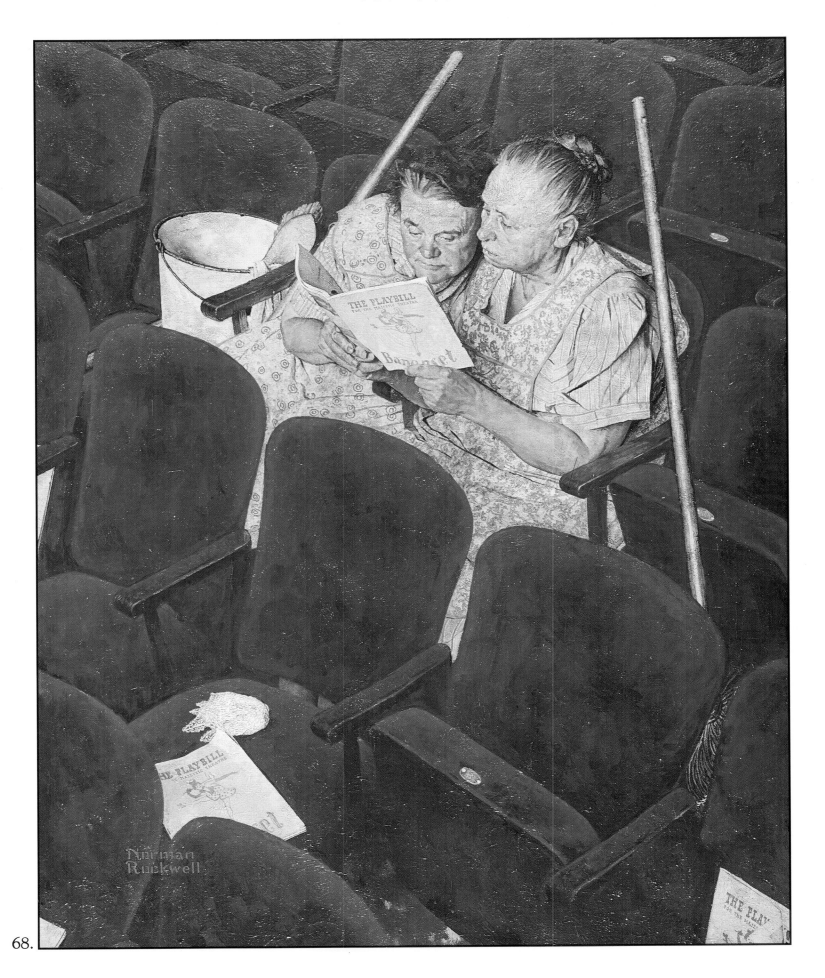

68.

68. *Charwomen in Theater*
Saturday Evening Post, April 6, 1946, cover. Oil on canvas.
Private collection.

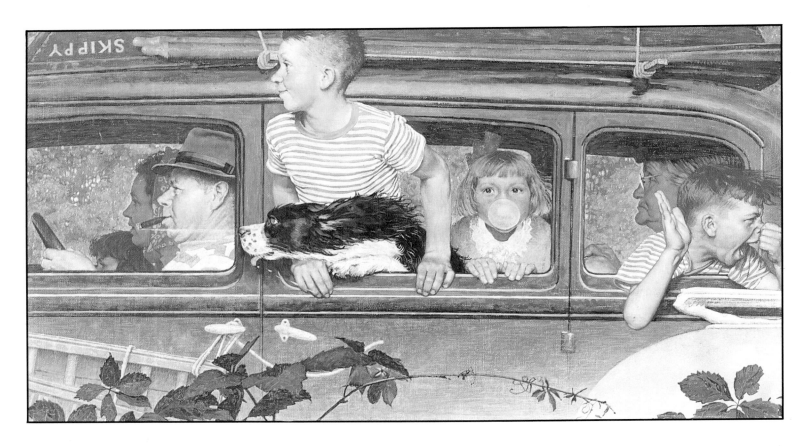

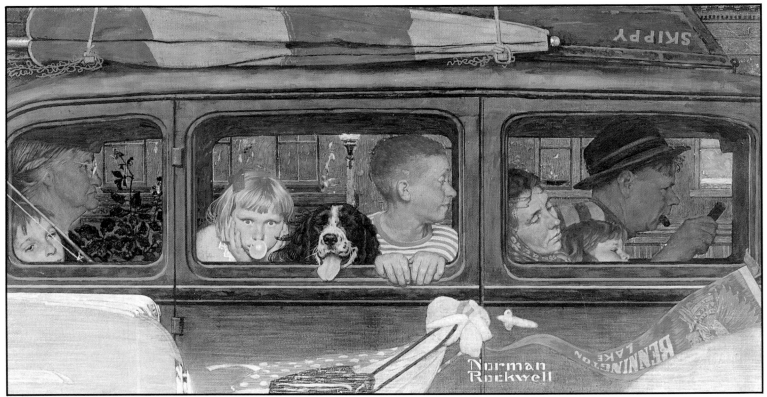

69.

69. *Going and Coming*
 Saturday Evening Post, August 30, 1947, cover. Oil on canvas.
 Collection of the Norman Rockwell Museum at Stockbridge.

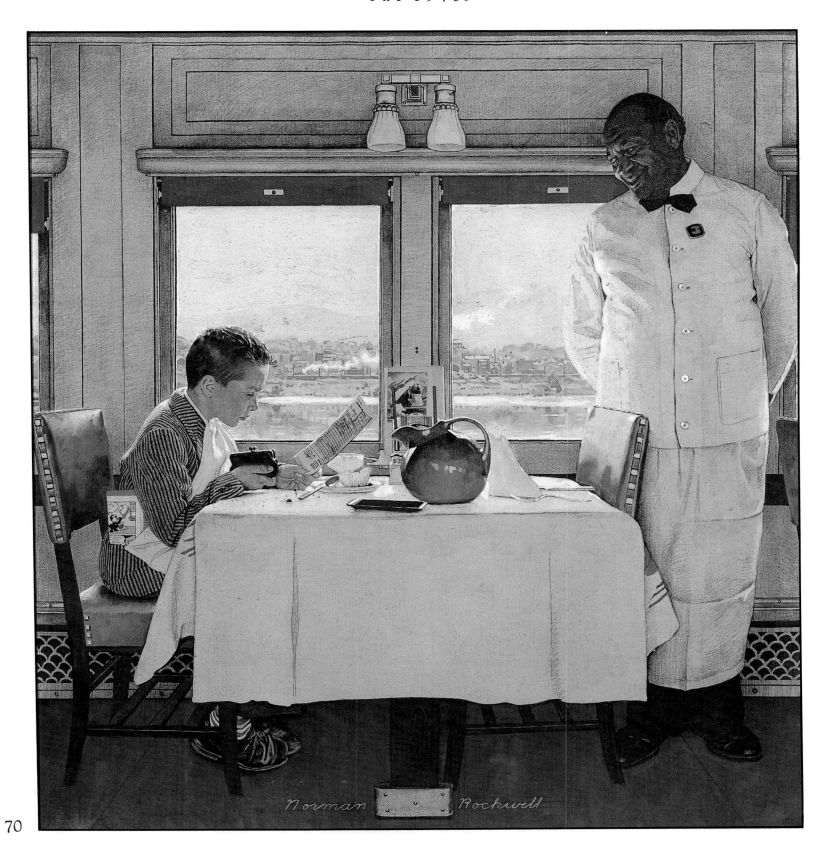

70

70. *Boy in a Dining Car*
Saturday Evening Post, December 7, 1946, cover. Oil on canvas.
Private collection.

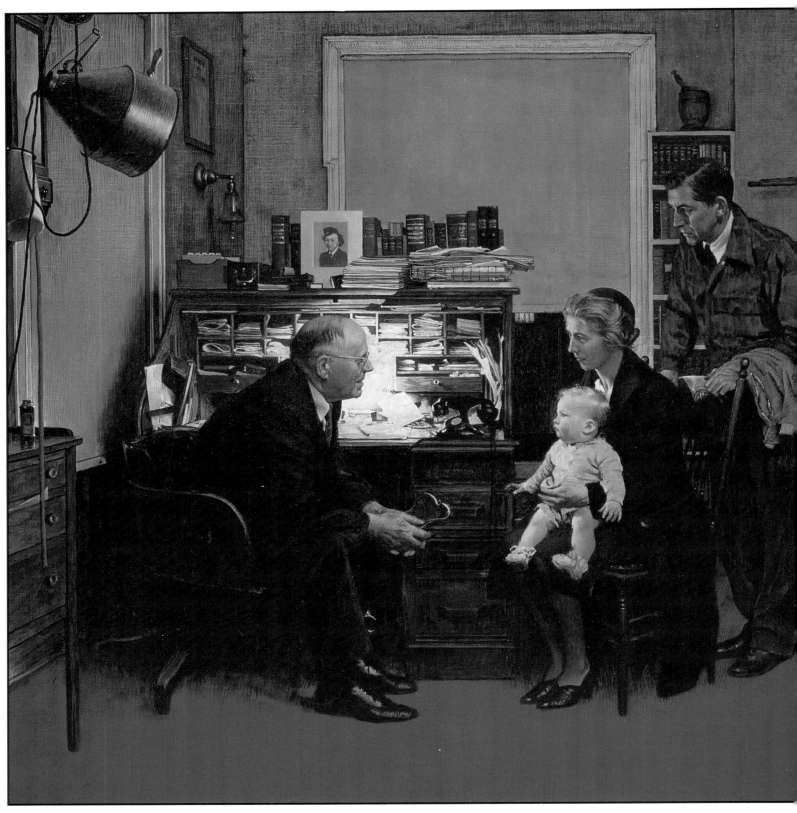

71.

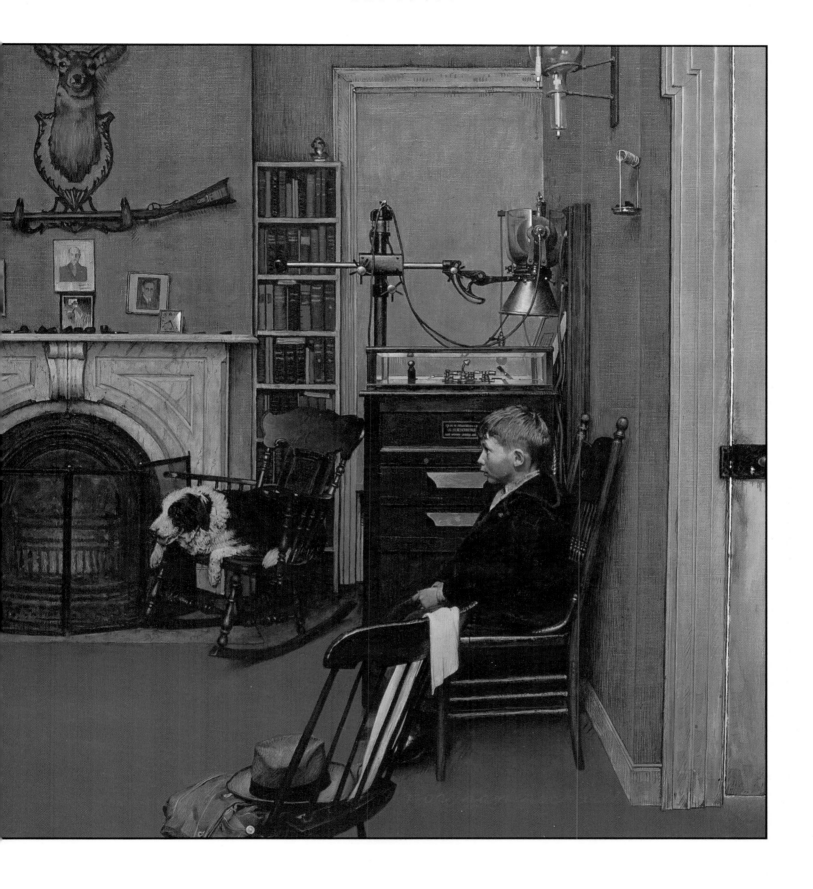

71. *Norman Rockwell Visits a Family Doctor*
 Saturday Evening Post, April 12, 1947. Illustration for "Norman Rockwell Visits a Family Doctor," pages 30-31. Oil on canvas. Collection of the Norman Rockwell Museum at Stockbridge.

72. *April Fool: Girl with Shopkeeper*
 Saturday Evening Post, April 3, 1948, cover. Private collection.

73. *The Gossips*
 Saturday Evening Post, March 6, 1948, cover. Oil on canvas.

74. *New Television Antenna*
 Saturday Evening Post, November 5, 1949, cover. Oil on canvas. Collection of the Los Angeles County Museum of Art.

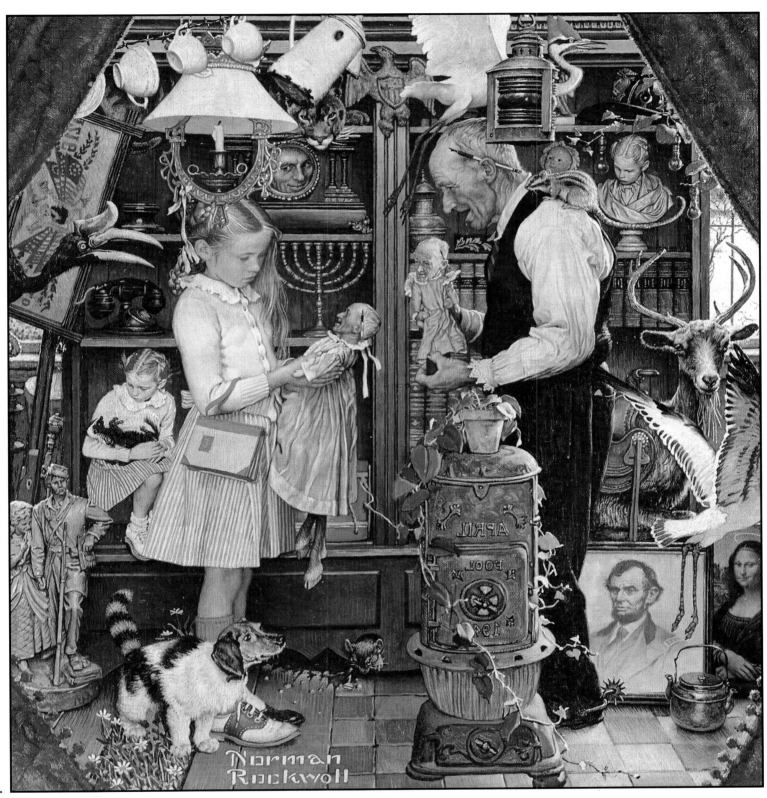

72.

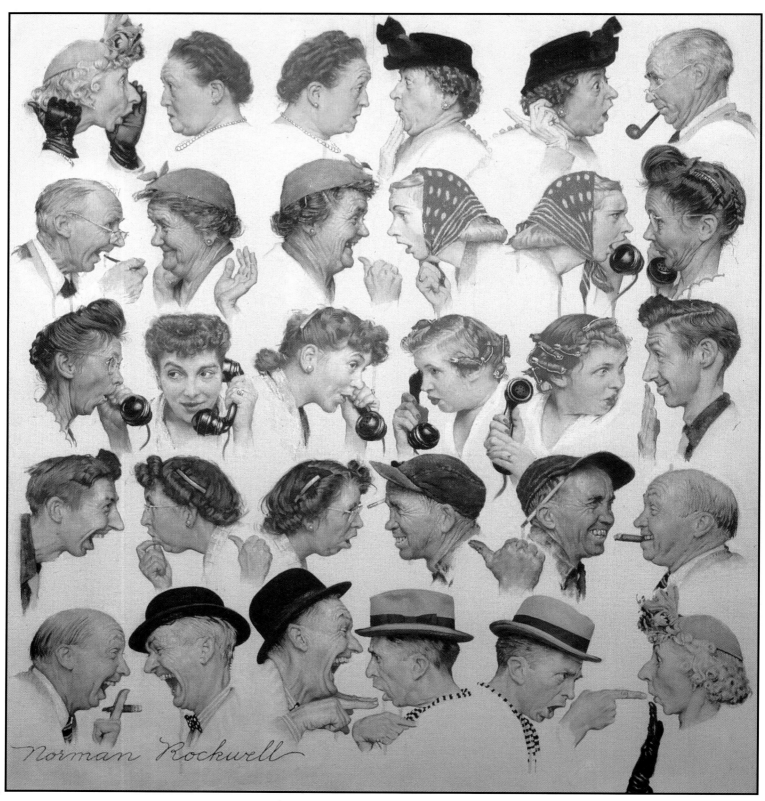

73.

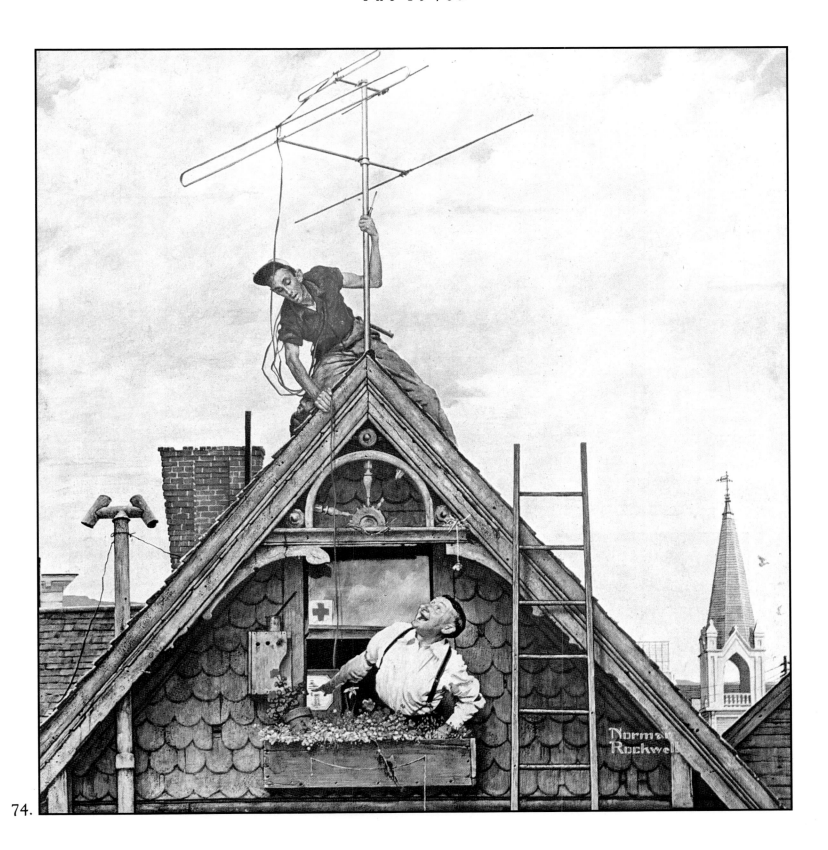

74.

Part Five
The 1950s and 1960s

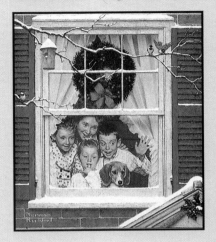

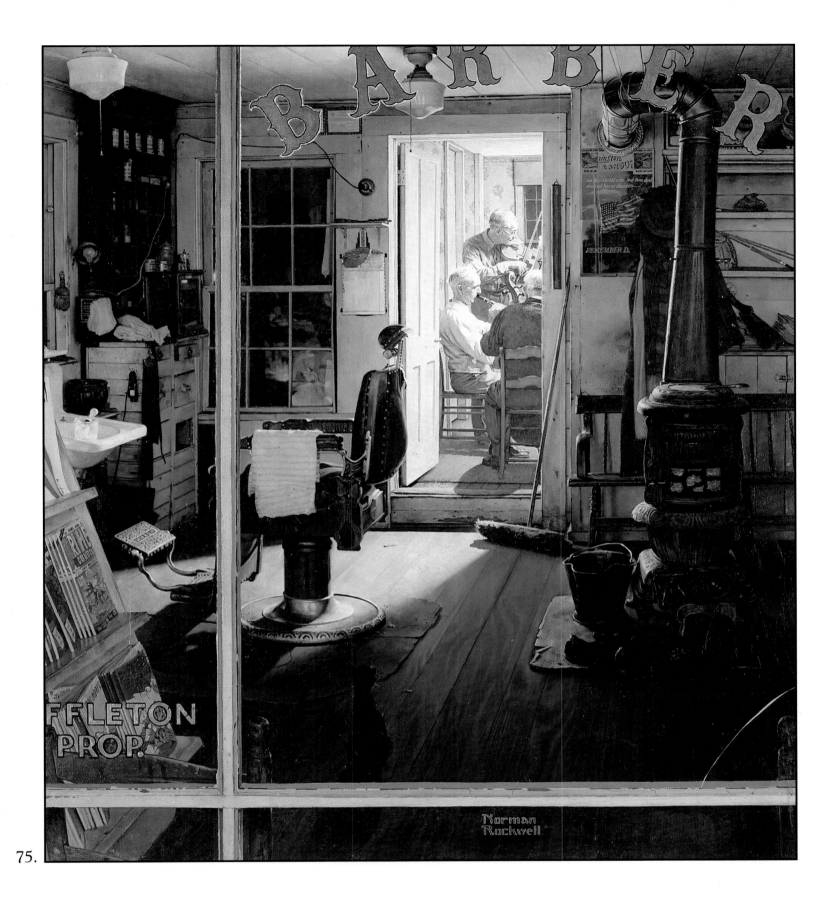

75.

75. *Shuffleton's Barbershop*
 Saturday Evening Post, April 29, 1950, cover. Oil on canvas.
 Collection of the Berkshire Museum.

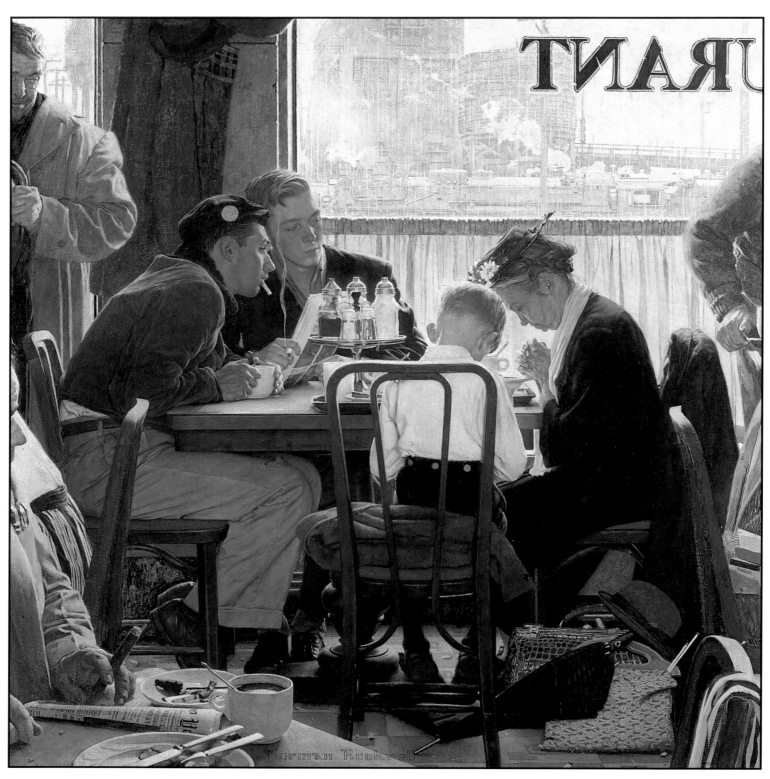

76.

76. *Saying Grace*
 Saturday Evening Post, November 24, 1951, cover. Oil on canvas.
 Private collection.

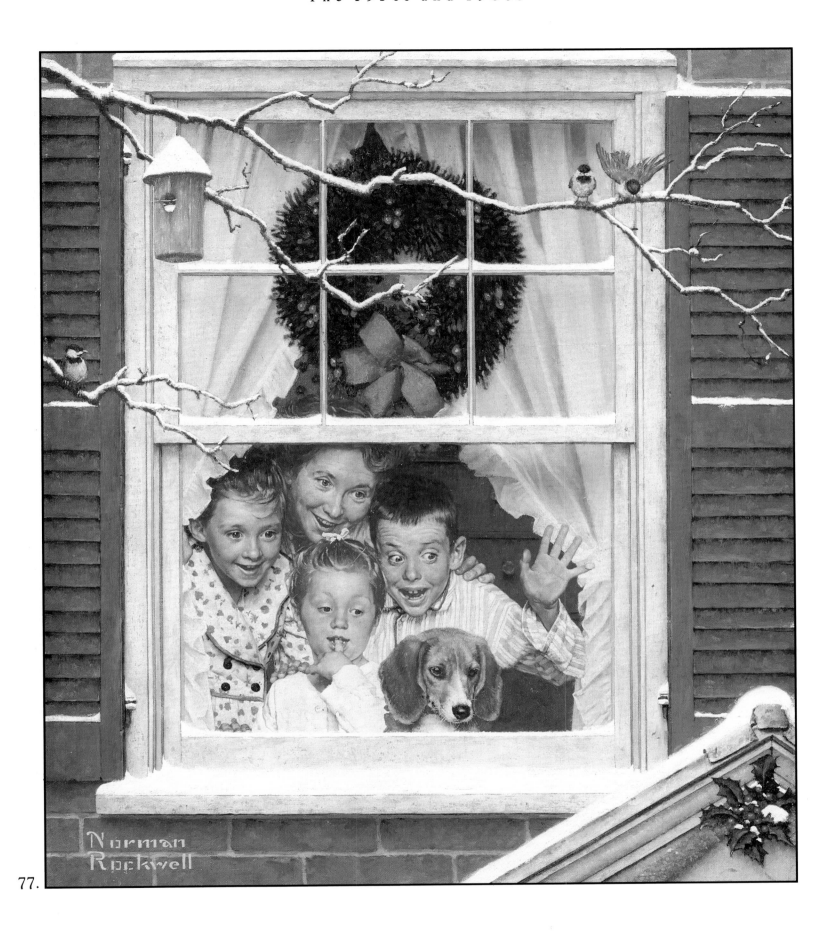

77.

77. *"Oh Boy! It's Pop with a New Plymouth!"*
Advertisement for Plymouth automobiles, 1951. Oil on canvas.
Private collection.

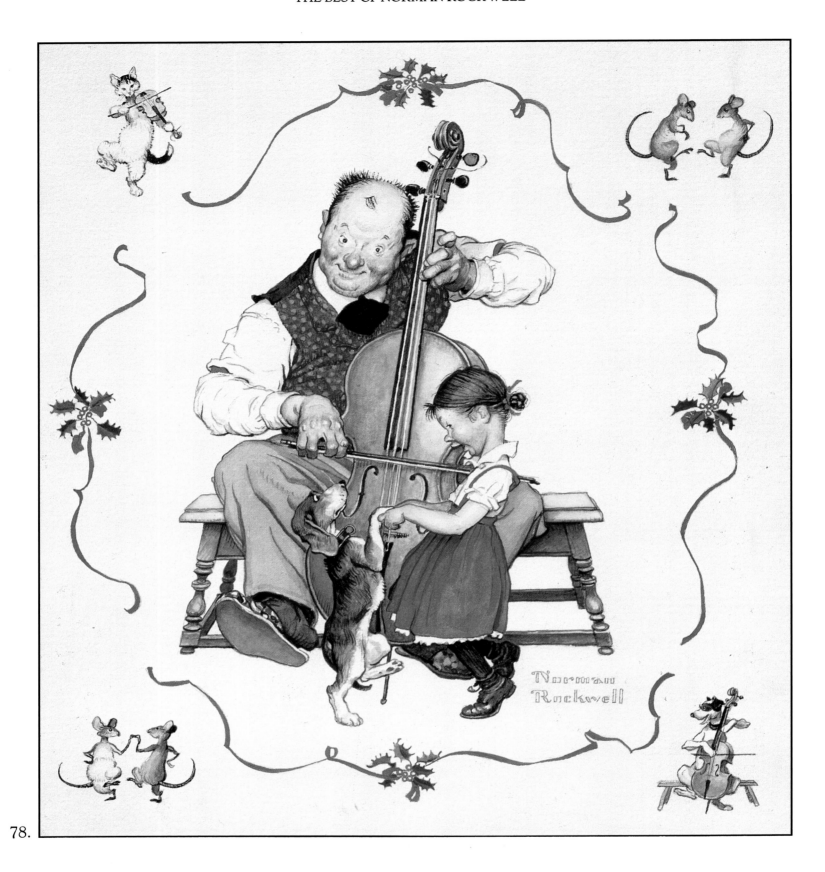

78.

78. *Christmas Dance*
 Christmas card for Hallmark Cards, 1950. Watercolor on
 posterboard. Collection of Hallmark Cards, Inc.

79. *. . . And to All a Good Night*
 Christmas card for Hallmark Cards, 1954. Watercolor on
 posterboard. Collection of Hallmark Cards, Inc.

When the holiday
hustle and bustle
has passed...

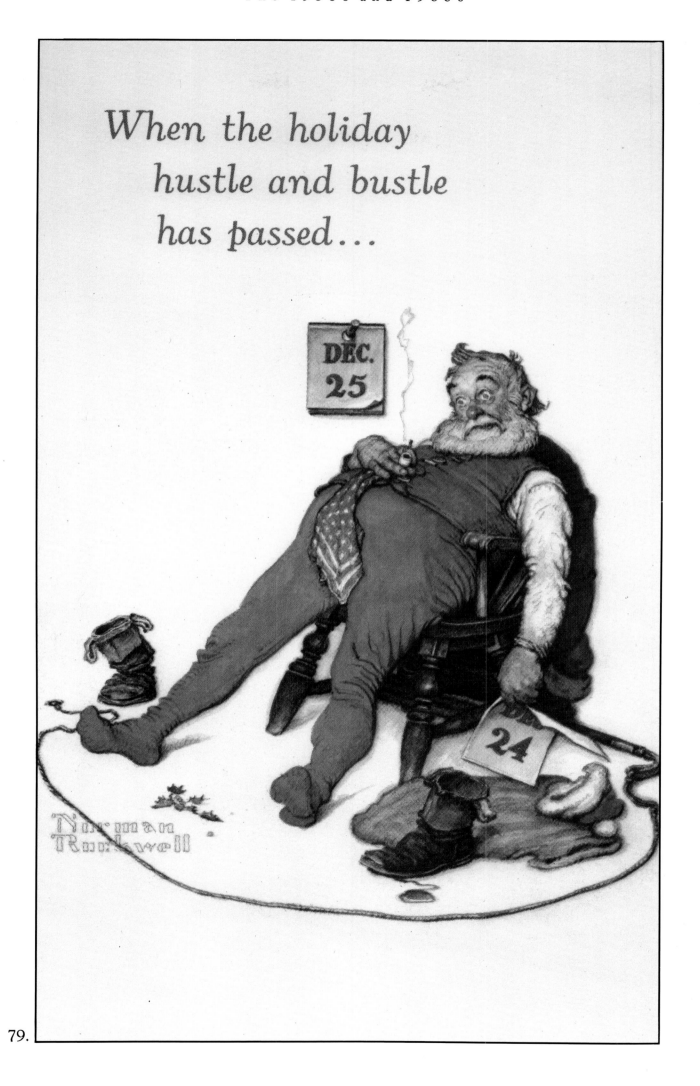

79.

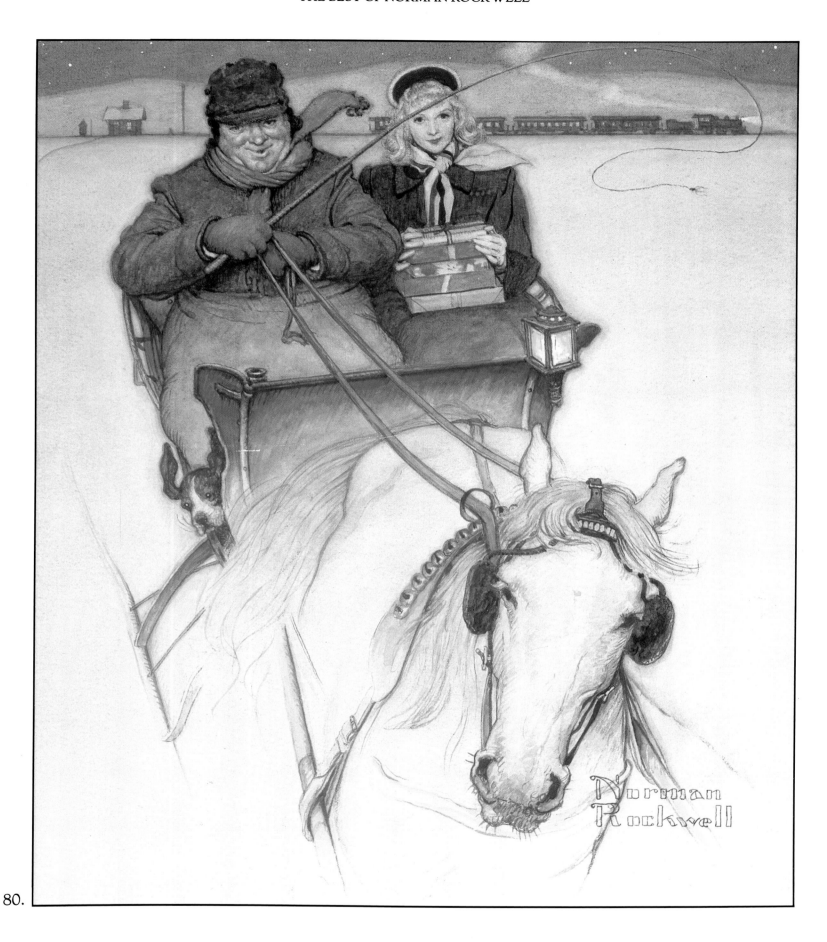

80.

80. *Homecoming*
Christmas card for Hallmark Cards. Watercolor on
posterboard. Collection of Hallmark Cards, Inc.

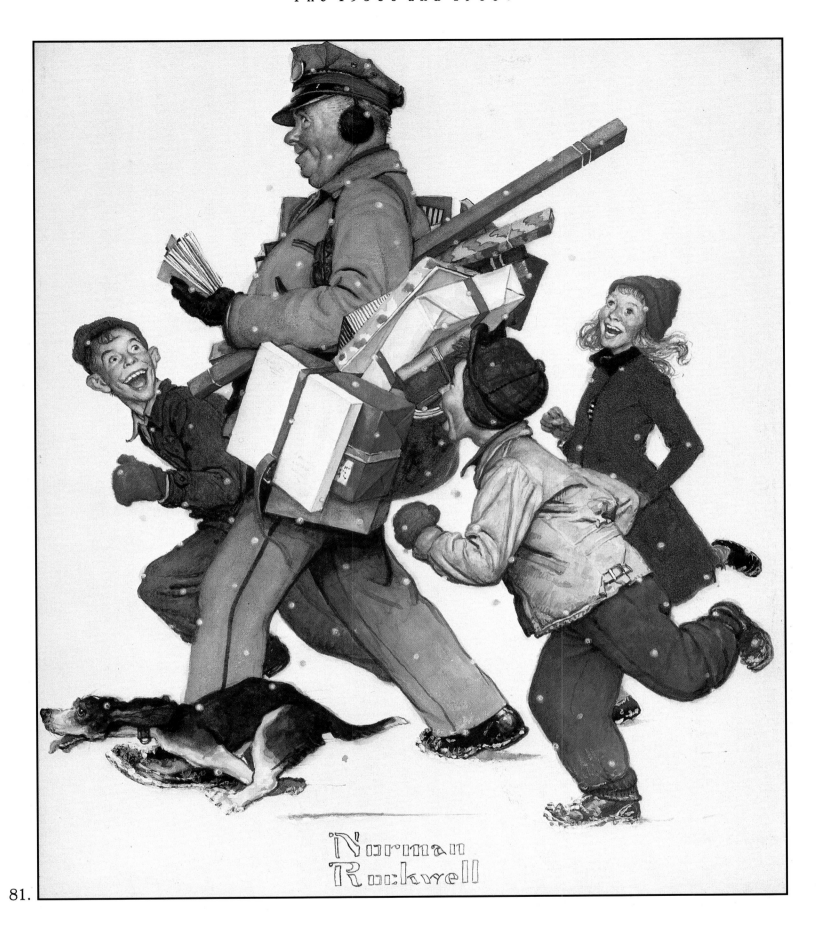

81.

81. *Jolly Postman*
 Christmas card for Hallmark Cards. Watercolor on
 posterboard. Collection of Hallmark Cards, Inc.

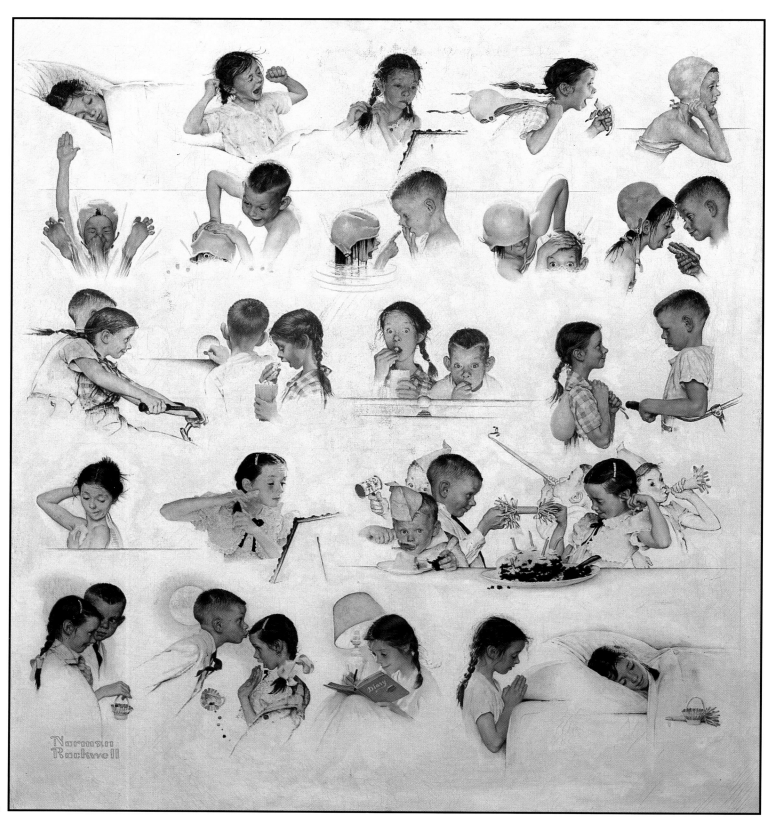

82.

82. *Day in the Life of a Little Girl*
 Saturday Evening Post, August 30, 1952, cover. Oil on canvas.
 Collection of the Norman Rockwell Museum at Stockbridge.

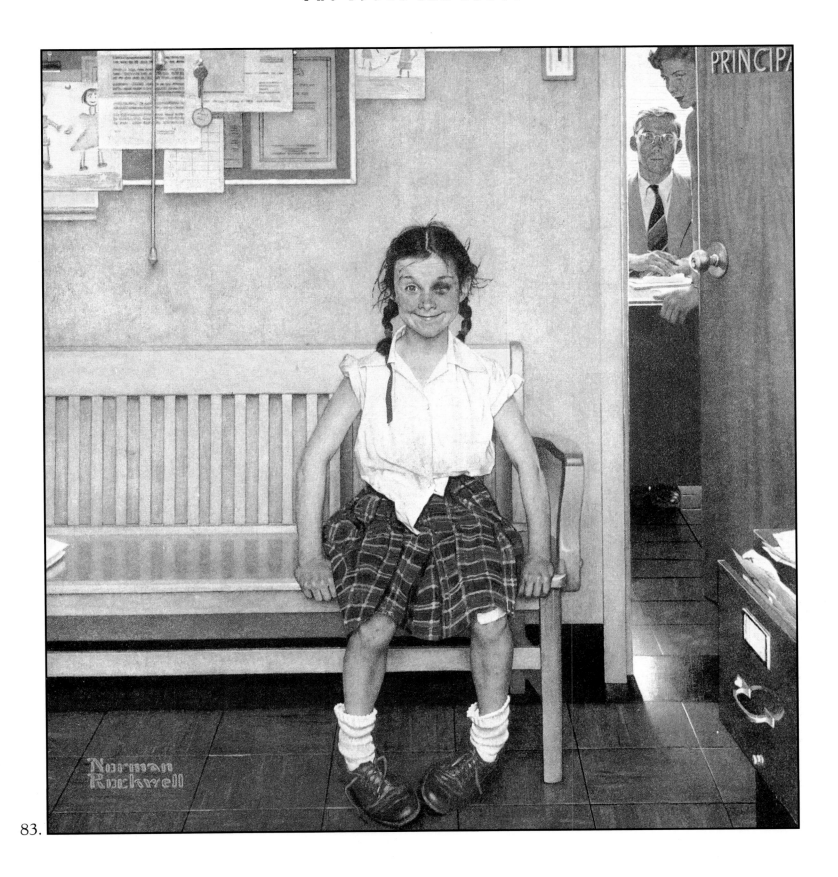

83.

83. *Girl With Black Eye*
 Saturday Evening Post, May 23, 1953, cover. Oil on canvas.
 Collection of the Wadsworth Atheneum.

84. *The Boy Who Put the World on Wheels (The Inventor)*
Fiftieth anniversary illustration for Ford Motor Company, 1952.
Oil on board. Collection of Henry Ford Museum and Greenfield
Village.

84.

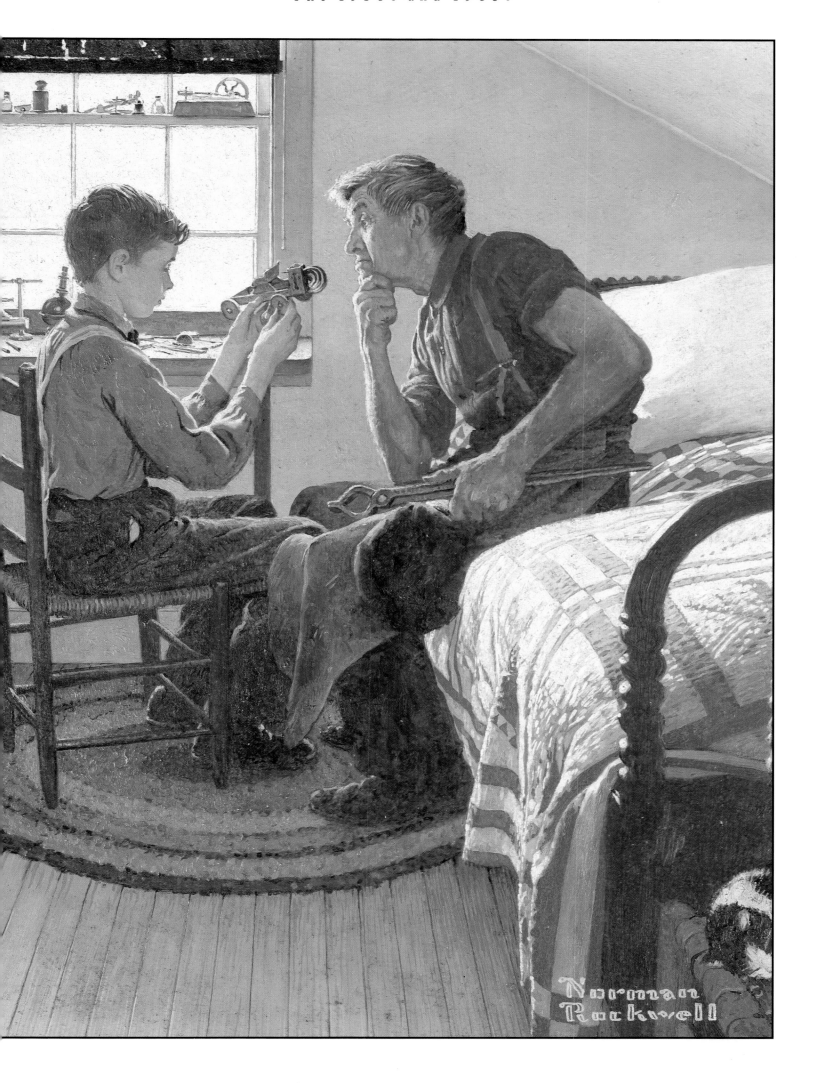

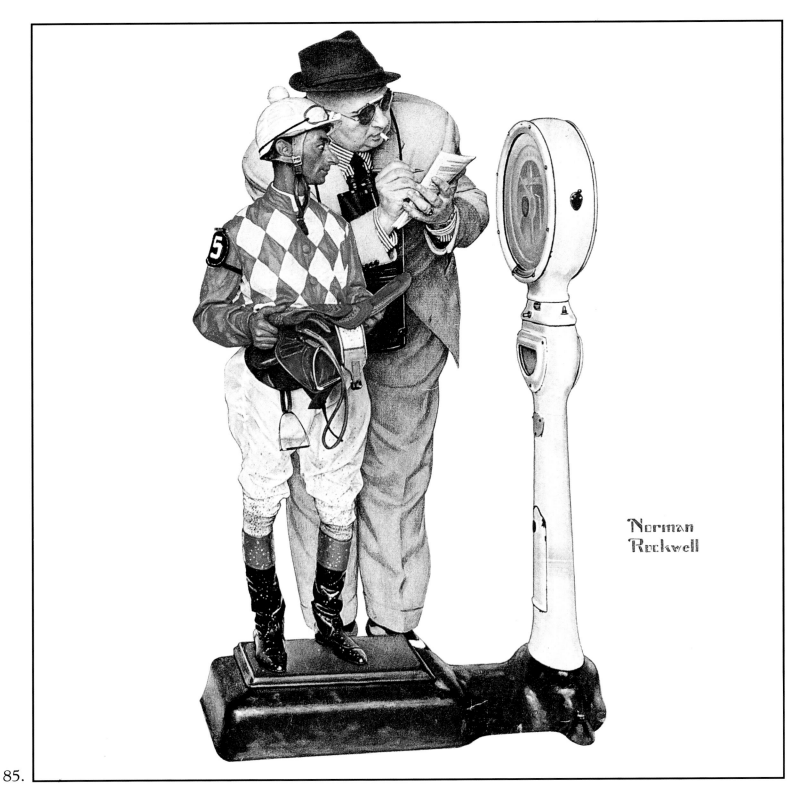

Norman
Rockwell

85.

85. *Weighing In (The Jockey)*
Saturday Evening Post, June 28, 1958, cover. Oil on canvas.
Collection of the New Britain Museum of American Art.

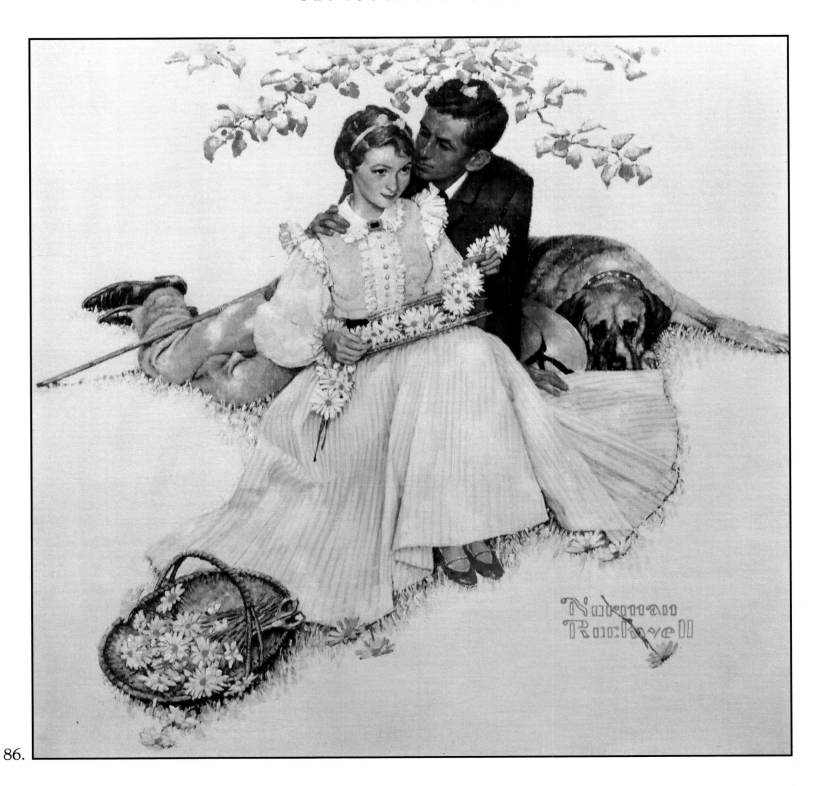

86.

86. *Flowers in Tender Bloom*
Four Seasons calendar, spring 1955. Copyright © 1953 by
Brown and Bigelow. All rights reserved. Oil on canvas.

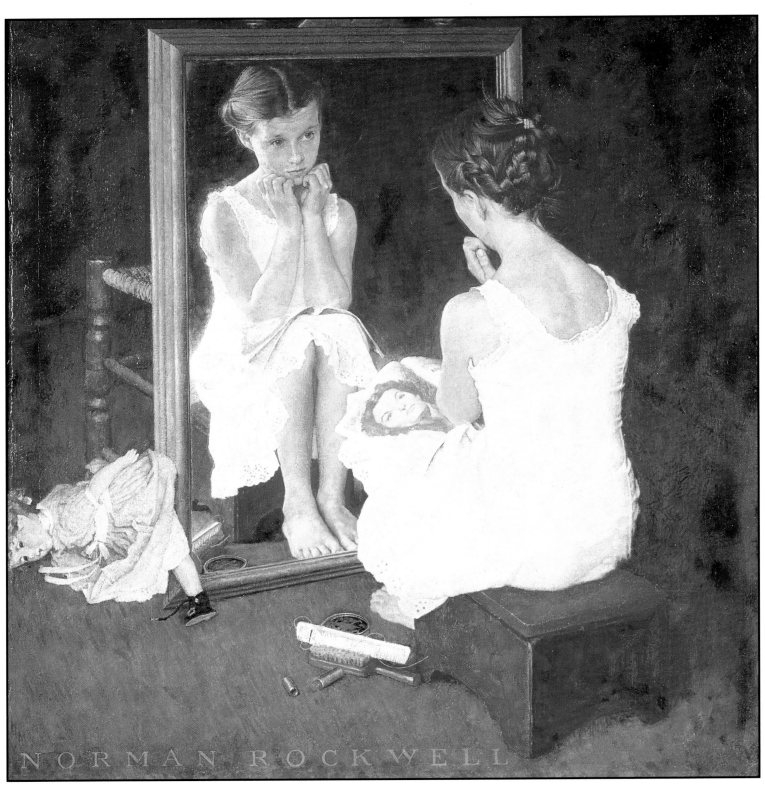

87.

87. *Girl at Mirror*
 Saturday Evening Post, March 6, 1954, cover. Oil on canvas.
 Collection of the Norman Rockwell Museum at Stockbridge.

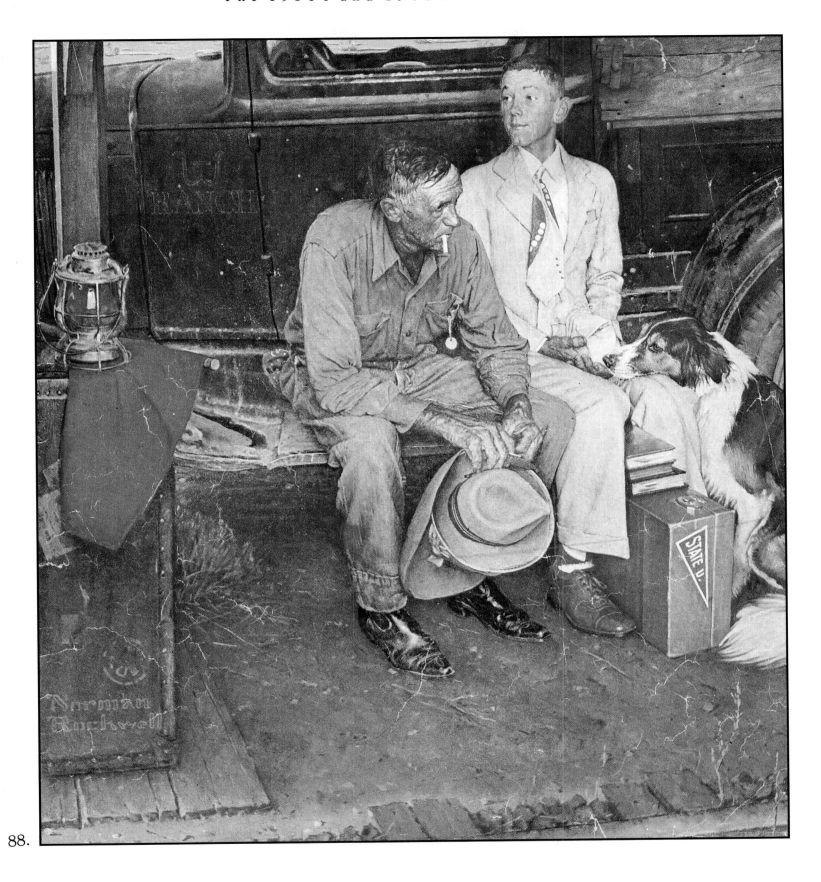

88.

88. *Breaking Home Ties*
Saturday Evening Post, September 25, 1954, cover. Oil on canvas.
Private collection.

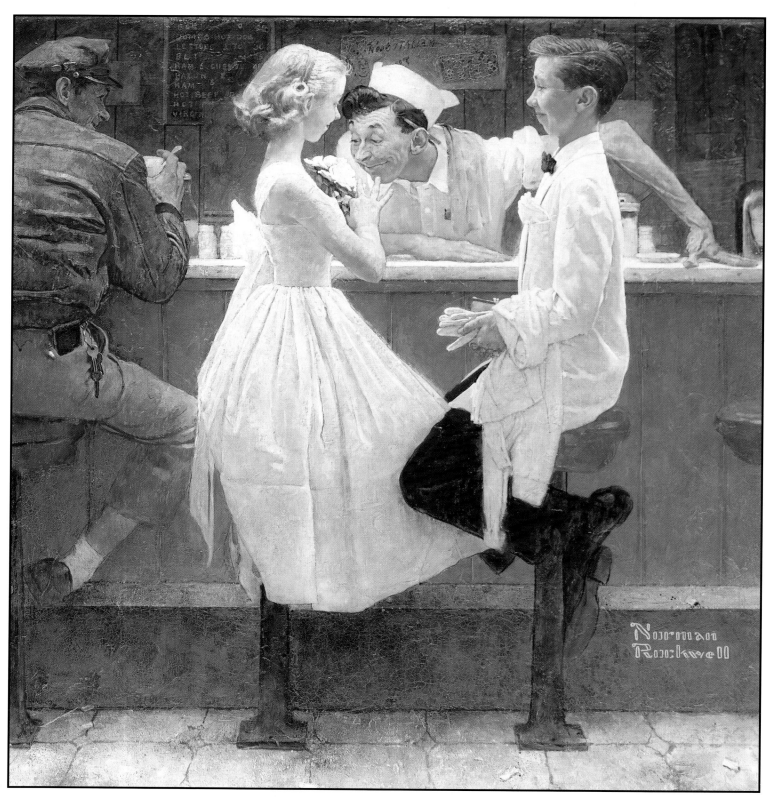

89.

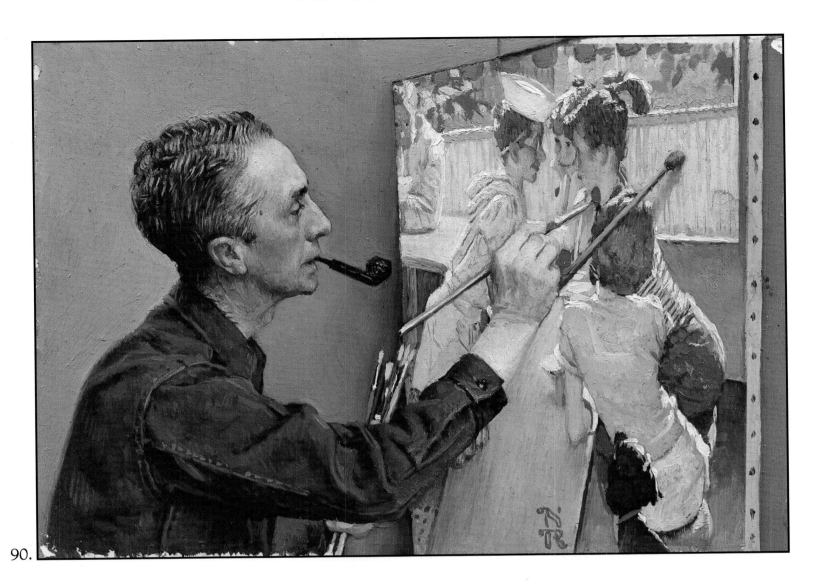

90.

89. *After the Prom*
 Saturday Evening Post, May 25, 1957, cover. Oil on canvas.
 Private collection.

90. *Portrait of Norman Rockwell Painting the Soda Jerk*
 1953. Oil on board. Private collection.

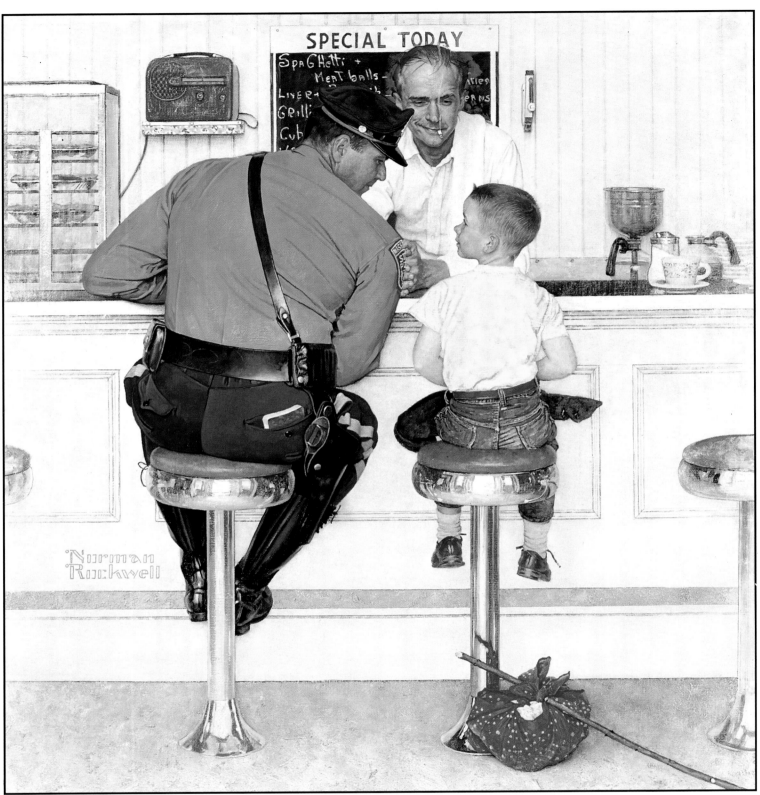

91.

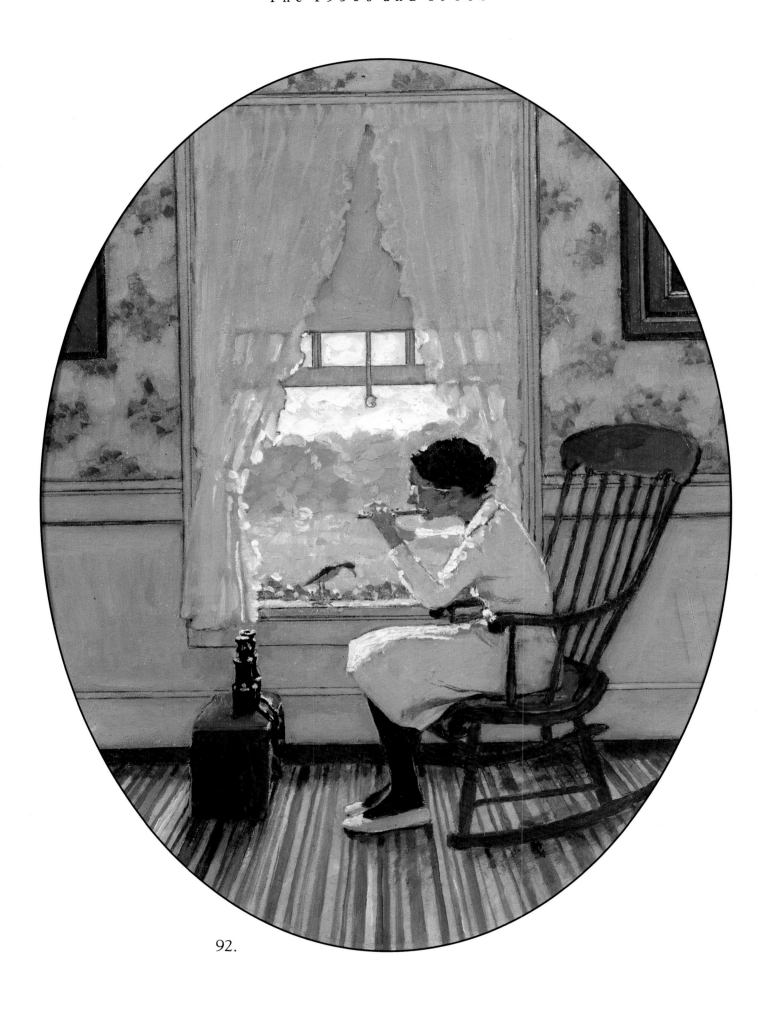

92.

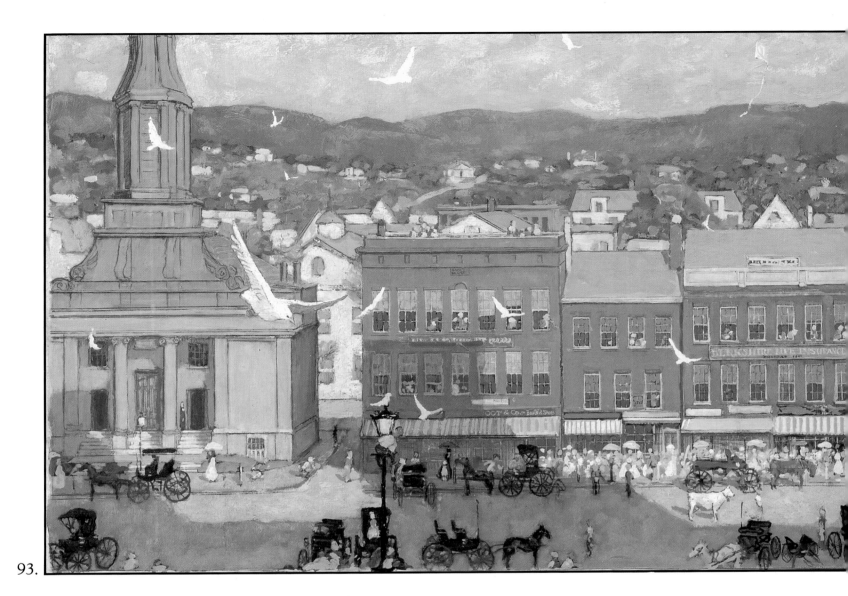

93.

91. *The Runaway*
Saturday Evening Post, September 20, 1958, cover. Oil on canvas.
Collection of the Norman Rockwell Museum at Stockbridge.

92. *Willie Was Different*
Illustration for *Willie Was Different* by Molly and Norman
Rockwell, New York, Funk and Wagnalls, 1967, page 16. Oil on
board. Collection of the Norman Rockwell Museum at
Stockbridge.

93. *Pittsfield Main Street*
1960 study for painting, "Pittsfield Main Street," 1963. Oil on
paper on plywood. Collection of Berkshire County Historical
Society.

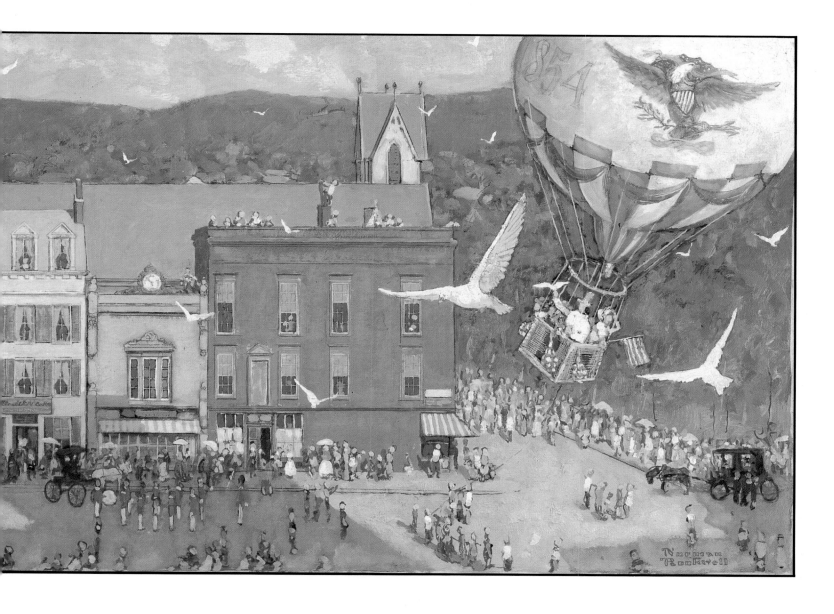

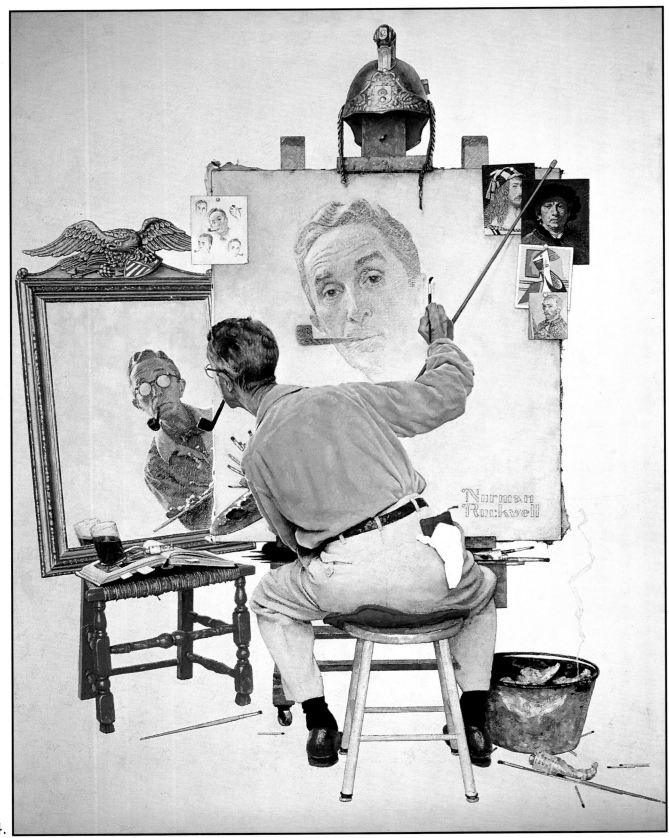

94.

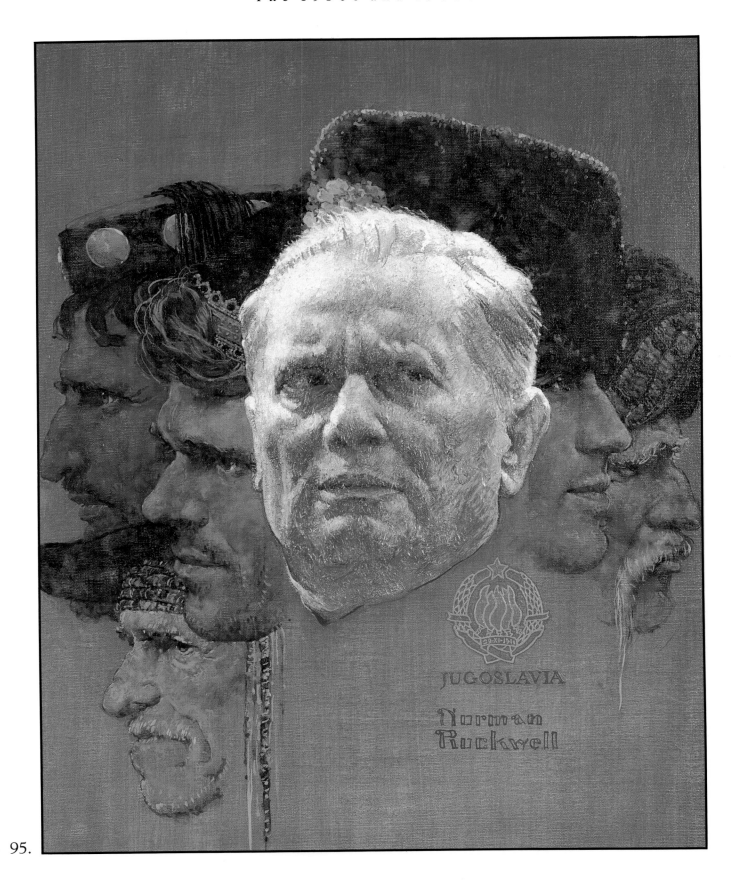

95.

94. *Triple Self-Portrait*
 Saturday Evening Post, February 13, 1960, cover. Oil on canvas.
 Collection of the Norman Rockwell Museum at Stockbridge.

95. *Portrait of Tito*
 c. 1964. Oil on canvas. Collection of the Norman Rockwell
 Museum at Stockbridge.

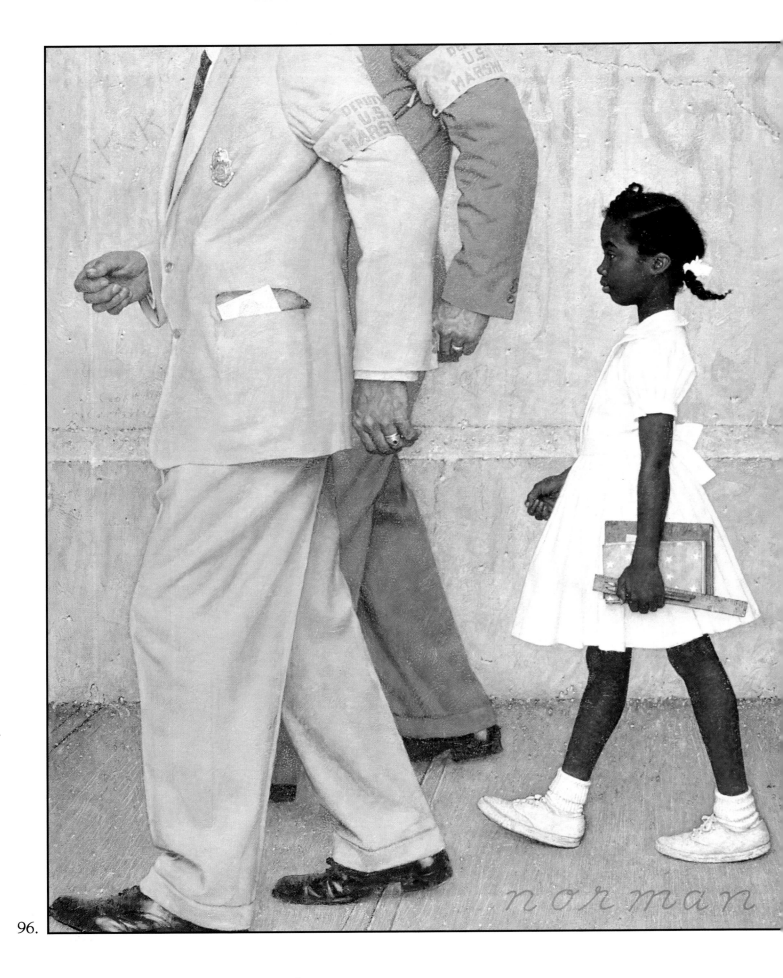

96.

96. *The Problem We All Live With*
 Look, January 14, 1964. Illustration for "The Problem We All
 Live With," pages 22-23. Oil on canvas. Collection of the
 Norman Rockwell Museum at Stockbridge.

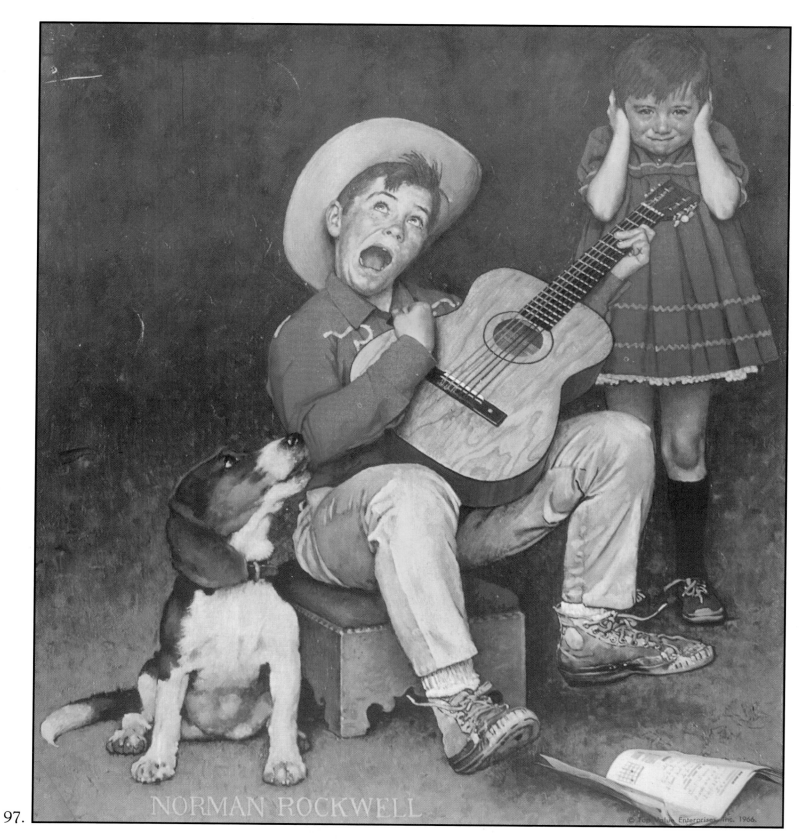

97.

97. *The Music Man*
 Gift catalogue cover for Top Value Stamps, 1966. Oil on canvas.
 Collection of Top Value Enterprises, Incorporated.

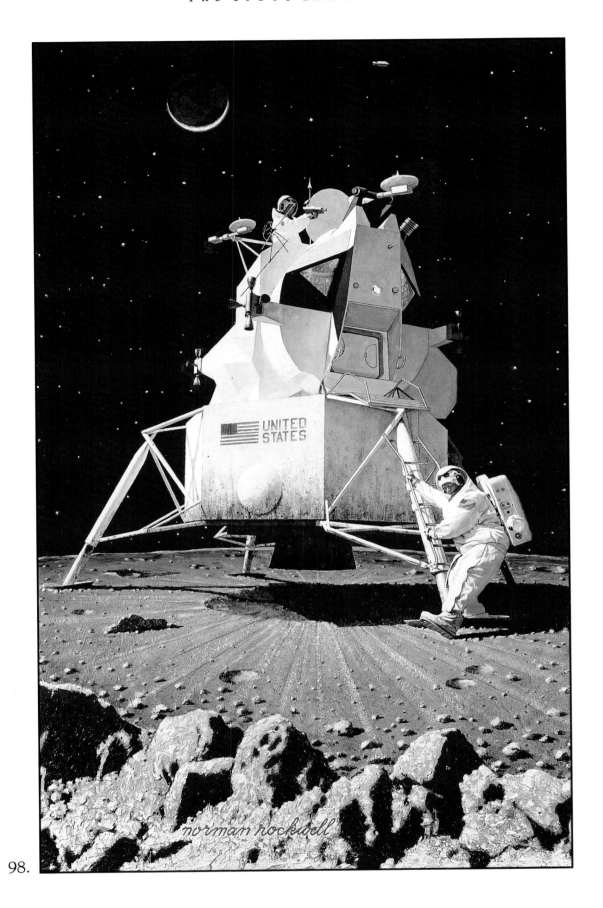

98.

98. **Man on the Moon**
 Look, January 10, 1967. Illustration for "Man on the Moon" by
 John Osmundson, pages 40-41. Oil on canvas. Collection of
 National Air and Space Museum, Smithsonian Institution.

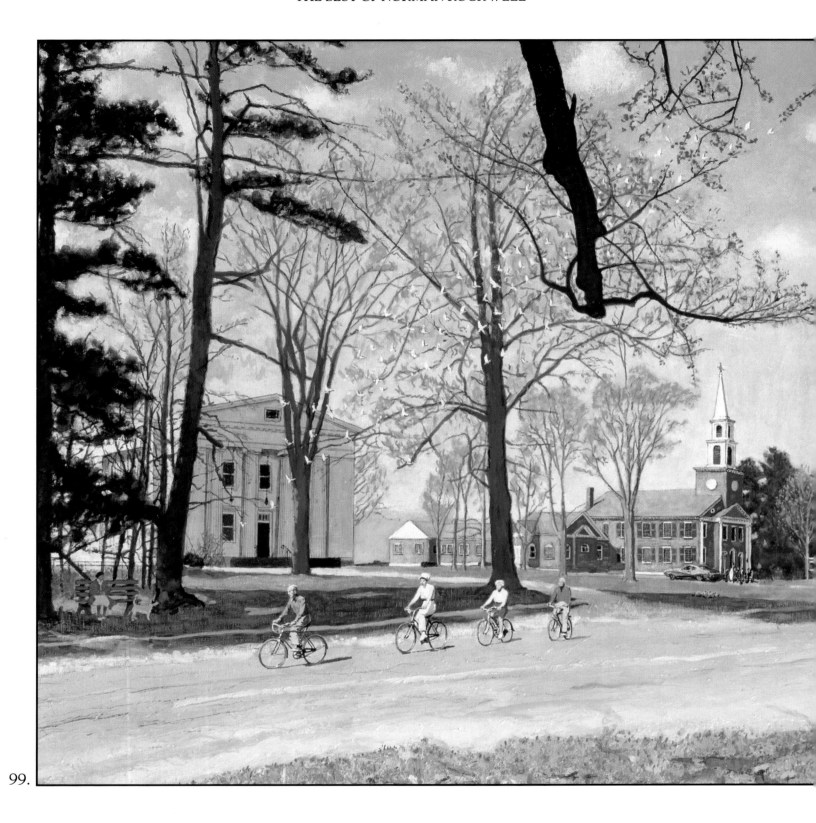

99.

99. *Norman Rockwell's 78th Spring (Springtime in Stockbridge)*
Look, June 1, 1971. Illustration for "Norman Rockwell's 78th
Spring" by Allen Hurlburt, pages 28-29. Oil on canvas.
Collection of the Norman Rockwell Museum at Stockbridge.

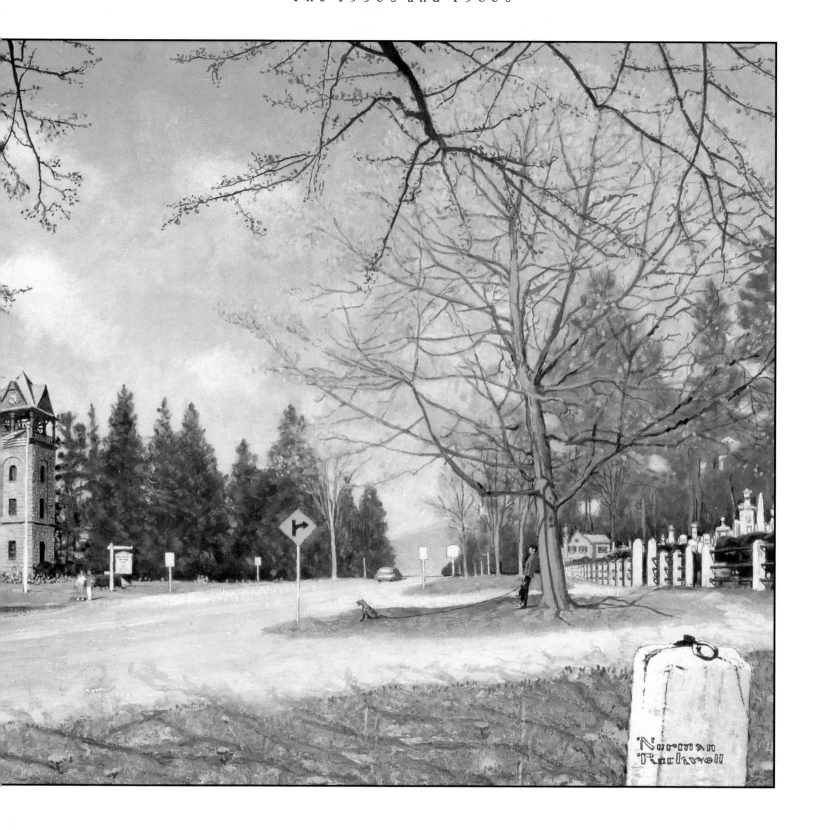

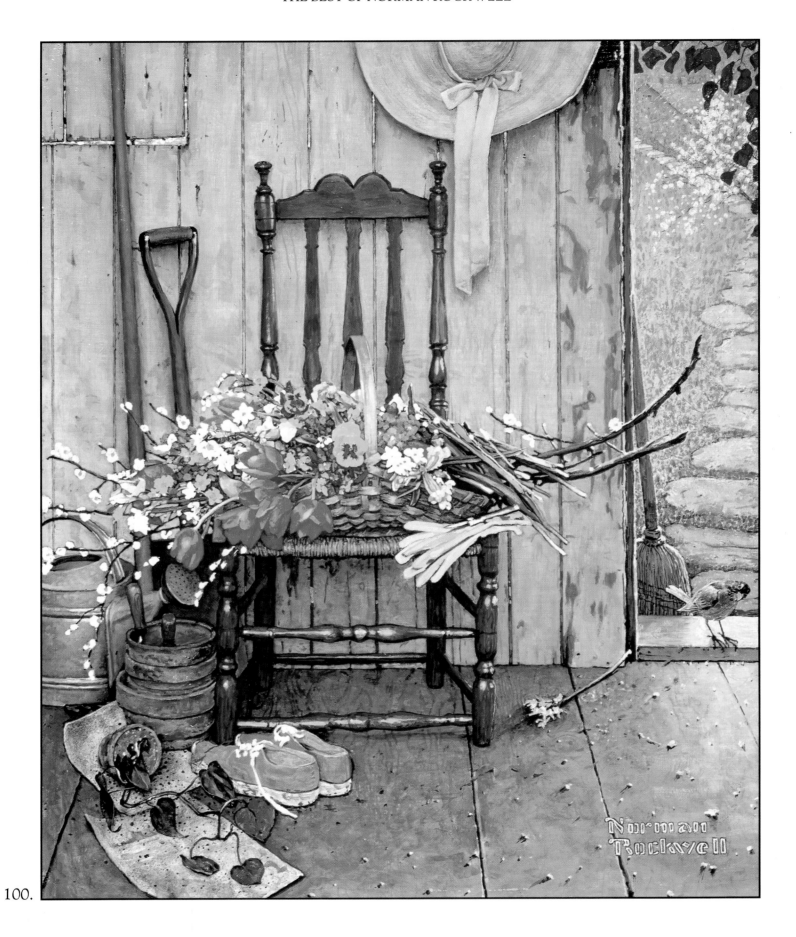

100.

100. *Spring Flowers*
McCall's, May, 1969, page 77. Oil on canvas. Collection of the
Norman Rockwell Museum at Stockbridge.